THE
AIRBRUSH
BOOK

THE AIRBRUSH BOOK

Art, History and Technique

Seng-gye Tombs Curtis
and Christopher Hunt

ORBIS PUBLISHING
LONDON

To Liz and Priscilla for the idea, and Rose and Jacqui for all their support.

Title page: An aeronautical illustration by Terry Pastor, reproduced by kind permission of Andrew Archer Associates, London.

First published in Great Britain by Orbis Publishing Limited, London 1980
© Seng-gye| Tombs Curtis and Christopher Hunt 1980.

Reprinted 1981, 1982, 1983

Printed and bound in Spain by Graficromo, S.A. — Córdoba

ISBN: 0 85613 275 6

Picture Acknowledgments

The authors would like to thank the following for their permission to reproduce the illustrations on the pages listed below: T (top, B (bottom), C (centre), L (left), R (right): Agency Repro Concept, Brussels: 51 T. Andrew Archer Associates: 19 TR, 19 B, 54 T, 54 B, 60 T, 78, 104. Avec Ltd.: 137. Peter Barry: 118, 122. Jonathan Cape: 55. Norman Catherine: 34 B (Collection Haenggi Foundation, South Africa), 35 (Private Collection). Bob Carlos Clarke: 134. Mike Cotten and Prairie Prince: 138, 139. Japan Creators' Association: 53, 56, 60 BL, 61 TR. Terry deLoach: 47 T. The DeVilbiss Co. Ltd.: 8, 9, 12, 13, 15, 16. Kenneth Durran: 129 T. Michael English: 48 (Collection Mr and Mrs Helmuth Griem). Esquire magazine: 14. Audrey Flack: 25, 26. Mel Flatt: 51 B. Buckminster Fuller: 92. Dr J. Hansman: 18. David A. Hardy: 22/23. O.K. Harris Gallery: 45, 46. Ray Hasgood: 135 TL. Nancy Hoffman Gallery Inc.: 20, 32 T, 32 B, 38, 39, 44. Andrew Holmes: 125, 126 T. Denny Johnson: 136. The Francis Kyle Gallery, London: 59 (Collection The DeVilbiss Co. Ltd.). Kurt Jean Lohrum: 52. Rodney Matthews: 90. Chris Meicklejohn Ltd., London: 58, 61 TL. Louis K. Meisel Gallery, New York: 26. 'Miracles', London: 135 BR. Motif Editions: 61B. Chogyam Parkinson-Smith: 96, 108. The Paasche Airbrush Co., Chicago: 11. Terry Pastor: 50 BL, 50BR. Sir Roland Penrose: 30, © by ADAGP Paris 1980. Peter Phillips: 40/41, 42, 43. Arnold Plummer, 102. F. Reeves: 131 T, 131 L, 131 BR. Rolls Royce Ltd.: 63, 121 T, 121 C. Doris and Charles Saatchi: 36. Sue Saunders: 127 B. Peter Sedgley: 28, 31. Seng-gye: 47 B (Collection Colin Lowery), 108 TL (Colin Lowery), 112 T (Private Collection), 112 B (Private Collection). Mrs I.J. Sneddon: 17 T. Studio JR: 131 CR. Studio Ri Kaiser: 57, 135 BL. Thumb Gallery, London: 49, 50T, 126 T. Toppan International: 6, 37. Charlie White III: 60 BR, Paul Wunderlich: 33, 34 T, 126 B. Line drawings are by Rex Kent and Rosemarie Leech. Black and white photographs unless otherwise specified are by Roger Hicks.

Authors' Acknowledgments

The authors'and publishers would like to thank Mike Drew of The DeVilbiss Co. Ltd. (Bournemouth, UK) and Ron Hunt of The Royal Sovereign Group (London) for their continued support and encouragement. The following airbrush distributors and manufacturers are also thanked for their invaluable co-operation: The Paasche Airbrush Co., Chicago, USA; Mike Maurice of The Artistic Airbrush Company, Portland, USA; Binks-Bullows Ltd., Walsall, UK; Frank Herring and Sons, Dorchester, UK; Frisk Products Ltd., London; Humbrol Ltd., Hull, UK; Malcolm and Nicholas Woodward of Microflame (UK) Ltd., Norfolk, UK (Paasche distributors); Morris and Ingram (London) Ltd. (Badger distributors). The following agencies, galleries and individuals also contributed valuable assistance to the production of this book: Andrew Archer Associates; Bristol Fine Art; British Oxygen Co.; O.K. Harris Gallery, New York; Nancy Hoffman Gallery, New York; Japan Creators' Association, Tokyo; Colin Lowery; Chris Meicklejohn Ltd.; 'Miracles', London; Chogyam Parkinson-Smith; Nick Pearson; Sir Roland Penrose; Redfern Gallery, London; Rolls Royce Ltd.; Sloane Street Gallery, London; Mrs I.J. Sneddon; Thumb Gallery, London; Toppan International, Tokyo and London; Waddingtons Graphics, London; Zip Art, London.

Contents

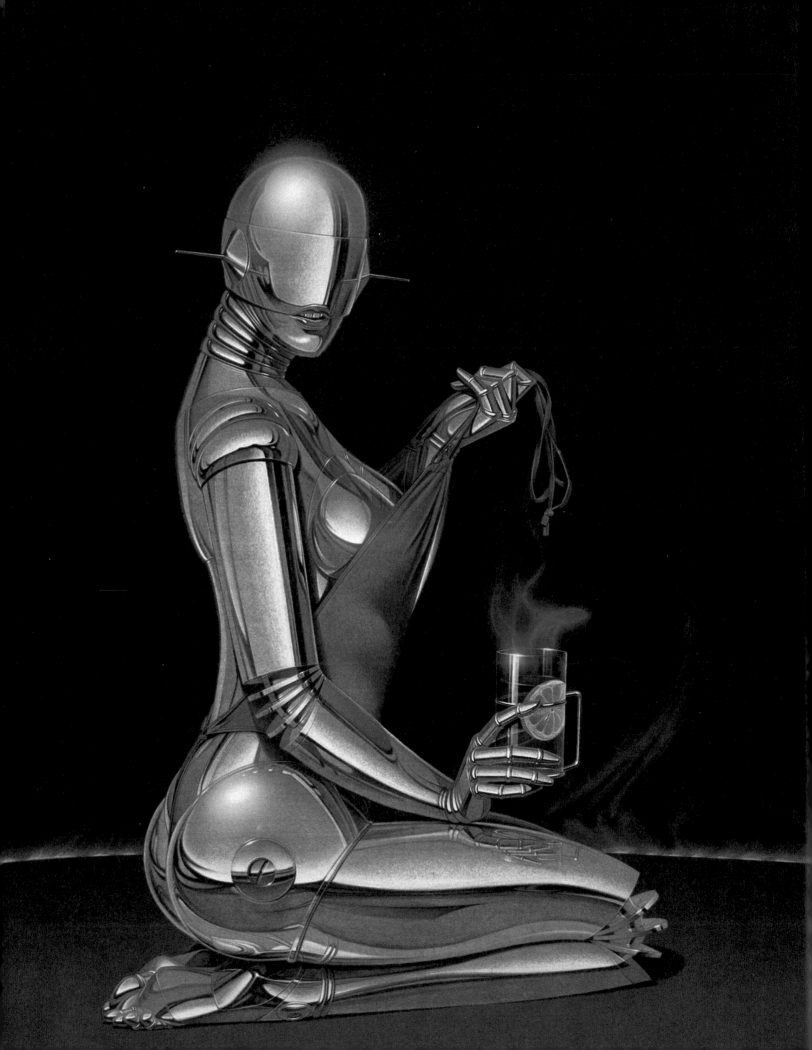

Introduction

A lot of people have never heard of the airbrush. We have all been exposed to its influence, and magazine advertising is utterly dependent on its abilities, but it hasn't been talked about. In fact, the first popular employment of the airbrush was in invisible mending – it ironed out the unfortunate wrinkles Edwardian portrait photography tended to pick out; and it has been popular ever since.

If you are interested in modern art, you will recognize the work of the Superrealists, some of whose work seems indistinguishable at first glance from photographs. They are, however, painted extraordinarily carefully and accurately, and often with the airbrush. It is an instrument capable of the fine gradations of light, the fading colours, and the flat tones which this exercise can demand. The history of the airbrush in fine art goes back to the turn of the century, for the airbrush was originally invented as a means of laying one water-colour hue on top of another. Airbrushed works hang in galleries throughout the world. They sell for amounts equal to those fetched by handbrushed pictures; the two instruments for painting are now recognized as allies, of equal validity in fine art.

Ever since Alberto Vargas in *Esquire* magazine created his immortal 'Varga Girl' using an airbrush, illustrators too have realized its potential, and exploited it. Many came to the airbrush through photo-retouching and saw that an unreal, physically flawless universe could be summoned without even an originating photograph. The Varga girls epitomize one kind of slinky perfection – the inviting, elusive woman. Since the thirties, graphic artists have conjured other plastic realities – surrealist illustrative art, or the nostalgic return to the thirties in some late sixties and early seventies artwork. The airbrush is glamorous and versatile – hardly a graphics studio is without one.

The airbrush can do other things, too. It is commonly used to paint models and murals, customized cars and cake decorations. Fashion garments, linens, furniture and ceramics – they have all been adorned with airbrushed designs. It also sprays unusual media, such as latex, and has been used in delicate brain surgery, directed onto fragile tissue. However, to use it properly requires skill and the assimilation of a new technique, quite different to that of any other instrument.

Consider briefly what an airbrush is. It is held like a fountain pen, and ejects controllable amounts of air and medium onto a surface. There are a number of variables – paint, air, paint-to-air ratio, distance from ground, for instance – which have to be mastered, quite apart from the skills of draughtsmanship. And masking is often used, the cutting of which can be an art in itself. Once the methods are learned, and the skills acquired, the airbrush can be put to any one of its number of uses; but you cannot just pick it up and paint with it, even if you are versed in handbrush technique. It can be difficult, but then it is also rewarding. With the increase in leisure time and with over 130,000 airbrushes sold in the USA in 1978, it is clear that the airbrush can only increase its already considerable popularity. This book is the most comprehensive guide to use there is. It suggests which type is most suitable to the individual's purpose; it teaches use from the basics to the advanced; it covers the orthodox – and unorthodox – applications; and it also gives a technical, and an aesthetic history of airbrush development with many wonderful examples of the airbrusher's art.

STC, CJH

Left: Hajime Soratama, illustration for an article on advanced airbrush technique in a Japanese graphics magazine (1979).

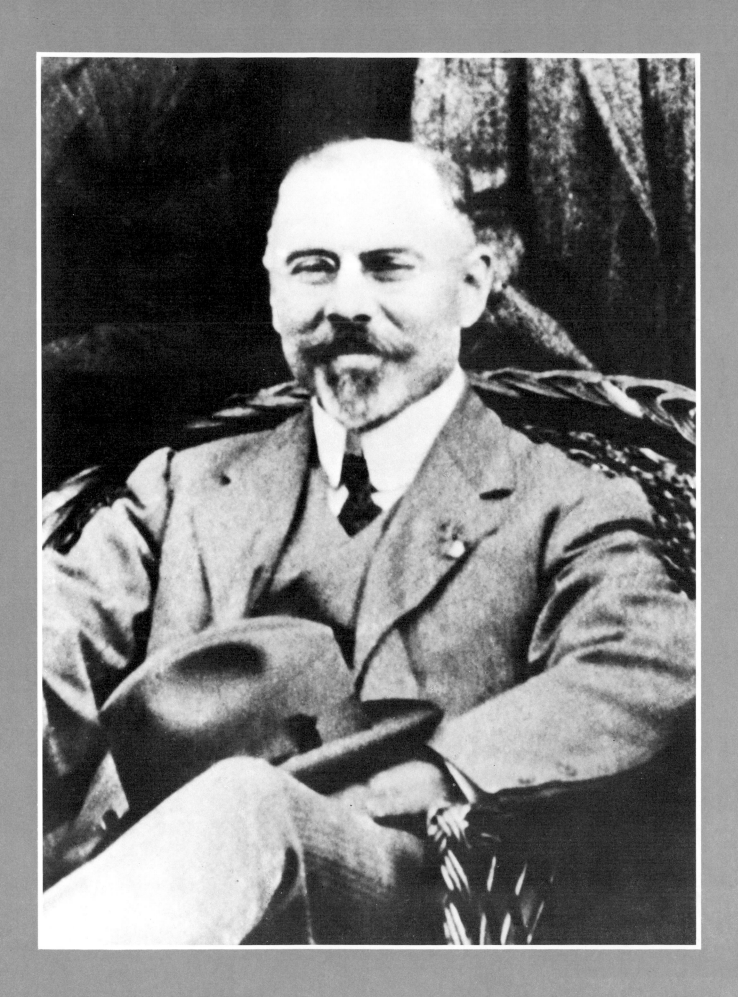

Chapter 1
Development of the Airbrush

Some 35,000 years ago, Aurignacian man blew powdered red ochre through a hollow pipe onto the stone walls of his cave. One of the earliest known examples, and a recurring image in the caves of Lascaux and Pech-Merle in France, is the outline of a hand. Air-powered art cannot be said to have had a continuous history since then; spray was known in Japan around the seventeenth century, but we have to wait until the late nineteenth century for it to become prominent in the West.

The exact date of the invention of the airbrush is not certain; it was probably shortly before 1893, which is the date that Charles L. Burdick patented the device in England and set up a manufacturing company in Clerkenwell Green, London. Burdick was an American and he invented the airbrush in the United States, shortly before crossing the Atlantic to found his 'Fountain Brush Company'. There is, however, a US patent which seems to be for an airbrush case design from 1888, which casts doubt on the exact date of origin.

Burdick was a versatile man. He also invented humidifying systems, coin counting and sorting machines, and even a machine for folding banknotes, though this never got off the ground. The airbrush is said to have been invented when he was looking for a way to apply one water-colour on top of another, without disturbing the colour underneath. He was a water-colour artist, and his device did the job nicely.

The particular innovation he devised was a centralized fluid tip, fluid needle and air cap – a principle that has become the basis of all conventional air-atomization spray-guns to this day. The original model marketed by Burdick's company was the 'A', a surprisingly sophisticated piece of engineering. It had a fluid nozzle of bore size 0.007in (0.18mm), made of platinum, and a colour cup actually in the body of the brush. In nearly all respects it was similar to today's fine airbrushes, such as the Aerograph Super 63. The hose to the air supply was push-on; it was not until the 1920s that screw-on connections were used. Other than that, it could have been manufactured last year. The dual-action lever was there

from the start, as was the concept of interchangeable nozzles. Burdick called his instruments 'aerographs' and airbrushing was for a while widely referred to as 'aerographing'.

Left: Charles Burdick, the American inventor of the airbrush.
Above: An advertisement for one of Burdick's early products, then known as the 'aerograph'.

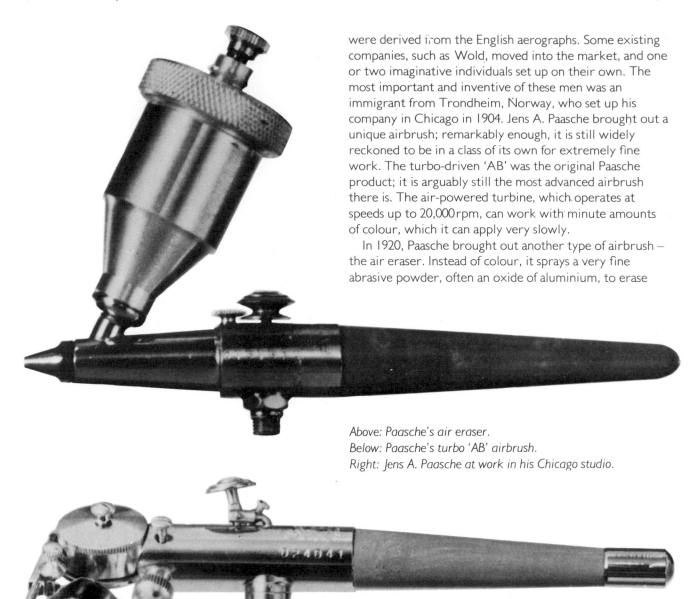

were derived from the English aerographs. Some existing companies, such as Wold, moved into the market, and one or two imaginative individuals set up on their own. The most important and inventive of these men was an immigrant from Trondheim, Norway, who set up his company in Chicago in 1904. Jens A. Paasche brought out a unique airbrush; remarkably enough, it is still widely reckoned to be in a class of its own for extremely fine work. The turbo-driven 'AB' was the original Paasche product; it is arguably still the most advanced airbrush there is. The air-powered turbine, which operates at speeds up to 20,000 rpm, can work with minute amounts of colour, which it can apply very slowly.

In 1920, Paasche brought out another type of airbrush – the air eraser. Instead of colour, it sprays a very fine abrasive powder, often an oxide of aluminium, to erase

Above: Paasche's air eraser.
Below: Paasche's turbo 'AB' airbrush.
Right: Jens A. Paasche at work in his Chicago studio.

Removable colour cups were developed in the early 1900s, as were open colour cups mounted on top of the airbrush (model 'E'), and large closed cups, also mounted on top (model 'C'). The 'Numograph' with a pre-set needle, which was for less precise work, appeared around 1920. There was even the 'AE', which was also called the 'amateur's airbrush' as it had an 'abutment piece' in the finger lever to prevent excess colour being delivered, and an extra cam which ensured that the air valve could not be closed before the colour valve, thus preventing 'spitting'. A similar cam is available in certain contemporary airbrushes, such as the German 'Efbe', though no equivalent of the 'abutment piece' exists today.

By the 1920s, several other companies had entered the field, particularly in the United States, and were producing gravity-feed airbrushes, though most of them

colour errors or to etch. It can be used to clean the fine parts of delicate instruments and jewellery, improve dental castings, engrave, even to highlight half-tones on lithographs. So, by the 1920s, many of the airbrushes we know today were already on the market; only slight modifications have been made to the gravity-feed design in the last 60 years.

However, it took two separate inventions to produce the technology for suction-feed airbrushes, although mouth diffusers worked along the same lines. One was the Burdick design for centralized needle and fluid tip; the other was the brainchild of Dr Alan DeVilbiss. He was an ear, nose and throat specialist from Toledo, Ohio, who was looking for a more satisfactory method than the swab of applying medicants to the throats of his patients. He developed an atomizing device for this purpose with a tin

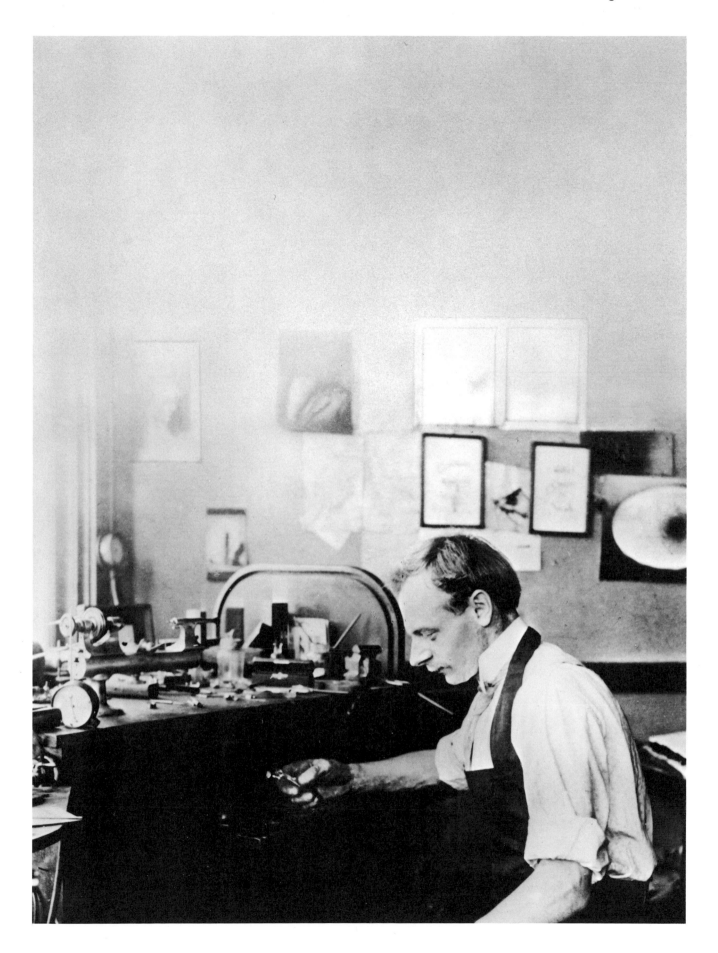

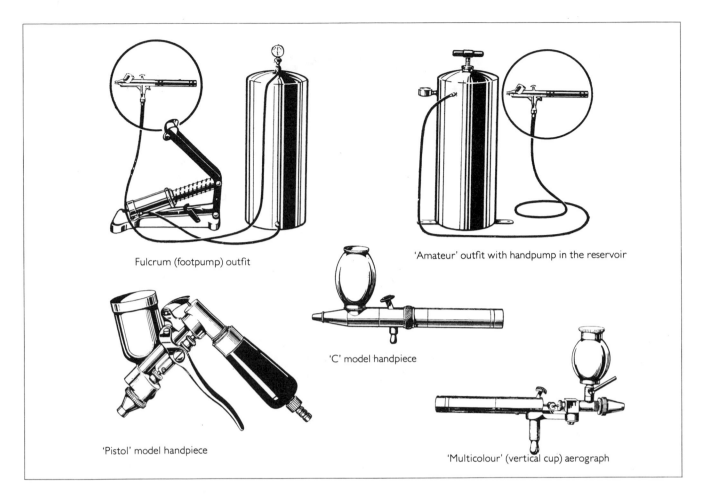

Fulcrum (footpump) outfit

'Amateur' outfit with handpump in the reservoir

'C' model handpiece

'Pistol' model handpiece

'Multicolour' (vertical cup) aerograph

Left: The Aerograph 'AE', often known as the amateur's airbrush.
Above: A selection of early Aerograph outfits and handpieces.

can, a rubber ball and some tubing; it turned out to be so successful that he formed a company two years later, in 1890. Perfume and other sprays followed, and The DeVilbiss Company amalgamated in 1931 with The Aerograph Company. DeVilbiss and Burdick were friends, so when Burdick decided to return to his native America he was happy to sell out to someone he knew, someone who already had an English subsidiary. Most of today's airbrushes are based on the work of DeVilbiss and Burdick.

There was also a good range of propellants available before World War I. There was a foot-operated pump with air reservoir; the fulcrum type was worked by an up-and-down motion of the foot, which tended to require the operator to stop spraying while he was pumping. There was also the skate, or swing foot-pump, which operated on a horizontal back-and-forth foot movement, and was far

easier. A hand-pump was also marketed. It was aimed only at amateurs, and demanded considerable effort. Steam-powered compressors were in evidence, but died out along with so many other steam appliances in the face of opposition from electricity. The electrical compressor, available from the first days of the airbrush, won out as the major source of air power, and has stayed as such. Small, portable compressors, available from around 1970, widened the accessibility of airbrushes considerably. So did the advent, in 1972, of the portable canister of compressed gas, which was easy and convenient if not cheap.

So propellants tend to be of recent development, and airbrushes adaptations of pre-1920s designs. There is now a plethora of makes and models on the market, manufactured in America, Europe, Britain and Japan. Like the motor car in Western culture this century, the growth in popularity of the airbrush has not really been due to radical innovation in design. Cheap propellants and a move towards mass culture have led to a proliferation of its uses, and a change in the status of the airbrush, particularly as regards art.

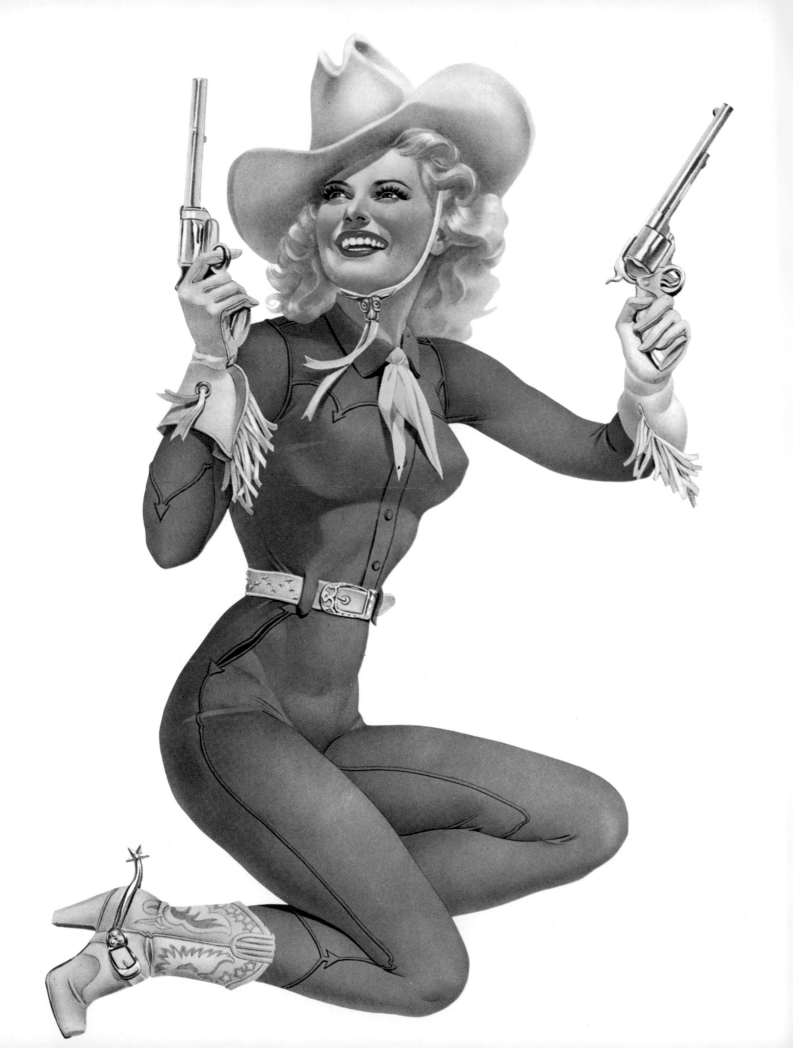

Chapter 2
The Airbrush in Art

Historically the primary uses of the airbrush have been for retouching photographs, and perhaps directly linked to that, for commercial art. But the major blossoming of the admass culture, born in particular out of advertising, also saw a substantial crossover of the advertiser's tool into fine art. Now the airbrush's position as a fine-art tool is established, though its acceptance as such in certain circles has been slower, as Charles Burdick discovered when the Royal Academy refused his work on the grounds that it was mechanistic. The objections expressed are not so much that work of a high standard is not feasible with an airbrush, but more theoretical: that the method is non-expressive by being mechanically operated; the artist is not in direct touch with the canvas; or that its origins in commercial art are difficult to shake off, its traditions being that of the immediate, discardable gloss.

Illustrative Art

Initially we should start with an historical look at the fortunes of the airbrush since 1893, with particular reference to art. Charles Burdick was not content to simply invent the airbrush, nor with founding a manufacturing company to distribute them. Almost certainly the first freehand airbrush attempt at fine art was made by Burdick in a magnificent portrait; it is a testimony to the versatility of even the first airbrushes. In 1900, he held a competition for airbrush paintings, the winner of which is a glorious piece of Victorian water-colour art. Yet it was 70 years before the potential in fine art was taken up in a concerted way.

Nineteenth-century photography had one major drawback, along with its embarrassing tendency to expose previously unseen flaws. Effective colour reproduction was not possible until the Edwardian age; not until 1910 was colour produced with any brightness and contrast. But the public wanted colour: so from about 1860 black-and-white photographs were tinted by hand. When the airbrush appeared it was evident that it could do the job far more

The original of the above was coloured by Messrs. RAINES & Co., of Ealing.
(Permission for reproduction granted by the Royal Air Force.)

Reproduction direct from original photograph before being touched up and coloured by the Aerograph as above.

Left: 'Pistol Packin' Mama', from the March 1944 issue of Esquire *magazine, is by Alberto Vargas, a popularizer of illustrative airbrush art.*
Above: The most common early application of the airbrush was photo tinting of a sepia original.

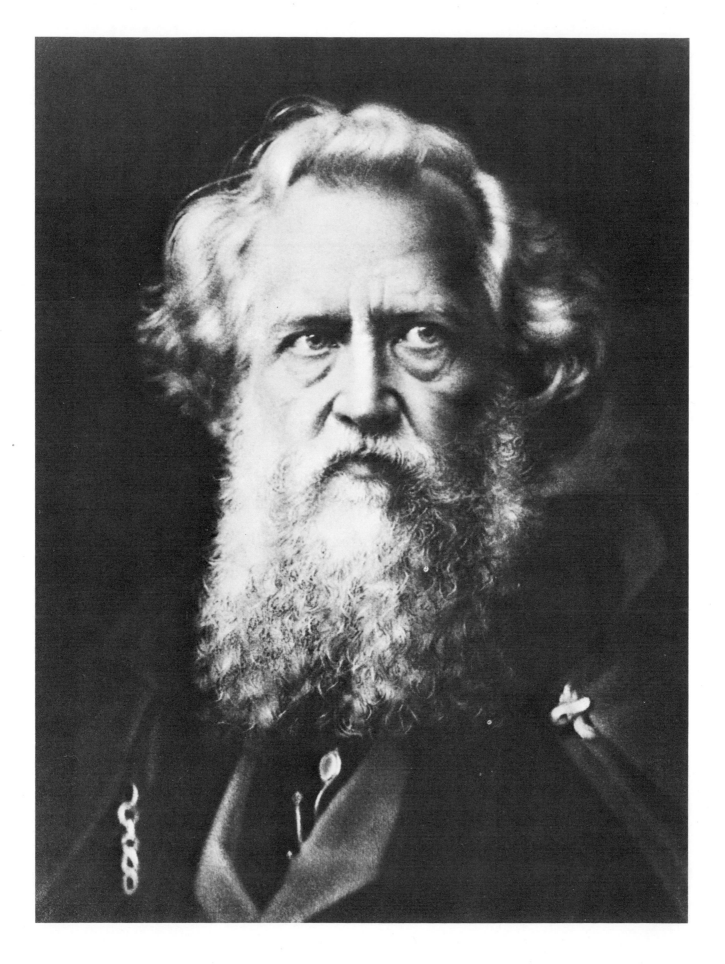

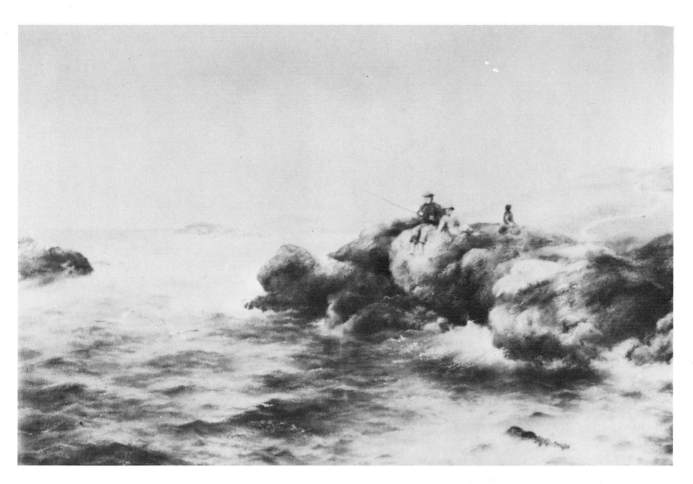

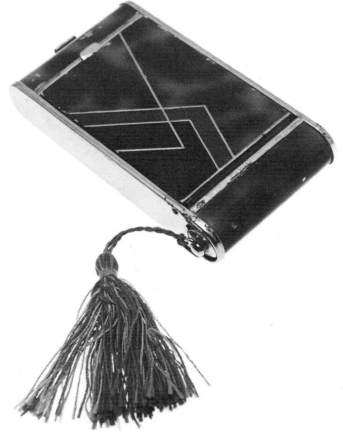

Left: An early freehand aerograph portrait of an unknown man by Charles Burdick, measuring 20 x 16in (51 x 41cm).
Above: Winner of a 1904 British airbrush competition; a water-colour by Sidney Winney.
Right: An Art Deco powder compact cum cigarette case made of airbrushed enamel on metal.

effectively than the handbrush – it left no visible brushstrokes and with masking was absolutely precise.

It was not until the 1930s that the airbrush made any significant headway in its graphic applications, and when that happened, it did so through a variety of causative factors. At the turn of the century, poster art had been strongly influenced by the *fin-de-siècle* style of Alphons Mucha. The style suited the temperament of the period, as did other fragile and evanescent Art Nouveau designs in their refreshing and extravagant manifestations, such as the jewellery of Fabergé and the glass of Lalique. All this came to an abrupt end with World War I when a new emphasis on form and function was evolved. The importance of the German Bauhaus in this was considerable. Led by Walter Gropius, and involving such eminent artists as Paul Klee, Laszlo Moholy-Nagy and Vasily Kandinsky, it proclaimed the synthesis of art with technology. Directly influenced by the Bauhaus, and partly as a result of the increase in visual advertising in the 1920s, the style known as Art Deco arose in France.

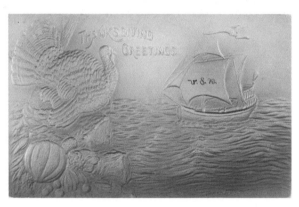

Above: Embossed postcards which have been hand coloured by airbrush (1903-10). The two on the left are from America where such cards were popular from 1906. The postcard on the right bears a Japanese inscription.

Bauhaus philosophy and geometric design had a mathematical rather than purely imaginative basis, and it is unsurprising that before long the airbrush made its entry into design. Its speed and accessibility led to it being favoured by many Bauhaus designers and graphic artists such as Herbert Bayer, Otto Arpke, Henry Ehlers and Toni Zepf; and the textured areas of colour that counterpointed the flatly geometrical character of much Art Deco were also ideal occasions for its use. An early example is in jewellery – a powder compact cum cigarette case, with textured colour effected by the airbrush.

A further involvement of the airbrush in the design of the thirties is rooted in the social history of the period. Predictably the economic and political hardship of the Great Depression resulted in an escapist reaction in popular culture. Amid this desolation, the cinema's articulation of hope and escapism was the Hollywood musical – wildly extravagant, with Busby Berkeley's spectacular and irrepressible dancing girls sweeping the blues away. And what Berkeley did in the cinema, George Petty and Alberto Vargas did in magazines. In the autumn

of 1933, the first edition of *Esquire* appeared, and in it the first Petty girl. Petty, previously a photo-retoucher, produced pin-up cartoon girls which became enormously popular; but in October 1940, Vargas, also in *Esquire*, created his 'Varga girl'. She outlived the Petty girl by four years. Both men used the airbrush in their pin-ups, though perhaps in retrospect the more interesting use of it was made by Vargas; but what is significant about them is the quality the airbrush lent to their work. Petty and Varga girls were not real; they were attractive and inviting, and unattainable. This style is highly individual, suggesting a plastic quasi-reality, a bedroom any man could escape to without a suggestion of the real world to bring him down to earth. The image was enormously successful; one million orders were received for the 1943 Vargas calendar.

It is a notable postscript to the story of *Esquire* and Vargas that a man from *Esquire* production department, Hugh Hefner, founded *Playboy* magazine in late 1953. *Playboy* was to become renowned for its pin-ups, including some airbrushwork from Vargas. The famous *Playboy* centre-spread girl was an idealization of Varga girls who had by then entered the American dream mythology; and there is little doubt that the airbrush was used to adjust reality by perfecting the bodies of the models. A little deft photo retouching removed blemishes, scars and other inappropriate natural features, transporting the pin-up out of reality into fantasy.

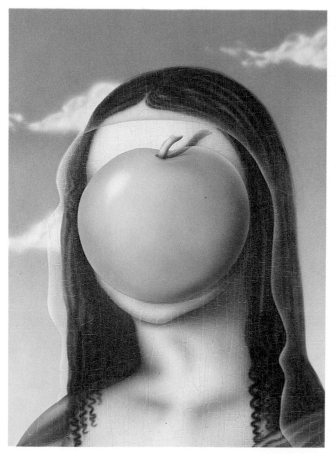

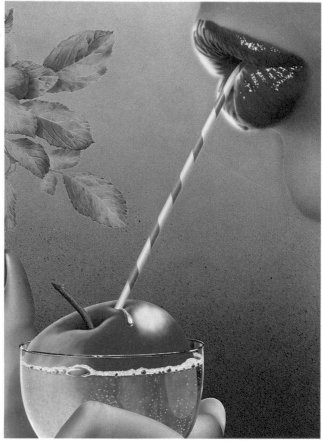

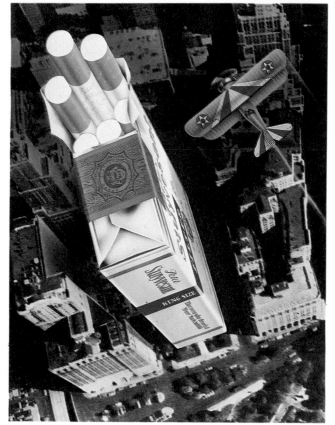

*Above left: Terry Pastor, Margrittalisa (1977), ink and
gouache on card, 20 x 14in (51 x 35cm). The Mona Lisa is
obscured by an apple – a skit on Magritte.
Above: David Jackson, self-promotional illustration (1978).
Left: Dick Ward's skyscraper cigarette packet, airbrushed
onto a photograph.*

It was in the 1960s that the airbrush made a major
return to commercial art. Poster art, after a long
period in which the demands of flat colour had
militated against the airbrush, returned, and Pop art
arrived. Post-war sobriety was discarded for exuberance
and experimentation. The growth of the admass culture
propagated a new set of symbols, emblems and imagery.
Packaged, commercial, pre-fabricated urban existence was
brought to general attention through the media. And the
contemporary art status of the airbrush is based here in a
culture of integrated advertising images.

The airbrush has been most discreetly used since then
when yoked to photography. Often we are not aware of
its presence; its value as a retouching tool has always been
its ability to remain invisible. But because we never see it,
we do not appreciate how a photograph can be, and is,
altered; its meaning can be altered too. For the advertiser
this presents the opportunity to perfect the image of his
product. Looking at a poster advertisement for a packet of

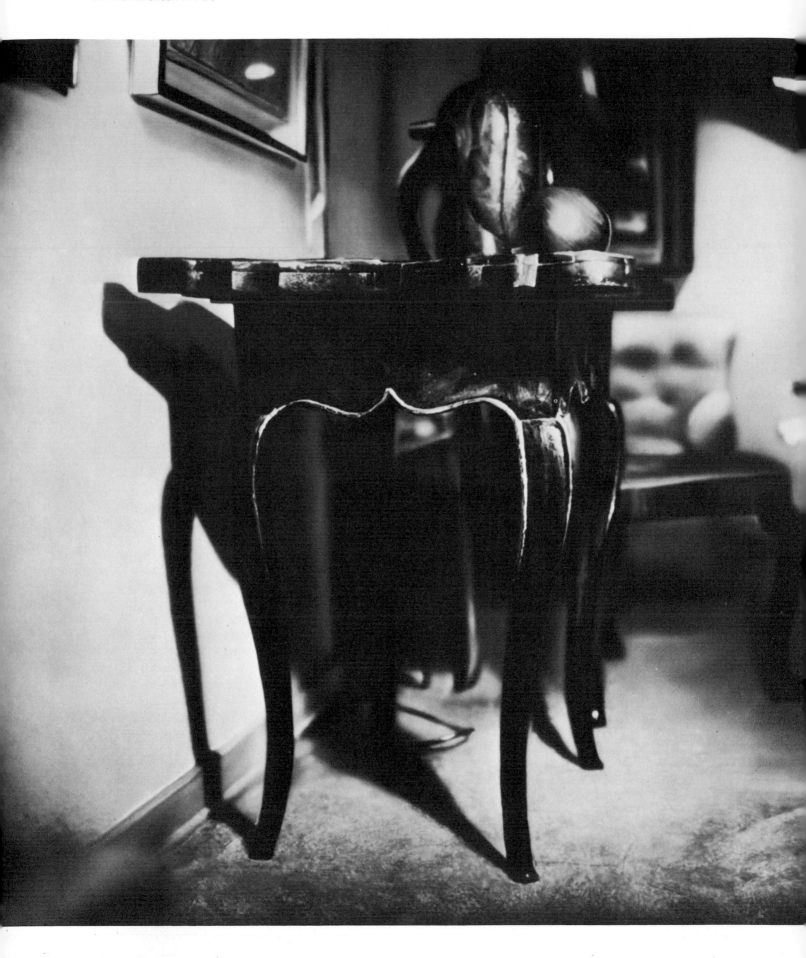

cigarettes, the pack itself looks new and flawless. That is not simply good photography; it is almost certainly the result of retouching. The airbrush can be used to give as accurate a statement of its subject matter as possible, by improving on photography. Conversely it can also be used to deceive. And just how prevalent is retouching in advertising? In a high-quality colour magazine, there are a large number of attractive photographic advertisements. Nearly all of them will have been retouched – not noticeably, but enough to idealize the product as far as possible.

The use of the airbrush in rendering as well as retouching has multiplied since 1960. What today's illustrators of excellence such as David Jackson or Terry Pastor achieve is a result of a plundering of artistic trends of the last few decades, often glamorized by the airbrush into a sardonic, plastic form of reality. Some of Terry Pastor's work echoes Magritte in its illogical juxtaposition. For example, the face of the Mona Lisa is replaced by a green apple in a perfect photographic representation. David Jackson is one of the many who uses airbrushwork in a manner that idealizes the featured product – very much in the way that magazine nudes are created or retouched by airbrush. In the better art of this type, the idealization is overt; a luscious pair of lips sucks cider through a straw, but it is an apple in the glass instead of liquid. It is gently humorous, which is appealing, and more than real in the sense of being 'surreal'.

One legacy of the Surrealists in more general terms is that they freed the illustrator to yoke together whatever images he pleased to link dream and reality, not just in photomontage but in airbrush-originated artwork. The major tenet of Surrealism, the widening of the available universe beyond the day-to-day perceived reality, was a liberating influence on the commercial image-maker. On record covers and in product promotion as well, images were pulled out of unlikely contexts and placed in the newly widened post-Surrealist universe, and the public loved it. However, there was also another unreal universe awaiting illustration: science-fiction art – futuristic and fantastic. With the enormous increase of interest in science fiction in the mid 1970s, this field has become the fastest growing area of commercial art. Perhaps the airbrush was used too eagerly by some; as David Hardy, whose *Thomas Cook's Galactic Tours* contains some fine examples of the genre, points out: 'I feel that this field has encouraged the use – and abuse – of the airbrush more than any other. There are many effects which are virtually unobtainable by any other method, yet a quick squirt does not necessarily produce a star field.'[1]

There is one more influence on commercial art that deserves a mention: the rendering of industrial machinery.

Left: Ben Schonzeit, Bergano's Table *(1977) acrylic airbrushed onto canvas, 36 x 36in (91 x 91cm). This is a deceptive piece of Superrealism.*

The airbrush has been used in technical drawing for at least 40 years, illustrating manuals and demonstrating designs. As with space illustration, it is the ability of the airbrush to achieve clarity and accuracy that counts, as well as an unsurpassed speed. Technical drawing has graduated into prestige commercial art; the illustration of, say, automobiles and engines has become popular in both product advertising and in fine art as well.

Fine Art

Meanwhile, what of fine art? In 1917, Man Ray, in a state of desperation, took home an airbrush he had used at his work, and started to spray in black and white. This fitted in well with his intentions to free himself from the conventional method of creating pictures and simultaneously to ditch the artistic pretensions that went with them. Man Ray was clearly pleased with his efforts, which he called aerographs: 'The results were astonishing – they had a photographic quality, although the subjects were anything but figurative . . . It was thrilling to paint a picture, hardly touching the surface – a purely cerebral act so to speak.'[2] Ray painted several airbrushed works but only hardened the attitudes of the establishment against him. His friend and biographer, Sir Roland Penrose, notes that he had already been 'labelled a degenerate, a charlatan, and a criminal for having destroyed the act of painting by mechanical means'. His airbrushed pictures, such as *La Volière* (page 30), 'just like the rest of his work, met with a hostile reception'.[3] Ray discontinued his experiments with the airbrush in favour of experiments with photography in 1919, but his extant aerographs serve as witness both to Ray's innovative genius and to the potential of the instrument he used. A somewhat embittered Ray said in 1978 that his aerographs were mistaken for photographs and never properly appreciated.

Art by mechanical means was the charge levelled at Ray and for a long time this was the reason behind the establishment's refusal to accept airbrush art. But the opening salvoes in the battle for the widespread emancipation of the airbrush came from Pop art which wrenched its subject matter out of the consumer culture and represented it, usually as neutrally as possible, in large scale, as art. If it is accepted as art, then it is art, according to the Pop artists, no matter how closely it represented the manufactured model. The Pop artists also rejected any distinction between good and bad taste. This new art form was accepted by the majority, even if such writers as Harold Rosenberg, Clement Greenberg and Peter Selz, strong vocal ambassadors for Abstract Expressionism, took stands against it. This was a threat to them. Willem de Kooning said of Pop artists: 'I am on one mountain, and they are on another.'[4] Jim Dine was less extreme: 'I don't believe there was a sharp break and this is replacing Abstract Expressionism. I believe this is the natural course

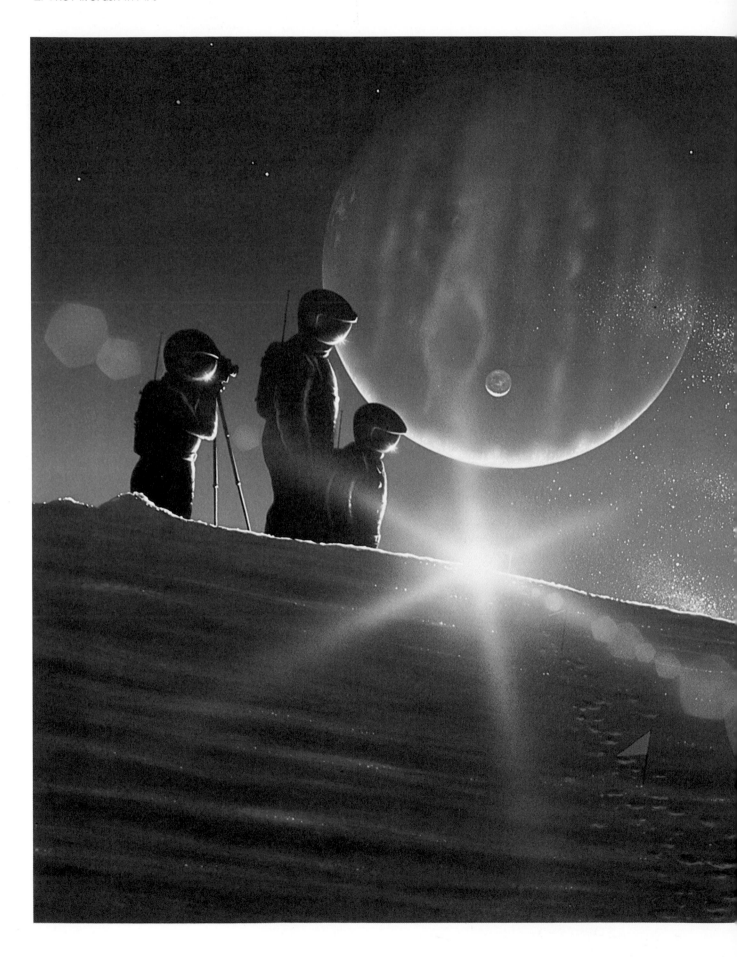

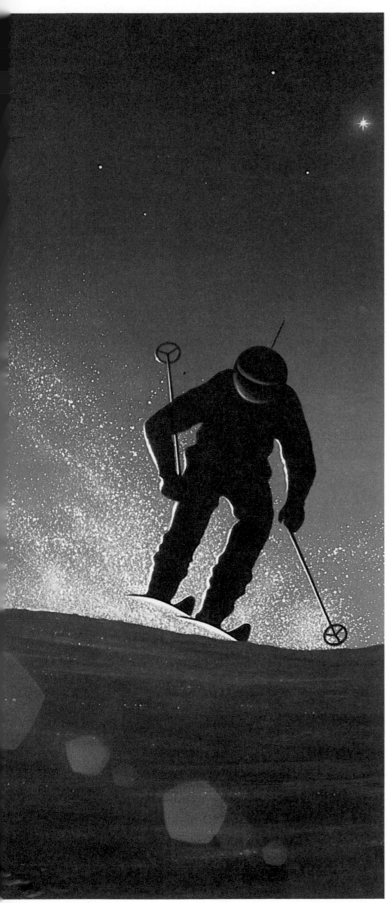

of things.'[5] But only the natural course presumably, because young American artists had become choked by the rarified air of Abstract Expressionism, which, according at least to Tom Wolfe, was fast vanishing up its own fundament, so that they turned back in a violent reaction to less exalted things like toothpaste tubes, coke cans and soup. Acceptance of the subject matter employed by these artists was as much a problem to the critics as the techniques they employed in rendering the image. This also applies to the Superrealists. But Pop art held out, presumably because it sold. It was accepted by a buying public who were glad to find something which was bright and enthusiastic, that they could easily understand.

The airbrush then, an instrument of commercial art, made its way into Pop art particularly in the work of Peter Phillips (pages 40-1, 42 and 43). Part of its attraction was probably that it was mechanical in style, allowing the painter a relatively neutral and removed approach; and such a style, of course, became expressive in its own way and seems less neutral now. Roy Lichenstein insisted: 'The meaning of my work is that it's industrial, it's what the world will soon become . . . To express a thing in a painterly style would dilute it; the techniques I use are not commercial, they only appear to be commercial.'[6] Words which could have been spoken 50 years before by Man Ray or Walter Gropius of the Bauhaus.

Following on the heels of Pop art was the movement termed Superrealism, which did much to consolidate the use of the airbrush in fine art. Certain artists incorporated the techniques of both in their style. But what perhaps links them is the one concern – to reappraise the conventions of the popular image, relying on scale and context to transform it into art. Superrealists often used photographs as a neutral source of visual imagery; again there is a move away from metaphysics into a set of empirical statements about the environment, a world of buildings, automobiles and motorcycles. The impersonality of the finished work often necessitated the use of the airbrush as the handwriting of the handbrush is too overt and intrusive. It immediately betrays a personal style and signals the method of construction of the work. The coldness of the finish is itself often disturbing, in a way that Surrealist work also is, and it is perhaps this quality that makes us look and look again at the images we see daily around us, transplanted to canvas. A wrecked car is an ugly, gargantuan waste; a truck in motion has an exciting grace of movement.

The Superrealist Audrey Flack wished to make accessible statements about life and used whatever graphic studio methods she required to achieve this. But for many other Superrealists formal considerations were more important. John Salt (page 36), who also uses the airbrush, does so out

Left: David Hardy, 'Skiing on Europa', a science-fiction illustration.

of a desire to get away from the influence of art itself. And what primarily interests these artists are the technical problems of rendering tones and highlights across a surface. All parts of the image are treated with the same impartiality, not simply out of coolness and desire to withdraw from overt social comment, but because subject matter is not an important point. John Salt: 'The automobile was very obvious . . . But I don't paint them because they are important or because they have some kind of message. It's just very obvious subject matter. Also, the way I was painting, using spray and airbrush — that related to the way the cars are painted.'[7] And Don Eddy: 'I think the subject matter is dictated to me by the kind of painting problems I'm interested in.'[8]

The Superrealist Ralph Goings when asked what the camera does to reality, answered '. . . about working from photographs. It's frozen, it's there, unchanging, once the photograph is taken. No matter how you're going to move your head, you're not going to compensate for certain overlappings or awkward combinations of things that violate traditional ideas of composition.'[9]

Whereas the Pop artists used an identifiable image in their paintings, the Superrealists give no actual connotation to their photographs; it is out of context. Richard Estes, for instance, is 'not trying to enlarge the photograph. I am making a painting, basically, and just using all these other things to do it.'[10] The photograph exists at the level of arbitrary source material, the starting point for the work. The technical challenge is in the production of a satisfactory, meticulous arrangement of paint on the surface. Chuck Close makes the point that: 'My main objective is to translate photographic information into paint information.'[11] And certain technical factors facilitate the use of the airbrush in the production of certain areas of imagery, certain lights and tones. In their concern with such arrangements of paint on a surface, the Superrealists reveal a kinship with Formalist Abstractionists.

But is it Art?

> The airbrush like the paintbrush requires skill to create technical feats of illusionism and if in the former instance the hand is at some remove from the canvas, what is significant is whether the artist has developed the skill to a level where the manipulation is an extension of the mind.
> (Bruce Glaser on the work of Audrey Flack)[12]

Certainly, the artist is not necessarily in tactile contact with his ground, although when working in fine detail he may be. Certainly also, a power source is employed, be it a can of compressed gas, or a compressor, and the airbrush is a piece of precision engineering, made of metal and operated by lever. So the instrument itself is mechanical;

but there is a distinction to be made here and it is one that Ray, Gropius, and a whole battery of critics have not made; the instrument and its lever operation are not the same as the range of ways the instrument can be used. A lever it may be, but capable of a continuous range of adjustments. This is of course the real point; there are as many expressive possibilities with the airbrush as with the handbrush. There is as much technique to learn — as will be evident from the following chapters — and just as much skill in application; and should one so choose, one can develop a personal handwriting with the airbrush as much as the handbrush. What there is not, to date, is a fully developed language of airbrush use, and equally, a strong tradition; but the airbrush is young.

This being so, why have some important airbrushers since Man Ray noted its mechanistic nature? The reason is probably a psychological one. The airbrush is a machine; the artist projects a little of himself into the machine he uses, and fancifully feels a kind of reciprocal influence. The airbrush is certainly not machine-like if that means non-expressive. This text is being written on a machine, a typewriter, but it does not necessarily make the result mechanical, and limit the possibilities of being expressive.

There is, incidentally, an expressive tradition that comes very close to airbrushwork — that ancient mode of painting, Chinese brushwork. A suggestion in a manual of Chinese painting reads: 'When manipulating the brush do not only move the fingers but move the whole arm.' Exactly the same could have been written for the airbrush. And whether the Chinese brush is held vertically or at a slant corresponds to the distance an airbrush is held from the ground. But the major physical similarity is not one of details; it has to do with the construction of the whole work. A Chinese painting is accomplished by a small number of bold gestures. One stroke creates a leaf, or a petal, in the same way that airbrushwork employs a few, sweeping strokes. In the use of wide gestures with the brush, rather than a huge number of tiny, detailed strokes, Chinese brushwork is much closer to airbrush technique than conventional Western handbrushwork.

If we turn from techniques of creating a picture to methods of reading it, we now find that the airbrush has a place in a current theoretical discussion. The operation of perception in the reading of a picture, both as regards how perception itself works, and what strictures it puts upon the interpretation of the work, is not a subject new to art theory. From his work in the Brain and Perception Department at Bristol University, Prof. Richard Gregory has noted that our perceptive processes only act when prodded in a particular manner; we do not learn to see, so much as to discriminate. (This point is taken up by E. H. Gombrich in his *Art and Illusion*, and the following argument is greatly indebted to him.) There is no such thing as the innocent eye; our perception is influenced by attitudes and expectations, which make us ready to see. Perception has been called 'primarily the modification of

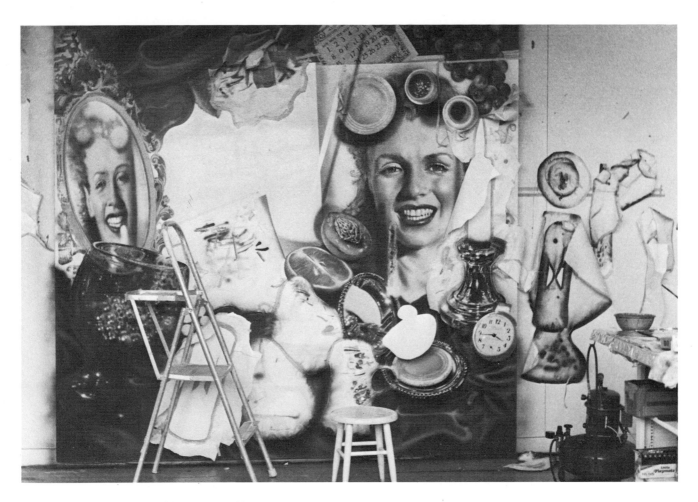

*Above: The paraphernalia of the painter of large canvases –
here epitomized by Audrey Flack's studio during the painting
of* Marilyn *(finished work on page 26).*

an anticipation'; where we can anticipate, we do not need
so badly to perceive. Reading an image, we are testing it
for its potentialities; and bringing into play our own set of
preconceptions – seeing what fits. A particular artistic
style brings with it its own expectations in the reader;
there are codified messages conveyed by a more or less
conventional notation. When a consistent reading is
forthcoming, we are quick to accept it; but if the whole
message is as previously expected, there is little joy in the
reading at all. Completely conventional artwork is
occasionally necessary – as when its message must be
crystal clear at a glance – but we do not consider such
work art, because it does not hold our attention.

We have here the beginnings of a criterion for art:
there must be some active interplay between expectation
and observation – this interplay is after all a basis for all
communication – but it must contain some deviation from
convention, some challenge to the attention. When this
challenge arises, there is some slight shock, and adjustment
of expectations; original hypotheses have to be revised.
The Russian Formalist thinkers in the early years of this
century had a name for this: *ostranenie*, 'making strange'.

This, which they also called the art of 'difficult perception',
was to them the basis of all the arts, and they reached this
point without modern perception theory.

That lemma probably points quite clearly to the place of
the airbrush in this discussion. Airbrush art brings with it
a number of obstacles: first, the mechanical quality;
second, its tradition in commercial art. This last has
probably been a considerable bugbear as far as fine-art
acceptance has been concerned. It dominates the mental
set which the reader may bring to a picture; a piece of
quasi-commercial art is expected. When this expectation
is thwarted, shock and adjustment should follow; the
receptive mind then admits that here is something a little
different, and perhaps brings another model, the 'fine art'
expectation, into play. This probably fits a little better,
but is still not exactly as predicted, as the use of the
airbrush gives the work a different quality to that of a
handbrush; but this is at least the right mental set, which is
expanded to contain work of the category of this picture.
This kind of active process is part of what reading a work
of art entails; so that, in theory, airbrush fine art makes a
positive extension to the vocabulary of art.

A piece of the Superrealist work reproduced in this
book, for instance, that closely resembles a photograph,
may make acceptance difficult, if the reader at first glance
thinks he is seeing a photograph, and brings that mental

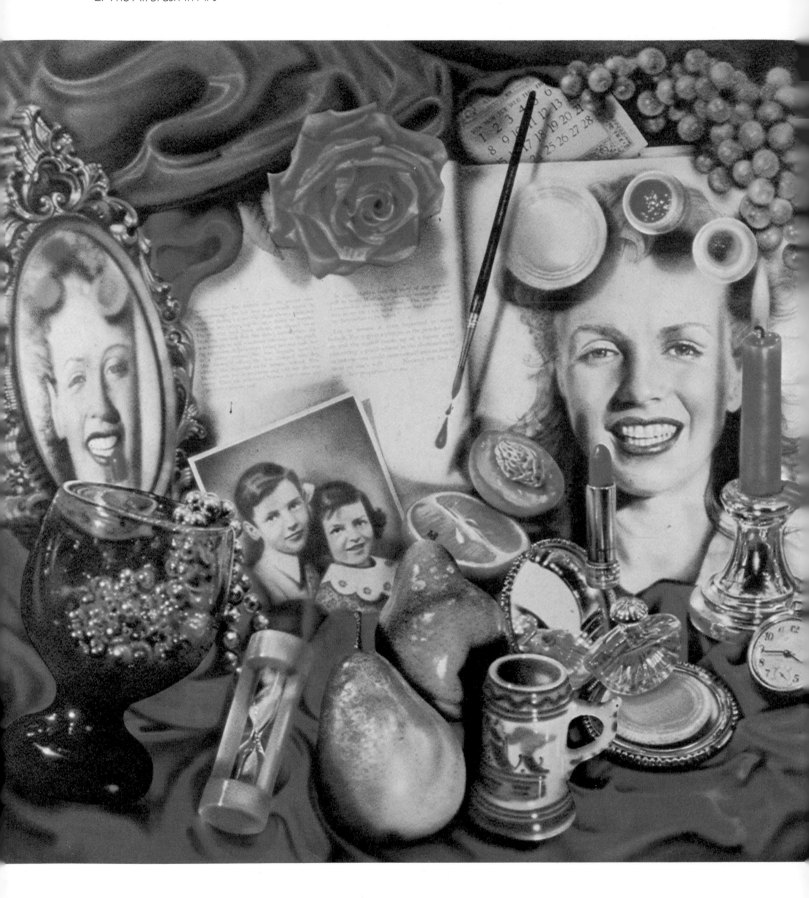

set to bear. Photographs are very familiar to us all; it is therefore difficult to accept that what resembles a photo is not one at all, because that preconception is so strong. Some may therefore look no further, and read the work inadequately. Those who do adjust, and try out fine art criteria, will be drawn past the subject matter into the more formal considerations that were paramount to the artist, and a useful reading can then be gained.

The artist has his own place in this process. He has, after all, to use the airbrush for a reason; and that reason is usually that a particular motif or style can only be caught properly with the airbrush. Andrew Holmes is interested in trucks, but the kind of verisimilitude he wants, the qualities of light and tone, are best captured with an airbrush (page 125). So the artist thus extends the language of art by bringing to it new motifs and new styles; whether or not he is accepted for so doing depends on the attitude of those who read the works – an attitude which can itself be ruled by prevailing fashions, or else vested interests.

More generally, the artist has his own mental set, a group of known methods and pictures; perhaps he begins to make a useful contribution to art when he finds that his usual interpretation of what he sees around him and paints is inadequate. Returning to Gombrich: 'Only experimentation can show the artist a way out of the prison of style toward a greater truth. Only through trying out new effects never seen before in paint could he learn about nature.' What does he get for his pains? In Gombrich's opinion: 'His reward might easily be the public's finding his equivalent hard to read and hard to accept because it has not yet been trained to interpret these new combinations in terms of the physical world.' [13] Some, from Man Ray onwards, have picked up the airbrush to try out new effects, and received brickbats. Perhaps now we should turn them into bouquets.

Having said this, we might finally look briefly at the work of two contemporary artists as examples of the versatility of the airbrush in art. Norman Catherine is a South African; his art contains overt political comment. The airbrush is used firstly to give the whole work an unfamiliar sheen – perhaps this is a cold neutrality not so different in kind to the neutrality of some Superrealists – and also to afford a single-minded clarity all the more striking by its directness, its lack of distractions. Both the featured works of his (pages 34 and 35) literally scratch this attractive surface away, lacerating the bodies – faces in

Left: Audrey Flack, Marilyn *(1977), oil and acrylic on canvas, 96 x 96in (244 x 244cm).*

particular – of his figures into a compelling, almost nightmarish, vision of still horror. The political message is clear, the black man savaged by the whites (even the lacerations are largely white); one picture proposes a kind of star of Bethlehem, but it is negative. The intensity of these works comes close to Francis Bacon's *Scream;* not surprising that the South African press has said of him: 'Sad that so much talent (and talent he decidedly has) is squandered on repellent pictures . . . Is he a kind of horrible prophet?'

Paul Wunderlich is German and internationally well known. His work is distinctly literary in character, commenting on existing myths or monuments of culture. In 1977 he had an exhibition at the Redfern Gallery in London entitled 'A Partir de Manet', in which he concerned himself entirely with new versions of Manet's works. Both *Sphinx & Tod* (page 33) and *Portrait George Sand* (page 34), newer pieces, are witty and accomplished comments. His liquid figures could almost be mannequins; certainly they exist neither in dream nor in reality. Like Catherine, he has moved away from the tradition of commercial art and the various orthodoxies of Superrealism, the two lines which generate so much airbrush art. By contrast, Peter Sedgley, who has been renowned as an Op artist since the 'Responsive Eye' exhibition at the Museum of Modern Art, New York, in 1965, uses the airbrush for its qualities of light and the optical effects possible in abstract ways. But Wunderlich is a great innovator within the figurative tradition. The airbrush lends a smoothness, almost a plasticity, to his work, which is perhaps its notable point; as he operates in the world of comment, of metalanguage, it is appropriate that his art should have a slightly alien quality, as indicator that he is doing far more than parody.

Wunderlich and Catherine are two artists who have used the airbrush to lend particular qualities to their work; the reader cannot easily approach either with the wrong mental set and refuse to adjust. They, in company with others such as Sedgley, Phillips and John Clem Clarke, perhaps bespeak the final movement of the airbrush into art; free from traditions of airbrush use, of commercial art or as a tool of rebellion, to the stage of being used as an instrument alongside the other instruments an artist can use, to create new effects, and extend the language of the airbrush into the vocabulary of art. Burdick was doing just this in the 1890s; but it has taken about eighty years for universal acceptance of a tool about which there should never have been any hesitation. Everybody gains from what the airbrush has to offer the artist – including, most importantly, art itself.

Gallery

The Airbrush in the Hands of Major Artists and Illustrators

Fine Art pages 30-50
Illustrative Art pages 51-63

Left: Peter Sedgley at work on his Target series.

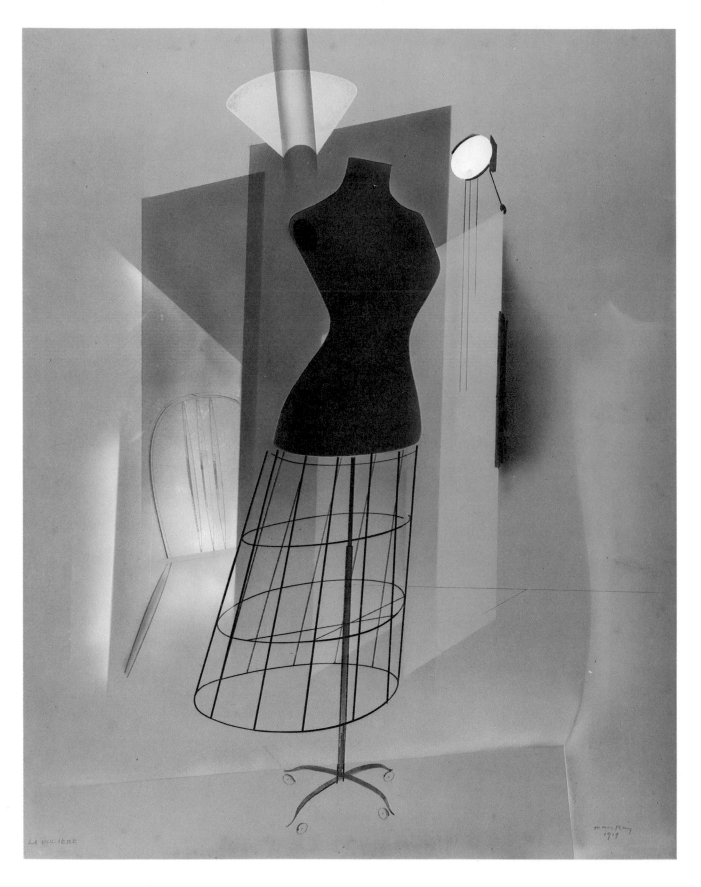

Man Ray, *La Volière* (1919)
gouache on paper, 28 x 22in (71 x 56cm)

Peter Sedgley, *Omen* (1966)
PVA on canvas, 72 × 72in (183 × 183cm)

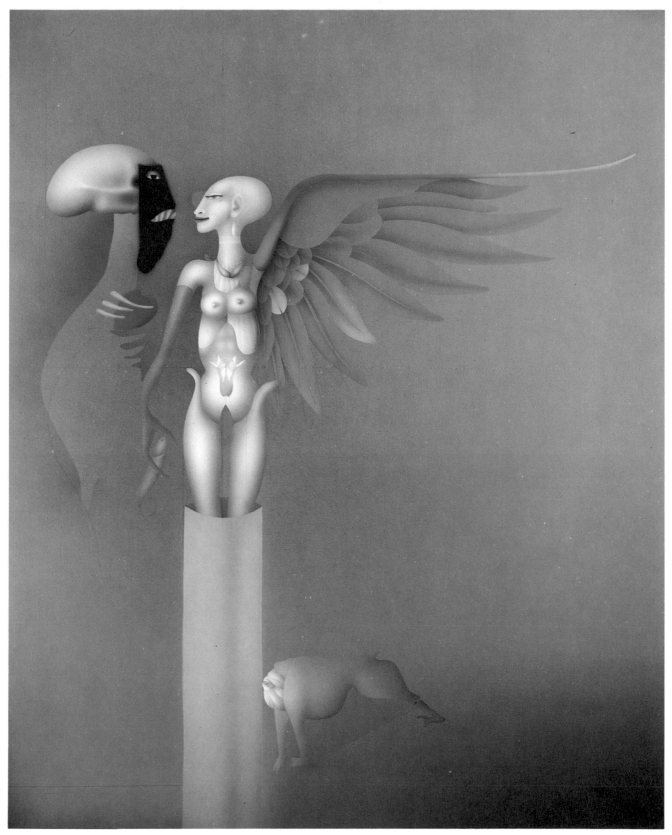

Left
Paul Sarkisian, *Untitled* (1979)
acrylic on museum board, 40½ × 61½ in (102 × 155cm)
acrylic on canvas, 78 × 108in (198 × 274cm)

Paul Wunderlich, *Sphinx und Tod* (1979)
canvas, 63¾ × 51 in (162 × 130cm)

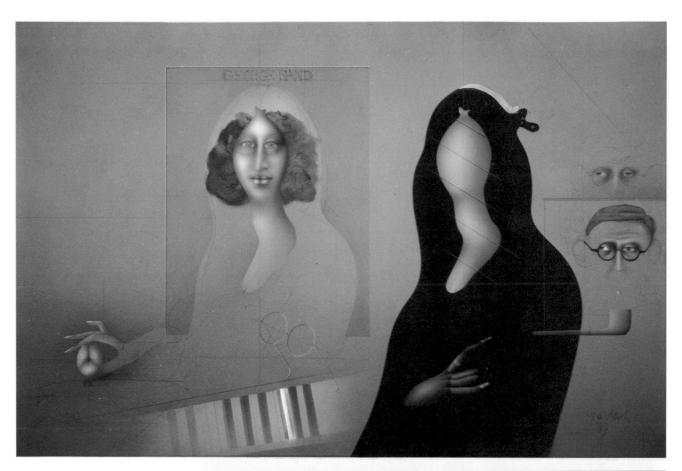

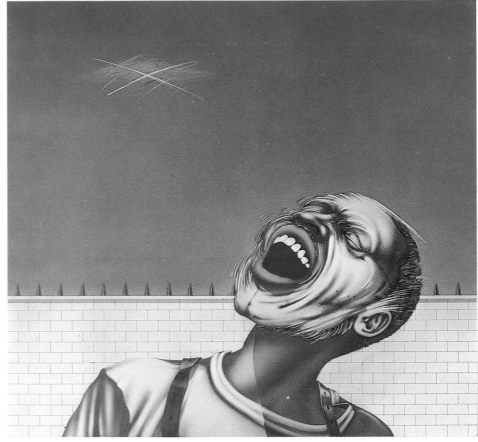

Top left
Paul Wunderlich, *Portrait George Sand* (1979)
canvas, $31\frac{1}{2} \times 47\frac{1}{4}$in (80 × 120cm)

Left
Norman Catherine, *Walls Without Clouds* (1979)
paint, pencil and crayon on board, $23\frac{1}{2} \times 21\frac{1}{2}$in (60 × 55cm)

Norman Catherine, *Unidentified* (1979)
paint, pencil and crayon, $23\frac{1}{2} \times 21\frac{1}{2}$in (60 × 55cm)

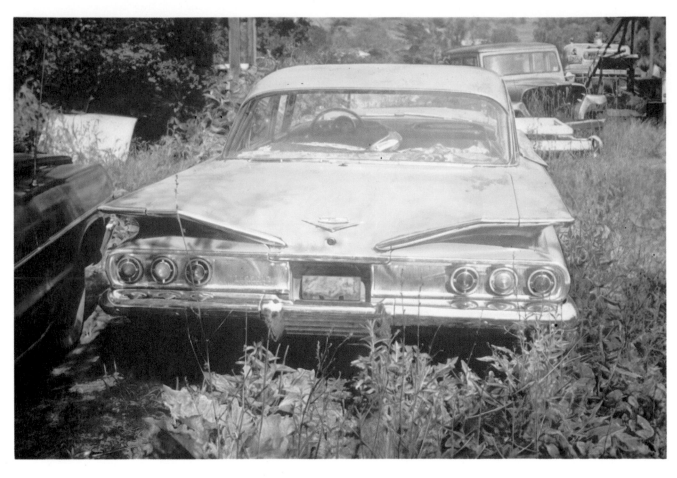

John Salt, *Green Chevy in Green Fields* (1973)
oil on canvas, 49 × 72in (125 × 184cm)

Right top
Kozo Mio, *Woman/Metamorphose* (1971)
acrylic on wood, 71 × 105in (180 × 267cm)

Right bottom
Kozo Mio, *Scene* (1971)
acrylic on wood, 64 × 97in (163 × 247cm)

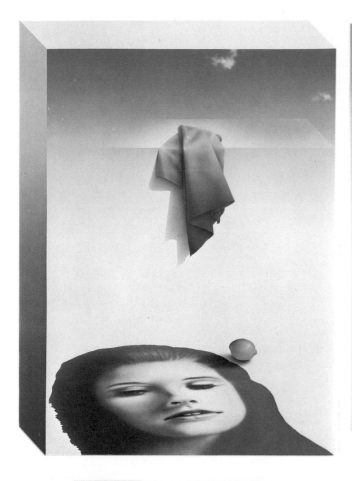

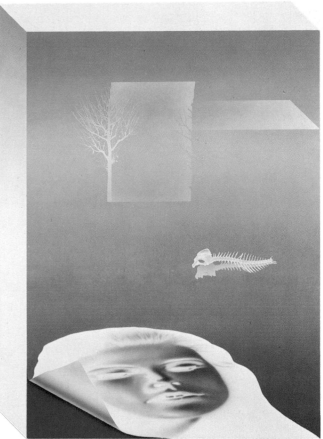

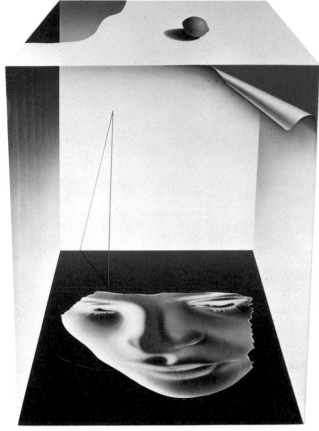

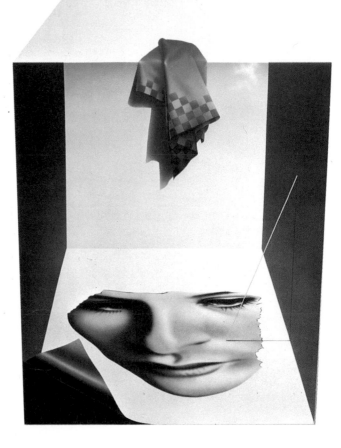

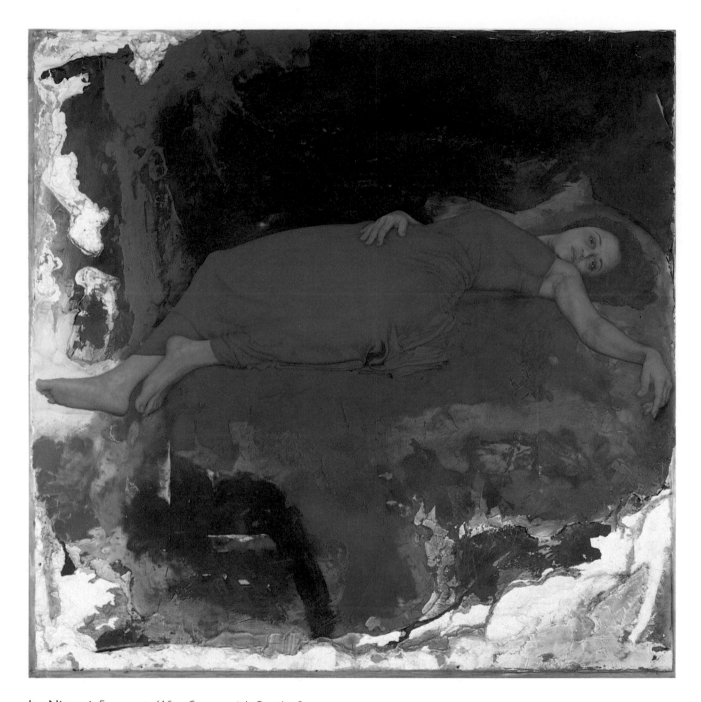

Joe Nicastri, *Fragments (After Caravaggio's Death of a Virgin)* (1978)
acrylic, plaster and wood, 38¾ × 38¾ in (98 × 98cm)

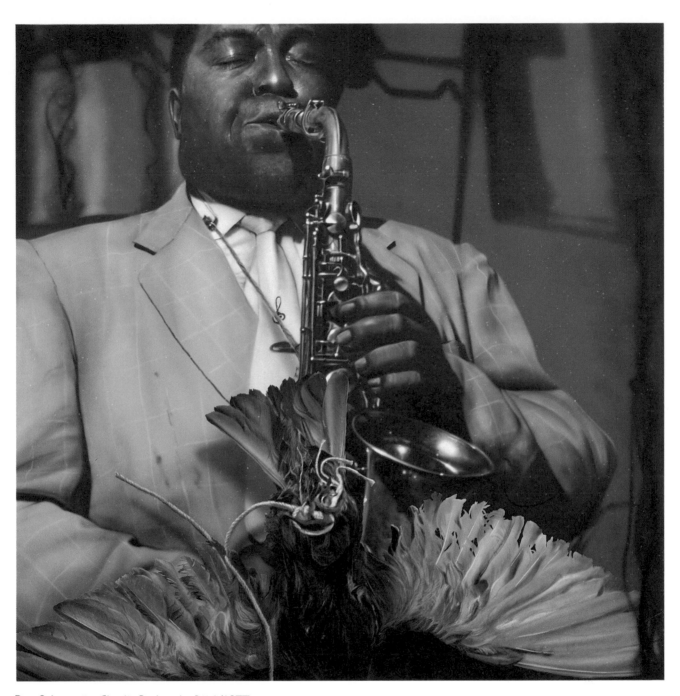

Ben Schonzeit, *Charlie Parker the Bird* (1977)
acrylic on canvas, 48 × 48in (122 × 122cm)

Peter Phillips, *Art-O-Matic Cudacutie* (1972)
acrylic, $6\frac{1}{2} \times 13$ft (200 × 400cm)

Peter Phillips, *Custom Painting No. 4* (1965
oil on canvas, 84¼ x 68¾in (214 x 175cm)

Peter Phillips, *Mosaikbild/Displacements* (1976)
acrylic on canvas, 86 × 90½ in (220 × 230cm)

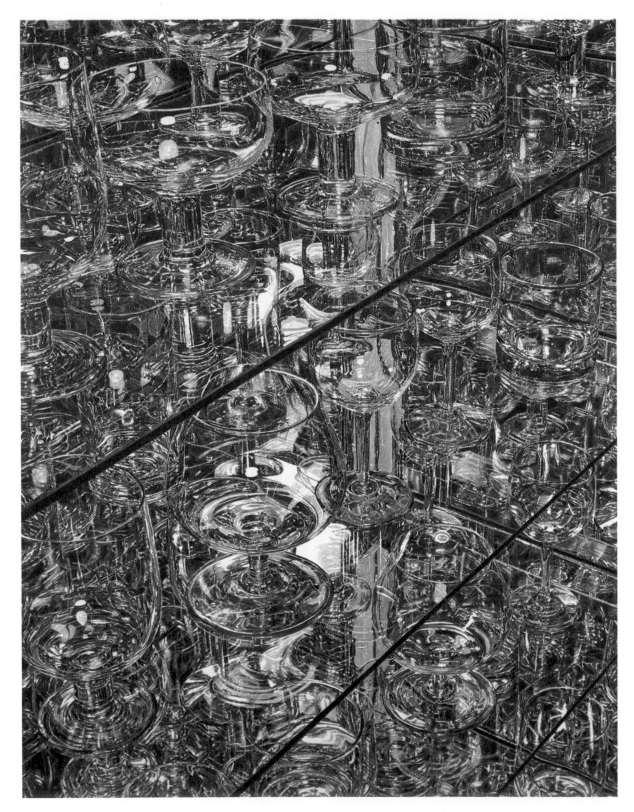

Don Eddy, *Glassware I* (1978)
acrylic on canvas, $52\frac{1}{4}$ × 40in (133 × 102cm)

Right
John Clem Clarke, *G Series (Napoleon in his Study – David)*
(1978-9)
oil on canvas, 80 × 56in (203 × 143cm)

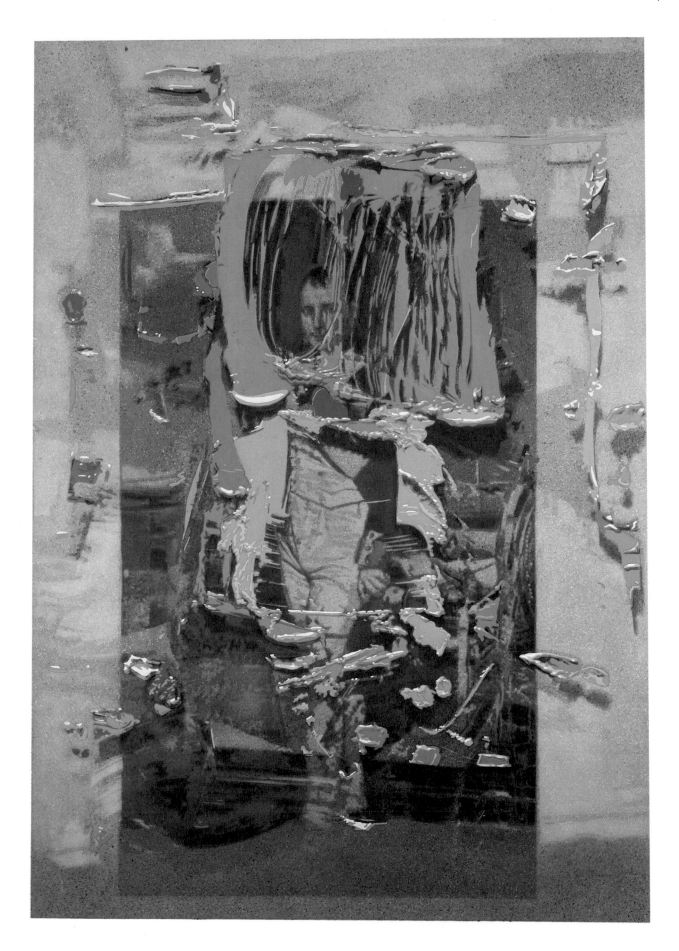

Stephen Woodburn, *Woodland Seen* (1973)
acrylic on canvas 72 × 93in (183 × 236cm)

Right
Seng-gye, *Voluntary in Deep Water* (1978)
alkyd on canvas, 48 × 72in (122 × 183cm)

Terry DeLoach, *Beth Plus One* (1979)
acrylic on canvas, 54 × 84in (137 × 213cm)

Michael English, *Big Steel Wheel* (1975)
acrylic on canvas, 60 × 60in (152 × 152cm)

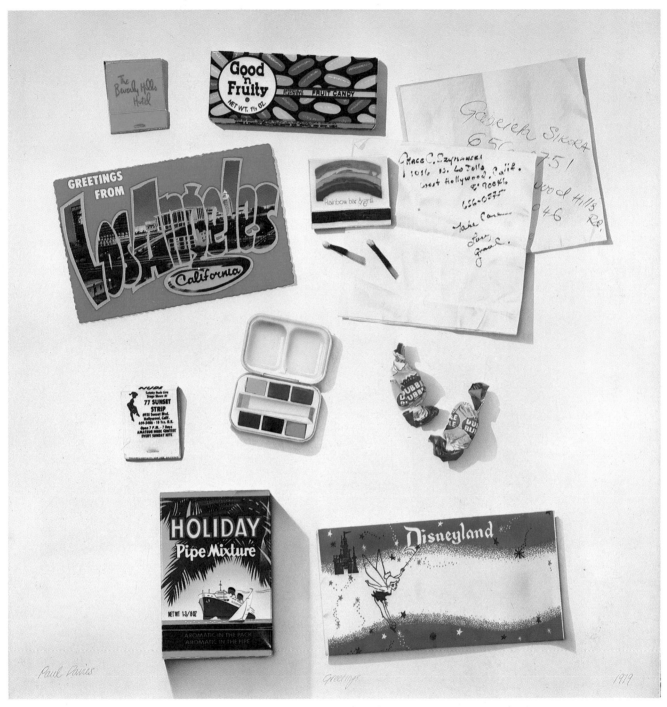

Paul Davies, *Greetings* (1979)
gouache, ink and crayon on board, 22 x 22in (56 x 56cm)

Right
Paul Davies, *Kimono* (1977)
ink on board, 16 × 15½in (41 × 39cm)

Below left
Terry Pastor, *Balancing Act* (Detail) (1980)
ink and gouache on card, 16 × 25in (41 × 64cm)

Below right
Terry Pastor, *Three-Legged Race* (1978)
ink and gouache on card, 28 × 18in (71 × 46cm)

Far right top
Jean-Jacques Maquaire, cover illustration for a Sony
promotional booklet (1978)

Far right bottom
Mel Flatt, advertisement for Chrysler automobiles

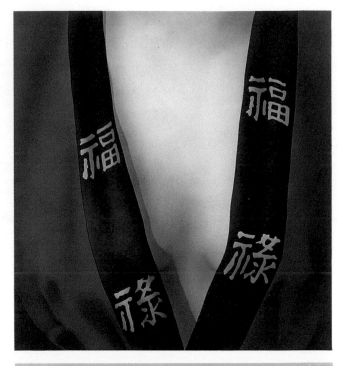

Left
Kurt Jean Lohrum, educational illustration

Katsuaki Iwasaki, self-promotional fantasy illustration

Page 54
Rick Goodale, logos

Page 55
Alan Aldridge in conjunction with **Harry Willock,**
children's book illustration from *The Butterfly Ball and the
Grasshopper's Feast* by William Plomer (1973)

Right
Ri Kaiser, *Karl Marx,* based on *Napoleon in his Study* by David, used as a cover for *Stern* magazine (1978).

Below
Ichiro Tsuruta, promotional illustration showing the tendency in contemporary Japanese graphics to combine the Westernized female ideal with traditional Japanese imagery.

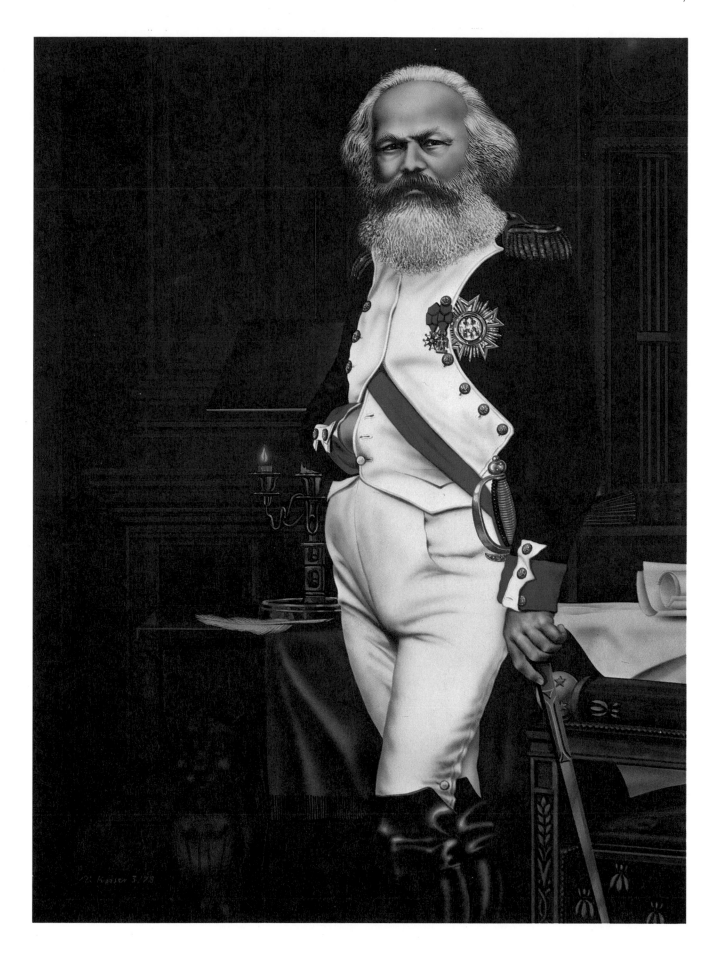

Brian James, one of a series of exhibition showcards for Stadium Ltd., manufacturers of motor-cycle accessories (1977)

Right
Philip Castle, *Handmaid,* a tempera on board painting used as an advertising poster for an exhibition of the artist's work at the Francis Kyle Gallery, London (1979)

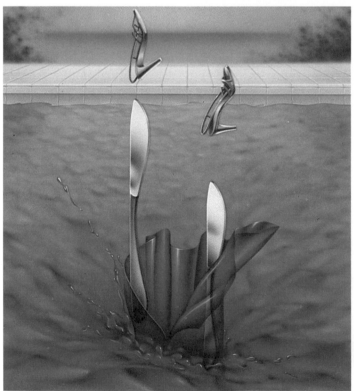

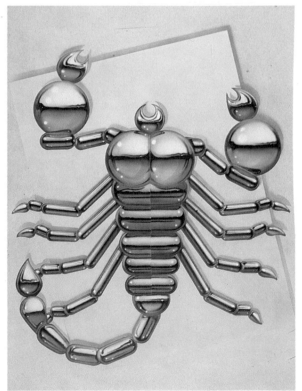

Opposite page
Top
David Jackson, editorial illustration for *Men Only* (1978)

Bottom left
Kazuo Hakamada, album cover

Bottom right
Charlie White III, *Scorpio* from the Zodiac poster series

This page
Top left
Gerry Preston, self-promotional art-work (1976-77)

Above
Izumi Ota, self-promotional art-work

Left
Michael English, *Coke* (1970)
gouache on canvas, 4 x 3ft (122 x 91cm), originally a
painting, now better known as a poster.

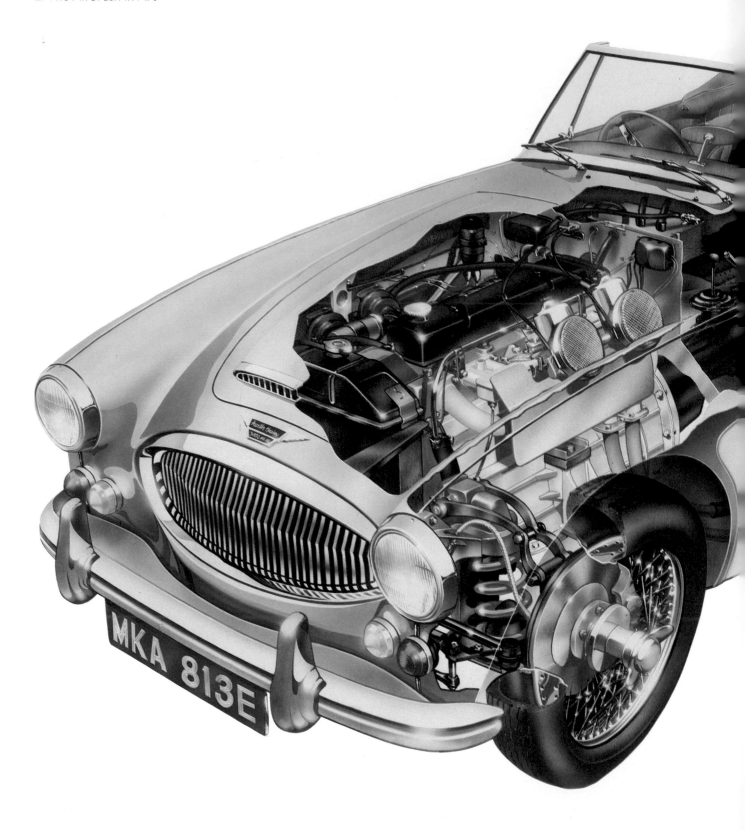

Keith Harmer and Roy Pickering, technical illustration of
the Austin Healey 3000

Below
Rolls-Royce Ltd., Bristol, technical illustration of the Viper
engine

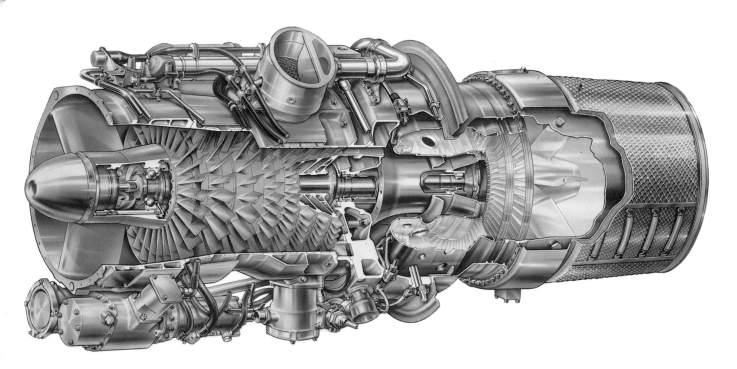

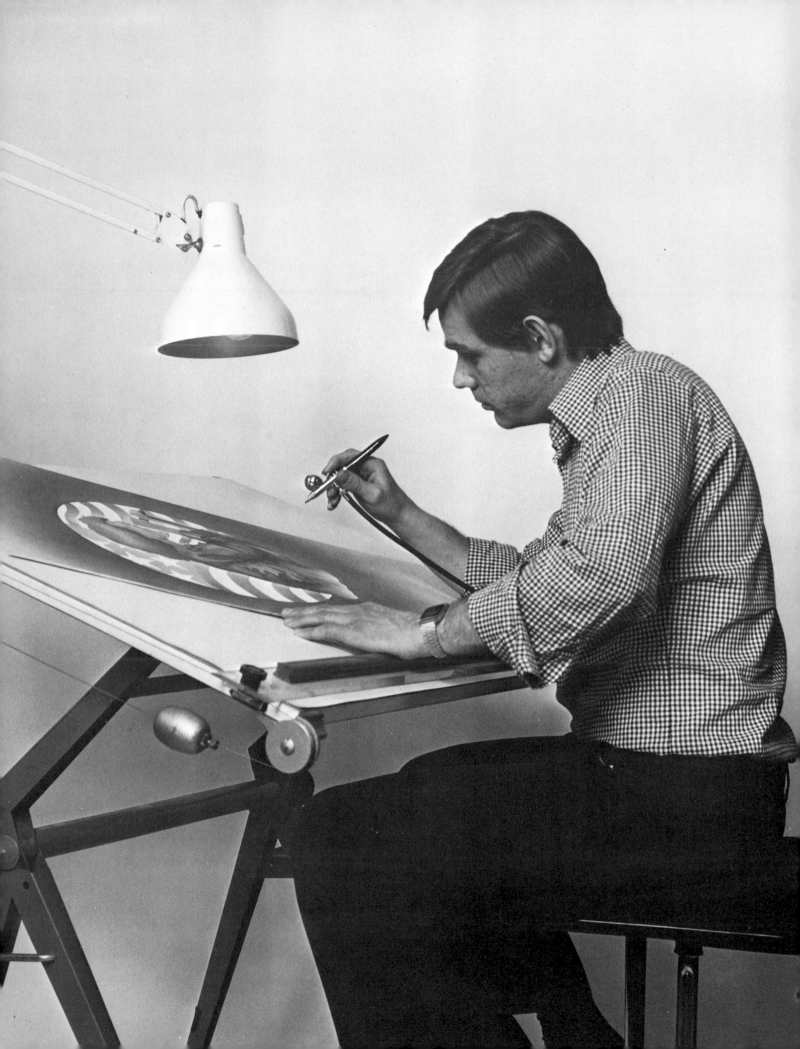

Chapter 3
Anatomy of the Airbrush

This chapter deals with the airbrush from the very first stage: deciding which one you need for your particular purposes; through the various basic types of airbrush, their advantages and disadvantages; and then on to consider the choice and use of some of the fundamental accessories – media, masking, and propellants. Most people who already possess and use the airbrush will find a lot in this chapter that is already familiar to them.

The initial question to be asked is do you really need an airbrush, bearing in mind that there are available some quite adequate cheap alternatives for certain functions? The airbrush is a sophisticated piece of precision engineering; it may be that you have to do no more than find an old toothbrush and a scrap of cardboard, if your purpose happens to be very simple.

Random Spatter Effects

If all you want to do is create an effect of unarranged stippling, with no particular regard to uniformity, precision, or pattern, then the toothbrush and card method will probably suffice. The technique is quite simple and any liquid or paste medium can be used.

Apply your paint to the toothbrush so that the tips of the bristles are soaked, and then, holding the toothbrush steady, bristles facing upwards, draw the piece of cardboard towards you across the bristles (3.1). The paint will then spray forwards onto your painting surface or ground, creating a random spatter. The method is beautifully simple but, like most simple ideas, not without its drawbacks. A problem only really arises if the area to be covered is a large one – for this is a very slow and laborious procedure, and will require reserves of patience. The end result is usually pleasing, even if uncontrollable for detail work (3.2).

Flat Spray

Mouth diffuser

If you intend to cover a fairly small area flatly and evenly – for instance to put a coat of varnish over a small painting, or to make a picture background – then a basic mouth diffuser ought to be sufficient. This can be bought from your graphics supplier for little more than the cost of a new toothbrush.

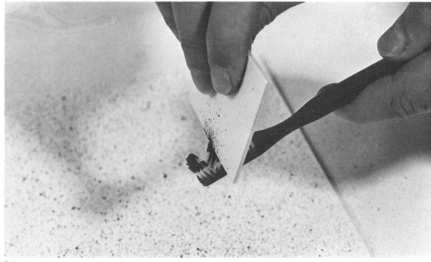

3.1

3.2

3. Anatomy of the Airbrush

It works, as do most airbrushes, by the operation of 'Bernoulli's Principle' (3.3), one of the corollaries of which is that a stream of high-pressure air will cause a corresponding drop in the pressure of the air around it. In this case the mouth blows at a high pressure which causes a drop in the air pressure over the paint tube (3.4). The medium, held at atmospheric pressure, is pulled into the paint tube (where the pressure of air is lower), and hence forced forwards in the airstream from the mouth. What results is a fairly even, wide and flat spray (3.5). Any detail you want, and this also applies to the toothbrush and card, the spray and the aerosol, has to be achieved by masking off the areas not to be painted (see page 76). Again the problem with this method is the energy it demands; you need to blow extremely hard to make the medium flow up the tube and out, and if the area to cover is large, it will probably wear you out. If you want to use the cheap method extensively, then you have to be fit!

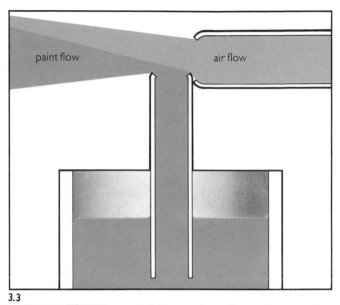

3.3

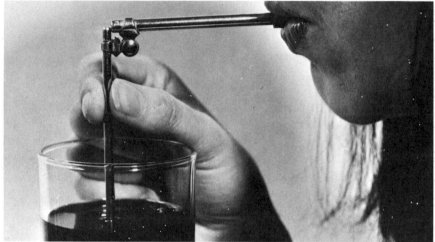

3.4

3.5

Badger 250 Spray Gun

1 Finger lever (air on/off switch)
2 Cam for air flow adjustment
3 Cam for paint flow adjustment

3.6

Spray-gun

If you have a considerable area to spray, you may feel that the physical effort is just not worth it, in which case the thing to do is buy a spray-gun, which need be no more than a powered mouth diffuser. These vary hugely in price, but models are available to suit most people's pockets. The operation is quite simple, but they really have only one function – to cover large areas in flat colour. This is fine if you are respraying a car, or colouring backgrounds, but inappropriate for intricate detail work.

Aerosol

Another method for achieving an even spray of flat colour is the aerosol. It is only practicable for one-off jobs, and the paint is supplied in the can. There is a substantial range of media available in this form, and providing a shade can be found that suits you, the aerosol has one advantage over the spray-gun – you do not have to mix the paint. On the other hand, if you are going to have repeated calls for this kind of spraying, it is probably worth buying the powered mouth diffuser. Detail again is impossible without masking.

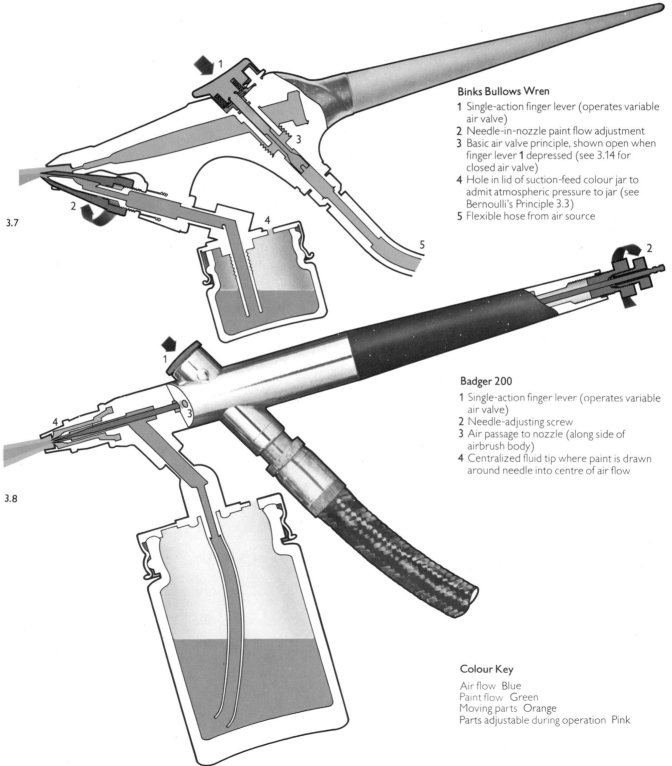

3.7

Binks Bullows Wren

1 Single-action finger lever (operates variable air valve)
2 Needle-in-nozzle paint flow adjustment
3 Basic air valve principle, shown open when finger lever **1** depressed (see 3.14 for closed air valve)
4 Hole in lid of suction-feed colour jar to admit atmospheric pressure to jar (see Bernoulli's Principle 3.3)
5 Flexible hose from air source

3.8

Badger 200

1 Single-action finger lever (operates variable air valve)
2 Needle-adjusting screw
3 Air passage to nozzle (along side of airbrush body)
4 Centralized fluid tip where paint is drawn around needle into centre of air flow

Colour Key

Air flow Blue
Paint flow Green
Moving parts Orange
Parts adjustable during operation Pink

The Airbrush

The airbrush comes into its own if details of less than 12in (30cm) across are required. It can be used for any sophisticated shading, free drawing or modelling, onto almost any surface. Its versatility is quite remarkable; it varies considerably with the kind of model, but a line as fine as a soft pencil line can be achieved with complete control, and the same brush can just as easily be used as a simple spray-gun instead, covering a reasonably large area. It is usually wasteful to use it in the latter function – rather like using a calculator to add two and two. So when customizing a car, for example, the basic background will normally be done with a commercial spray-gun, and the design with an airbrush.

There is, however, a bewildering variety of airbrushes on the market. Having decided that an airbrush is appropriate for the job, the next step is to select which airbrush is suitable for your purpose. The actual makes and models of airbrushes available on the market are given on page 152 with a note of what type they are. The general principles that airbrushes conform to are listed here.

Adjustable spray-gun (powered mouth-diffuser type)

It is debatable whether this type is actually an airbrush at all, or simply a sophisticated spray-gun. The only aspect in which it differs from the basic powered mouth diffuser is that the jets of air and paint can be adjusted at their junction by two rings, cams or nuts. The effect is to control the ratio of paint to air in the spray at a crude level, although it is difficult to make adjustments whilst actually spraying, and the range of settings is limited. Certainly the manufacturers of this type of equipment are persuaded that this qualifies as an airbrush, and it is the cheapest variety on the market.

The adjustable spray-gun (3.6) is quite adequate for fairly rough applications such as basic colouring for modelling, and the manufacturers suggest that this is its prime function. For controlled and detailed work, masking must be used to give good definition to shaping and shading, but on large-scale efforts such as murals, it can be used freehand, although the lines will not be extremely fine.

The main disadvantage in the operation of some of these models has been that they have tended to lose their settings after hard use. The airbrusher then has to stop, re-adjust the air-to-paint ratio, test it, and recommence. Improvements in design seem to be overcoming this problem.

Diffuser and needle

The next type of airbrush has a needle and a nozzle. It comes in two main types. The basic version has a horizontal air stream whose volume is adjustable; and a tube from the paint jar below that ends in an angled needle and nozzle, controlling the amount of medium (3.7). The paint flow is adjustable in two ways: the nozzle can move up and down, and the needle is adjustable within the nozzle. Often, however, you need a spanner to make this last adjustment, which can be inconvenient as well as make you pause in your spraying.

The second type has the needle in the nozzle at the front of the airbrush, so that they are horizontal. Paint and air now arrive at the nozzle together, so that it controls the mixture, not simply the amount of paint. The needle is adjustable from the back of the airbrush by a screw mechanism. This is clumsy, but does not necessarily force you to stop spraying while adjusting (3.8).

These are the standard kinds of airbrush for most modellers, and have the advantage over the powered mouth diffuser that they are capable of quite detailed work – a much finer and more controlled spray can be achieved with a needle inside a nozzle. This version is good for texture work, which is of course a primary concern of the modeller, but for the finest pieces, up to exhibition standard, the conscientious craftsman will probably look to a more versatile and advanced airbrush. The diffuser with needle is also used for some simple graphics work and is competent to handle most jobs which do not require very fine detail, or speedy execution.

The major drawback of this model is its cost-effectiveness. The cheapest airbrushes of this type start at just over double the price of a powered mouth diffuser, but when you come on to the more expensive versions, you might find yourself paying more than the price of the lower-range gravity-feed airbrushes, which are far more sophisticated and versatile.

Professional Airbrushes

We now come onto the more complex and expensive valve systems. These give the finger lever a double action. Instead of controlling only the air, it now controls both air and medium; the air is controlled at the air valve to the source, as in simpler models, and the fluid needle is adjusted by the same lever controlling the flow of paint into the air.

It is worth briefly outlining the difference between single- and double-action airbrushes at this point, as some catalogues differentiate between types of instrument on this basis.

Single-action

Single- and double-action refers to the use of the finger lever only; hence a single-action airbrush is one where the lever only controls the supply of air (3.7). The simpler types already discussed operate this way, with the paint being controlled at a separate point. Most airbrushes of this type are 'suction-feed'.

Independent double-action

In an airbrush with independent double-action, the finger lever controls both air and paint flows separately (3.10). Both 'suction-feed' and 'gravity-feed' airbrushes can be of this type; it gives the operator maximum control over his airbrush, and features on all the most sensitive and sophisticated models (3.13).

Fixed double-action

On this type the finger lever controls both the paint and air flows, but this time they are in a fixed relation to each other (3.14). This makes them easier for the beginner, but less versatile. It gives a reliable fine spray, but like an automatic gearbox on a car, it can be limiting.

Suction-feed

The term has been used above, and refers to the method of introduction of medium into the airbrush. All those so far discussed in this chapter are suction-feed. Whereas 'gravity-feed' involves dropping the medium from above (by gravity), suction-feed airbrushes pull the medium up, into the line of the air. Again, it is Bernoulli's principle at work, with the air pressure forcing paint up from a jar below. This would seem to be wasteful of energy if there existed a method of mixing the paint with the air and atomizing it without relying on the compressed air itself; here, it is doing two jobs – sucking up paint, and then atomizing it.

3.9 The range of spatter available on an independent double-action airbrush, due to the free play of the finger lever.

3.12 A range of typical free drawn fine lines available with various kinds of airbrush. (a) adjustable spray-gun; (b) diffuser and needle; (c) basic single-action airbrush (needle inside body); (d) broad nozzle double-action suction-feed airbrush; (e) fine nozzle double-action suction-feed airbrush; (f) fixed double-action gravity-feed airbrush; (g) independent double-action gravity-feed airbrush; (h) turbo. The pawn is largely effected in such lines.

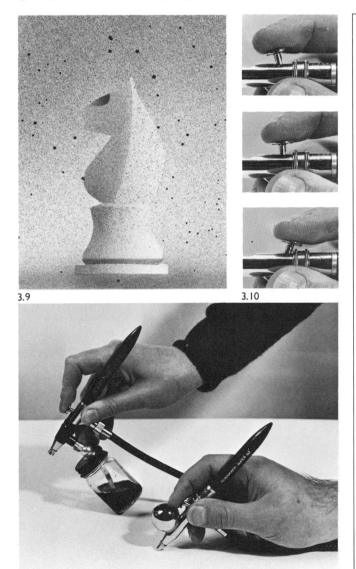

3.9 3.10

3.11

3.12

Suction-feed does have one or two advantages over the other system. The bonus is in the paint jar: it hangs below the airbrush itself, and so can be any size and hold a substantial amount of medium. When a change of colour is required, the medium is easily interchangeable (but see page 73 for cleaning between colours), with the substitution of a new jar. The system is relatively simple to keep clean as it is uncomplicated.

There are two main disadvantages to this kind of system which might make it unsatisfactory to the perfectionist. Firstly, when an airbrush with a jar is not held horizontally, the paint feed may come out of the medium unless a ball joint at the jar allows adjustment. If that happens, of course, no medium is sprayed. The second drawback is that the position of the paint jar underneath the airbrush body obstructs the operator when working very close to the ground, if he wishes to spray at a narrow angle (3.11).

Gravity-feed

Gravity-feed airbrushes may have top- or side-mounted cups, or simply a recess in the body, allowing medium to flow into the airbrush by gravity. Those with top-mounted cups are better balanced in use. Top- or side-mounted cups may be interchangeable but they must be emptied before removal, or else they will continue feeding the medium through, probably all over you. It is possible, with care, to replace a cup with another that has medium in it.

As gravity-feed airbrushes are nearly all double-action, there is also some sophisticated engineering necessary to control both air and medium flows. Fixed double-action instruments have a control lever which pushes the needle back and opens an air valve, as the control lever pivots backwards (3.14). On an independent double-action airbrush the lever moves in a vertical groove, so that it can be pulled back or down separately; an adjustable

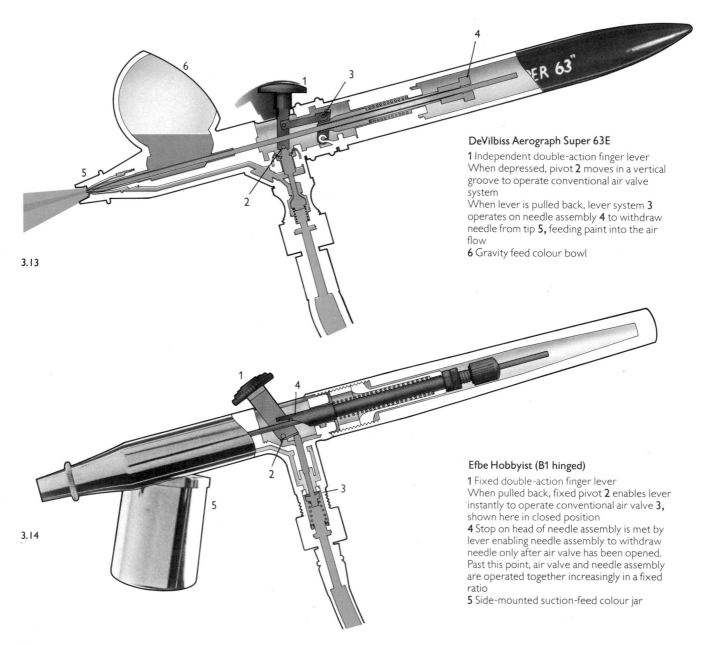

DeVilbiss Aerograph Super 63E
1 Independent double-action finger lever
When depressed, pivot 2 moves in a vertical groove to operate conventional air valve system
When lever is pulled back, lever system 3 operates on needle assembly 4 to withdraw needle from tip 5, feeding paint into the air flow
6 Gravity feed colour bowl

3.13

Efbe Hobbyist (B1 hinged)
1 Fixed double-action finger lever
When pulled back, fixed pivot 2 enables lever instantly to operate conventional air valve 3, shown here in closed position
4 Stop on head of needle assembly is met by lever enabling needle assembly to withdraw needle only after air valve has been opened. Past this point, air valve and needle assembly are operated together increasingly in a fixed ratio
5 Side-mounted suction-feed colour jar

3.14

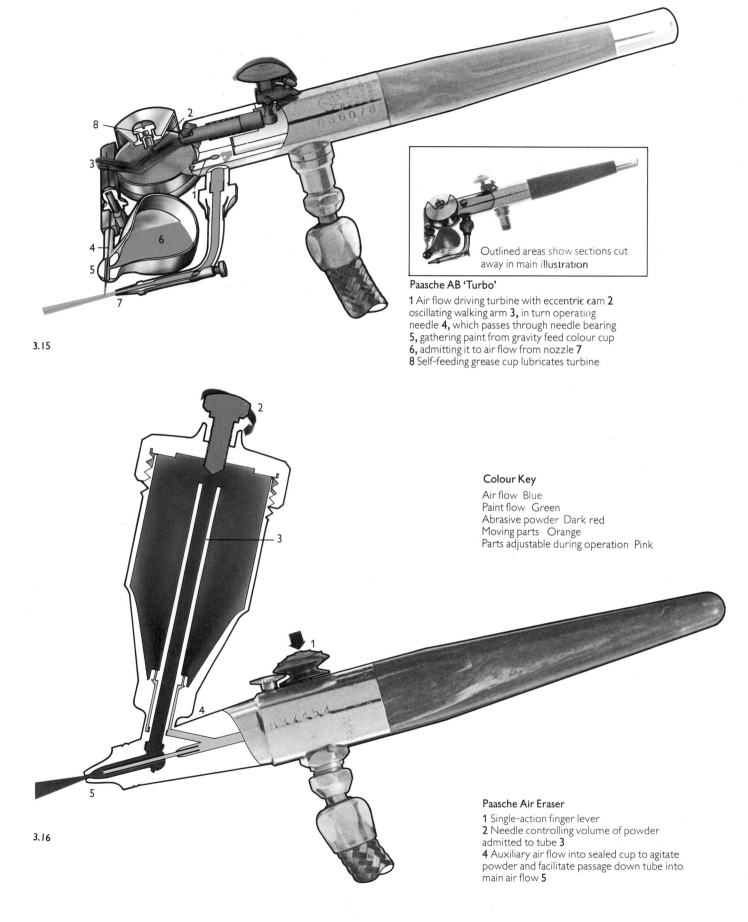

3.15

Paasche AB 'Turbo'

1 Air flow driving turbine with eccentric cam **2** oscillating walking arm **3,** in turn operating needle **4,** which passes through needle bearing **5,** gathering paint from gravity feed colour cup **6,** admitting it to air flow from nozzle **7** **8** Self-feeding grease cup lubricates turbine

Outlined areas show sections cut away in main illustration

Colour Key

Air flow Blue
Paint flow Green
Abrasive powder Dark red
Moving parts Orange
Parts adjustable during operation Pink

3.16

Paasche Air Eraser

1 Single-action finger lever
2 Needle controlling volume of powder admitted to tube **3**
4 Auxiliary air flow into sealed cup to agitate powder and facilitate passage down tube into main air flow **5**

diaphragm assembly at the head of the airflow gradually allows more air into the brush as the lever is depressed (3.13). The gap between nozzle and nozzle cap is so small as to be barely visible – Burdick's original airbrush had a nozzle bore of 0.007in (0.18mm); these days fine models are made down to 0.006in (0.15mm) bores. An instrument which works to these specifications, and has such a sophisticated control mechanism, is clearly a piece of precision engineering. These kinds of airbrushes are built to exacting standards; they are expensive, and need to be treated with respect.

Here we have reached what is in the opinion of the authors the most versatile and successful general purpose airbrush on the market – the independent double-action gravity-feed airbrush. It is capable of thin lines or washes, and is fully controllable through that range. There are, however, one or two specialist airbrushes and accessories designed for certain very specific requirements.

The turbo

This kind of airbrush (3.15), the only type not to use Bernoulli's principle at all, is ideal only for extremely fine detail work. The air in fact goes two ways. Firstly it operates a turbine at up to 20,000rpm, connected to an arm which pushes the needle back and forwards extremely fast. The air flow also rounds a corner and goes through a conventional air nozzle. The medium gravity-feeds into a tiny 'needle guide' along which the needle is oscillating, and some of the medium is picked up by the needle, due to surface tension, to be pushed out sideways into the path of the air jet emanating from the nozzle. The air blasts the needle clean, and it returns for more medium, which gets blown off again by the air jet – and so it repeats, all at extremely high frequency.

The turbo is an independent double-action gravity-feed airbrush; pulling back on the lever controls the travel of the needle, which determines whether the medium attaches itself to the thin tip, or the thicker body of the needle. The further the lever is pulled back, the greater the surface area of the needle with medium attached that is subjected to the air flow, and therefore the greater the volume of medium emitted. As in conventional airbrushes, a downward pull on the lever operates the air valve. There are, however, two further controls. The turbine speed can be separately controlled; and a stipple adjustment screw at the air nozzle controls the amount of air coming through, and hence the degree of spatter.

This model is probably the most advanced airbrush there is; it requires tuning when bought, and occasionally afterwards. Only the professional engaged in the drawing of fine lines freehand will need an instrument this delicate. Many top artists use it, but some, like Terry Pastor, resent its 'temperamental changes in tuning'. It is expensive, takes a lot of skill to operate, needs time to set up, cannot handle some media such as alcohol or lacquer colours, and cannot have colours drying in it. But for all that, it has no equal for really sensitive work.

Air eraser

This is basically a controllable sandblaster (3.16). The major difficulty in the course of its development was to prevent the powder clogging when it was put through the small nozzle; the solution was ingenious. A single-action suction-feed airbrush has in a way been turned upside down, so that there is a large cup on top of the body. It looks as if it should be gravity-feed but it is not. There is a tube in the cup, the top of which is higher than the level of powder. This is pulled up to the top of the tube and then down to the nozzle by Bernoulli's principle; that is, it is sucked into the body of the airbrush by the compressed air. This suction in fact occurs from the nozzle, not from the bottom of the cup, because the air is sealed from the powder in a small central feed. A needle on top of the cup can increase or decrease the amount of powder allowed into the tube; the finger lever only controls the air, so is single-action.

The air eraser normally uses pumice or aluminium oxide powder, but any lightweight powder, such as pigment, can be used. It can be employed in many ways: for erasing colour errors, for glass etching, for engraving, even for shaping dentures.

Trigger spray-gun

If the air eraser is not a conventional airbrush, rather a useful element in the set, then so is the spray-gun. You can buy low-pressure, low-air-volume versions of the industrial trigger-action spray-guns, in either suction- or gravity-feed types. Gravity-feed models tend to be fixed double-action; suction-feed guns can be single-action or fixed double-action.

These miniature industrial models have needle and nozzle, but are not airbrushes (3.17). You cannot draw

3.17

with them, as you do not have the same control that you have with an airbrush. But many airbrushers use them to cover large background areas, and car customizers can obtain special effects through the extra power of the spray. Most spray-guns will run off a large airbrush compressor.

Control lock, or line-adjusting nut

This is an accessory that is fitted as standard on some airbrushes, and deserves mention. It is simply a cam ring, knurled ring or bolt which locks the finger lever in any minimum position, removing the necessity for the operator to keep critical control of it all the time, and hence, theoretically at least, ensures an even coverage.

Different types of airbrush have different functions, and, as we shall see, it is important to select the right instrument. Some professionals use a basic model for stencilling or mask-dependent work; however, from the authors' experience, the independent double-action gravity-feed airbrush is the best type for general purposes, from drawing fine lines to washes. For large areas, an independent double-action suction-feed airbrush is advised, as gravity-feed models are too fine. For very fine work, requiring slow control, there is the turbo.

Media

Having selected your airbrush, you need to decide what medium to use (3.18), and also what means is best for supplying the air. In general, almost anything liquid can be put through an airbrush, from the totally fluid dyes to suspended hard pigments such as oils or alkyd. It does not mean that you have to use these conventional media: you can spray varnish quite easily, or food dye, or even latex.

Total liquids (inks, dyes etc)

These can be applied readily and easily straight to your colour well or jar, provided they are free of dust and small hairs which can catch in the nozzle and cause spitting. The most important consideration is that the colour well and the body of the airbrush be cleaned thoroughly with a thinner after use and, if the paint well is not interchangeable, both well and body must be cleaned whenever a new colour or kind of medium is being introduced. The most important area to keep as clean as possible is the nozzle, where clogging can occur.

Pigment-based media

Pottery slips, or any medium which contains suspended solids, can be used provided the solids are finely ground. If the pigment is hard, it will erode the nozzle and the needle, however well ground it may be. The method for pigments is as follows: thin your paint so that it will flow rather than drip through a fine mesh tea-strainer. Use what comes through, but do not attempt to push through the lumps that are left in the strainer, they will still be too thick. Problems may arise if the pigment starts to settle, as it may with metallic paints or process whites. If that occurs, the airbrush will totally clog up, so that nothing is sprayed at all. Either change this kind of paint frequently, or agitate it in the well with a brush. These media are not recommended for beginners; inks are easier to work with.

With pigment it is especially necessary to empty and clean your airbrush frequently during use, to prevent the nozzle becoming congested. Whenever you pause, paint can dry around the nozzle. With total liquids the same

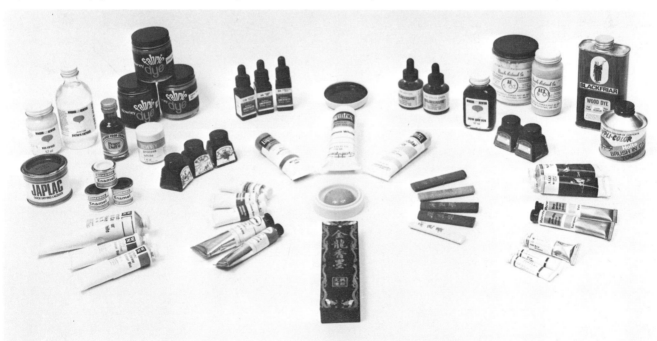

3.18

frequency is unnecessary; it is adequate to clean between colours and after use. More is explained about cleaning in the chapter on care and maintenance (page 140).

Propellant Systems

Having decided upon the right airbrush, you will need a flexible hose to attach the propellant system of your choice to the body of the brush. Ideally this should include at the propellant end a control valve: either a simple on/off mechanism, which will operate as an extra safeguard against pressurized air coming through at the wrong time, or, and this is normally far more useful, an adjustable pressure control so that you can dictate the pressure of air reaching the airbrush, without being tied to the pressure of the propellant. More than that, it is often worthwhile decreasing at this control the degree of pressure the propellant system is producing, partly to help iron out any fluctuations that may occur, and partly to admit increased sensitivity to the finger control on the airbrush. If less pressure is coming into the airbrush, each millimetre the finger control is moved will cause a smaller change in pressure in the ejected spray – hence the control will be that much more sensitive. So for fine and detailed applications, this can often be of considerable advantage.

There are four basic types of propellant systems, from the extremely simple to the sophisticated and expensive.

Deflating tyre
This is an old favourite, particularly with modellers, but it really demonstrates dedication and perseverance in the face of difficult odds, more than the enduring efficacy of the system. The principle is that a tyre is inflated, and the pressure of air as it deflates is used to power the airbrush Marvellously cheap and simple but open to such major disadvantages that it is hardly worth considering, except for the roughest possible jobs. The major problems are damp, dirt, and unevenness of air supply.

Can or cylinder of compressed air
Many begin with the can of compressed air (3.19-20). There are two ways of doing it: hiring a large cylinder, available in various sizes, or purchasing a small can. The former is initially expensive, bearing in mind the deposit on the canister, and somewhat unwieldy; it will be the same kind of cylinder as pressurizes your beer in a bar, and uses carbonic air. The small can is almost certainly a better option to go for at the beginning.

It is useful to know roughly how much propellant your airbrush will get through. If it is only to be used rarely, then the small cans will probably suit you well. Otherwise, the cylinder may turn out to be more economical in the long run. And apart from these, for roughly the cost of 20 of these disposable cans, you can now buy a small

compressor, a more satisfactory instrument altogether. So here at least a little forethought would not go amiss, and might end up saving you money.

If you do decide on the can of air, you will discover that you probably need some further hardware; in particular a control valve, which is fitted between the can and the hose. You can opt for a simple one, which is open or closed, or a complex one which combines an adjustable control valve and a safety valve.

The can of propellant gives an adequate and fairly even pressure – though it does drop slightly towards the end of the can. This can be mediated by standing the can in lukewarm water. If the water is too hot, you may get a gas 'blow-off'; this can also happen if the can is overfull when bought. To remedy this, simply release some gas, or remove the can from the water, and the blow-off will subside.

Footpump and reservoir
This system is composed of a pump like those used for inflating car tyres, coupled with a large tank and a pressure gauge. Before you start work, however, you will find yourself burning up considerable energy inflating the tank. Depending on the scale of the job, you may find that one initial inflation is sufficient.

If you are prepared for the rigours of manually filling the tank, the footpump and reservoir will prove to have quite significant advantages. The system is cheap, running costs are low, and it is quiet to operate. Because it needs no power supply, it is normally a portable means of propulsion. But one word of warning: sophisticated footpumps and reservoirs are often more expensive than the cheapest electrical compressor.

Basic compressors
The simple versions of the portable compressor (3.19) are certainly adequate for general use, though not for high-quality work with expensive airbrushes. Apart from a tendency to burn out or develop faults, the cheap compressors have other drawbacks. The major problem is that you can fit the airbrush directly into the compressor, with no pressure gauge and no moisture filter. The lack of a reservoir causes a 'pulse', the results of which are unfortunate: a fine line, for instance, may turn out as a series of dots, which show up in detailed work. It is possible to incorporate a moisture filter and put a reservoir between the airbrush and the compressor; the most common solution being something like a clean bicycle inner tube, elastic enough to iron out those pulses. You simply remove the valve and clamp it in place at each end. With this acting as a large reservoir, and a moisture filter attached to one end of the tube, fluctuations will be minimized. Cheaper compressors are therefore not recommended, unless adapted, for very fine work; they are also apt to distract the airbrusher, as they must be kept running all the time the airbrush is in use.

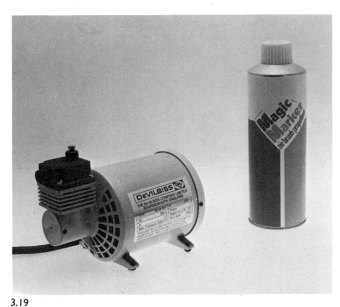

3.19

3.19 A simple compressor on the left and a disposable gas canister.
3.20 A professional compressor and a refillable gas cylinder.

Sophisticated compressors

Larger, more expensive compressors (3.20), will be fitted with a reservoir as standard. Air enters the reservoir and builds up to the required pressure. Once this is reached, you can turn off the compressor to use the airbrush if the noise of the machine disturbs you. There will be other features – a pressure regulator, which normally also houses a moisture filter, and a safety-valve to prevent over-pressurizing. There will be no problem of pulses with this kind of system.

Most sophisticated models feature an automatic return-valve, which can be as energy (and anxiety) saving as a thermostat on a central-heating system. The effects are analogous. If, for instance, you want your airbrush to operate at 20psi (1.37bar), a normal working pressure, then you set the pressure return-valve to 40psi (2.75bar). This will be sufficient to prevent the pressure going too low, even in the event of an unexpected drop, without being so great that your airbrush finger control has to cope with a disproportionate air flow. You then start work with the compressor off and the reservoir containing those 40psi, but only feeding 20psi through the airbrush. When the air level in the reservoir is lowered, the pressure will decrease. When it gets down to around 30psi (2bar), the automatic return-valve will operate to switch the pump back on again. In other words, it is a self-regulating pressure control, which will leave you free to concentrate on the actual airbrushing.

There is a warning to be given when using these compressors. It is possible to produce very high pressures of air with some systems, sufficient to pierce the skin and to push possibly toxic pigment into the capillaries of your hand. The pigment may poison the blood, or the air can cause an embolism – a blood clot which can be fatal if given time to travel round the circulation. So, if you are working at very high pressures, keep your hands (and the rest of your anatomy) away from the spray: exceptionally high pressures can also damage your airbrush.

Compressors for other uses

It is possible to obtain variations of the standard compressors for use by several airbrushers. One type simply involves an enormous reservoir, from which several airbrushes can run simultaneously. Outlets are piped to individual work areas, and the operator fits the outlet into his airbrush when he wants to use the supply. Each outlet has an adjustable pressure control, so the airbrushers are not bound by the pressure of the reservoir. To forestall any possible fluctuations in air supply from the central compressor, individual 'pressure regulating tanks' (mini-reservoirs, of about 9 × 6in (22 × 15cm) can be added to each outlet.

A less permanent, large-scale solution to the problem of several operators, is the compressor on wheels. It is simply moved around to supply whoever needs it at the time. Petrol-driven compressors are also available for outside uses such as car spraying; they are not recommended for use indoors, because of the smell and fumes. Compressors are even available that can work on both petrol and electricity.

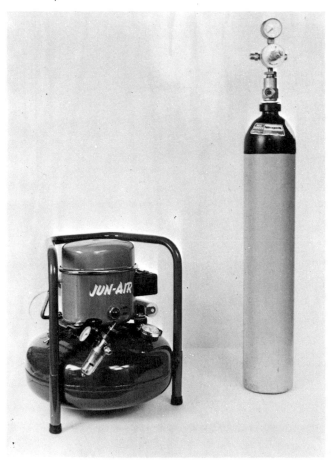

3.20

Masking

Masking can be defined as anything that lies between the airbrush and the ground, preventing the spray from spreading further than desired (3.21). For example, a torn-off piece of newspaper held in the line of fire counts as masking. This will cause a soft-edged coverage on the ground because a little of the spray will spread or bend round it. To get a hard edge, the masking must be hard against the ground; otherwise the edge will be increasingly soft as the masking becomes distant from the ground (3.22). There are two main types of masking that will give hard edges: liquid and film.

Liquid masking

This is a rubber and ammonia based solution, sometimes containing a dye so that it can be seen. When painted onto the ground the ammonia evaporates, leaving an area of rubber which can be cut, and later removed. It can also be pasted onto a laminate sheet and then applied to the ground; in this form, it is known as a frisket. This was, until the advent of film masking proper, the most common type of mask. Now it is seldom used.

Liquid masking is only suitable for certain grounds and media. Some card and paper absorbs the coloured dye in the masking. The surface of the ground can also be lifted when the mask is removed. Or, when a plastic dye such as acrylic is used, it settles on the surface of the masking, which cannot then be taken up at all.

Liquid masking is best suited to impervious surfaces: its main applications are in photoretouching and modelling. Wax, melted out afterwards, is a kind of liquid mask used in batik work.

Film masking

For just about every application other than those mentioned above, film masking is most suitable. This is basically a film of low enough tack not to lift what is already underneath when it is removed from the ground. On textured surfaces, such as canvas, a somewhat higher tack is required, and bookbinding film is usually the best. For a flat surface use a lower tack masking such as proprietary airbrush film. You can make film masking yourself, by making friskets – but this is a tedious practice. It is possible to be inventive and save money by using something such as masking tape with newspaper. This has

3.22

3.21

3.23

one sizeable drawback – you cannot see underneath it to check and compare what you are spraying with what you have already done. Film is at least transparent for cutting, though it becomes translucent or opaque when sprayed.

To obtain the desired shape, cut the masking with a scalpel (or similar instrument) while it is stuck to the ground. This is an acquired art, and demands hours of perseverance. The trick is to avoid cutting the ground, and at the same time not to make too shallow a cut which would result in tearing when you attempt to lift it from the surface. Once the unwanted areas are removed, you are left with crisp, hard edges, and can spray freely (3.23).

In most forms of airbrush work, certainly where time is important, mask-cutting is a higher art than the actual operation of the airbrush. Masking decides and defines shape; the airbrush controls the texture, and coloration.

There is one golden rule in the application of any form of masking which touches the surface: the medium underneath must be absolutely set and dry. (In some cases, it is not sufficient for the paint to be merely dry to the touch.) The reason for this is self-evident: if the paint is damp, it may come off with the masking. Some paper and card surfaces can lift if the film is pressed down too hard or left on too long, so it is worth testing first.

Masking is not the only way to control the area of spray of an airbrush. One other method, which comes in handy particularly for photo retouching, is to spray the area freehand and then remove the excess. This is best done with a swab of cotton wool (cotton) soaked in the correct thinner.

Preparing to begin

The essential ingredients are now assembled for you to begin airbrushing: airbrush, medium, propellant system and masking. To load the airbrush, use a teat pipette

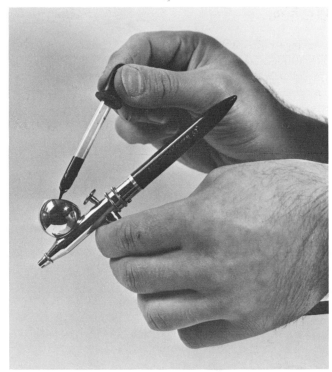

3.24

(3.24); you will need at least one for each colour to be sprayed. Some airbrush manuals suggest a brush for loading the paint; we do not recommend this, as the brush contains dust and may lose its hairs. It is very important that there are no impurities or unwanted solids in the colour well; a teat pipette will ensure this, as well as making sure you don't overfill the airbrush.

You should connect the airbrush to the propellant system and test the air supply before adding the medium; this will not only check the system, it will give you a chance to get used to the feel of the air pressure. Test the medium on a scrap until you are happy with it. Now you are ready to start airbrushing.

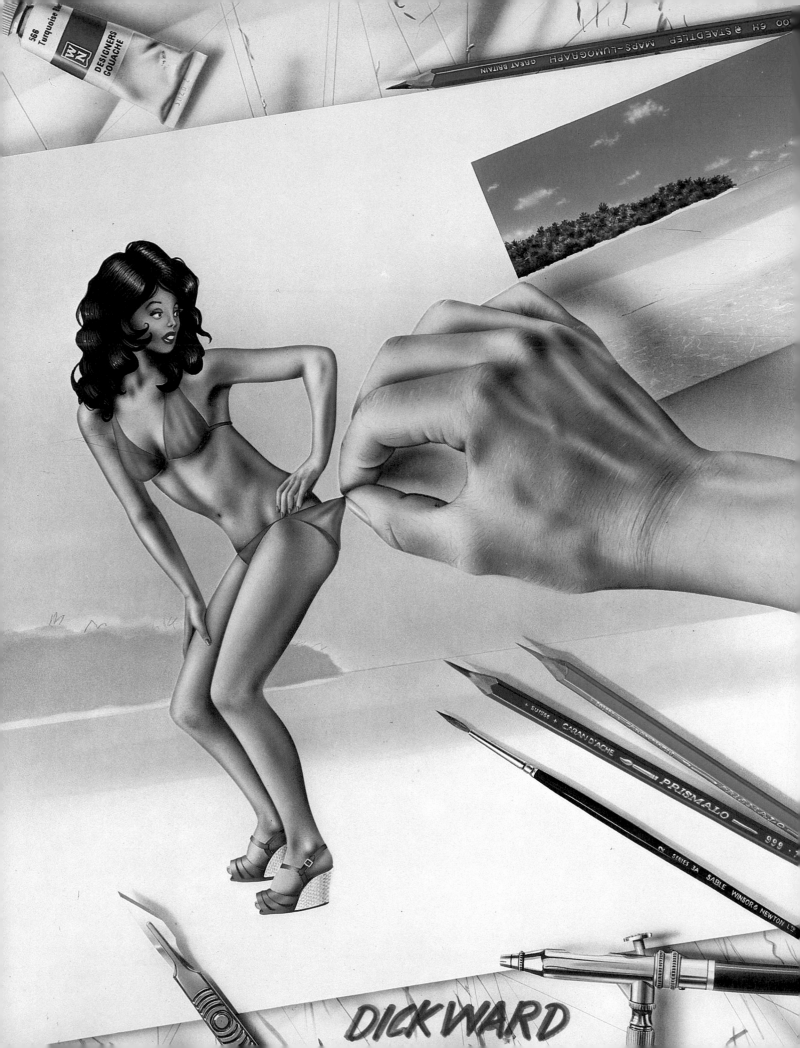

Chapter 4
Basic Method

This chapter deals with exercises you can do using the materials discussed in the last chapter, and with no experience in the use of either airbrush or masking. Accordingly, it is written for the complete beginner – anybody who has used the airbrush for any length of time will have become accustomed to its methods and habits, and will not need these lessons. Their function is as a gentle introduction to the idiosyncrasies of the airbrush.

Basic Exercises

We recommend that you begin with ink, of some strong colour such as black or dark blue, and use as ground a reasonably heavy cartridge paper laid on a flat surface. Expect to get through a lot of paper: learning and experimenting consume a great deal of space – something which even advanced airbrushers always find. Airbrush

Left: Dick Ward, self-promotional illustration.
4.1 Various lines which can be drawn with incorrect and correct handling of the airbrush.

sprays drift in the air, so you should clear the area. When you come to use a heavy medium, you will find it necessary to clear the entire workroom as the atomized droplets hang in the air for some while.

Exercise 1: a line

This exercise does not depend on the line being straight, it can be any shape or length you want. Hold the airbrush about 4in (10cm) away from your ground, and make two or three 'dummy runs' at your line, keeping the airbrush as evenly distant from the paper as you can. You will need to hold the instrument fairly level if you are using a gravity-feed or side-cup airbrush, otherwise the ink will spill over the top. Once you are happy you have the feel of it, actually operate the airbrush, using the finger lever. Begin to move your hand across the ground as you have in your practice runs, but only operate the spray once your hand is in motion. Follow the path you have already determined for the line, and release the control before you stop the hand movement. It is vital to start and stop the spray while on the move; if you are static, a thick blotch of ink forms at both ends of the line. This does not

insufficient air

erratic finger lever

too close to ground

too much ink

lines correctly drawn with airbrush gradually approaching ground

4.1

4.2

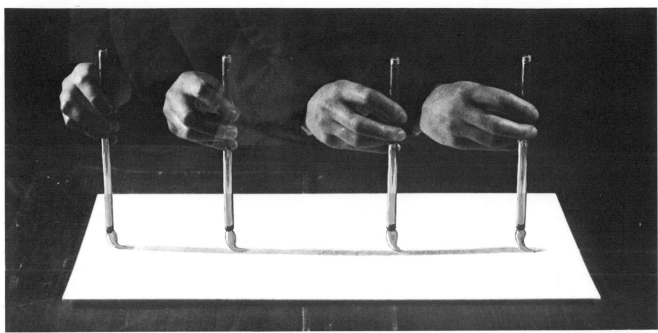

4.3

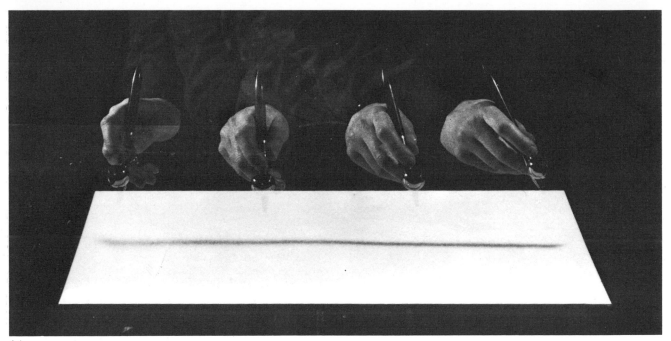

4.4

4.3-4 Anyone familiar with the use of the Chinese brush will find a similar hand movement in creating strokes with the airbrush.

matter if you happen to be working right the way across a partially masked surface, beginning and ending the stroke on the masking. When you stop, gradually ease the lever off, rather than suddenly releasing it; otherwise some ink may be left in the nozzle when the air is shut off, which will cause spatter at the beginning of your next line (4.1).

Carry out this exercise three or four times, until you

have found out how hard to press the lever to achieve an even line which does not flood the page. It is entirely a matter of practice; different airbrushes require different amounts of pressure. If your line looks grainy, then there is too little air going through; you either need to increase the pressure from your supply, or else simply to press harder. If your line has spidered out, then there is either too much ink — in which case reduce the force with which you operate the ink supply — or else too much pressure; reduce it at the lever or the supply. It is important at this early stage to experiment with the pressure levels at both points until you find a balance that suits you: correct

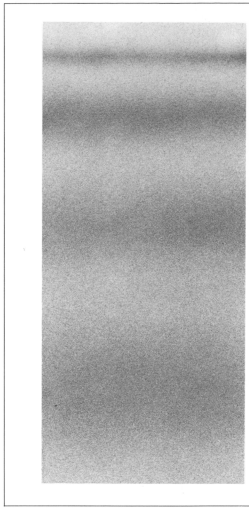

4.5

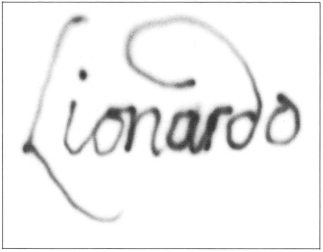

4.6

pressure is fundamental to good airbrush work.

To draw a straight line with an airbrush, you can use the same method as you would with a pencil: place a ruler where the line is to be drawn, and spray along it so that the airbrush rests on the ruler's edge. A straightforward method, but not immediately obvious (4.2). Note that the ruler is not flat on the ground.

Exercise 2: a tone

To obtain a tone, hold the airbrush about 6in (15cm) away from the ground, and repeat exercise 1. You will find that the further you retreat from your ground, the harder you need to pull back on the finger lever – both pressure and volume of ink must be increased. Again, practise the motion until you are happy with it, before actually operating the airbrush, and continue the exercise until you can produce a fairly even tone at will.

Now move the airbrush a further 2–3in (5–7cm) away from the ground, and repeat exercise 1 again, until you are confident. Then move back the same distance again, and draw your tone; then again until you are covering a large area with your stroke; in other words, until you achieve a 'spread tone'. Each time remember to increase

the pressure, and be sure to repeat the tone until it is smooth every time (4.5)

Exercise 3: a fine line

This time bring the airbrush nearer the ground, firstly to 3in (7.5cm) away, and then 2in (5cm), each time repeating exercise 1. As you might expect, you will have to decrease the pressure at source, or move your hand more quickly when working close to the ground. For a very fine line, the airbrush should be actually touching the ground. If you are using a suction-feed airbrush, the ground needs to be vertical otherwise the paint jar will obstruct the nozzle from getting close enough to the paper. You may find that to effect a very fine line without the spray spidering, you have to decrease the pressure at source.

Now repeat the exercises above, until you can draw a line to any thickness. When you think you have grasped them, try signing your own name. Give yourself a lot of space! You will probably watch helplessly as your hand gets in its own way. If it doesn't, you are doing very well. If it does, don't despair yet. It is a matter of practice to move the whole arm, rather than the wrist (4.6).

Exercise 4: line pattern

If the signature did not come out well, try a pattern of descending loops, keeping an even line thickness and loop size throughout as far as possible. Continue practising, using both thin and thick lines, until you can draw the whole pattern evenly (4.7). Sign your name again. It should be easier now.

Exercise 5: overall flat wash

Take a fresh sheet of paper to use as ground, and fill your well with ink. Holding the airbrush about 8in (20cm) away from your ground, spray continuously and horizontally, backwards and forwards, moving gradually down the page; you will need to keep your hand in motion throughout. Because the spray flies about a little, you will find it better to spray at an angle to the ground, rather than simply

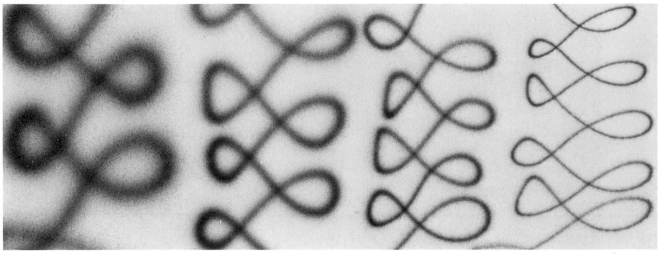

4.7

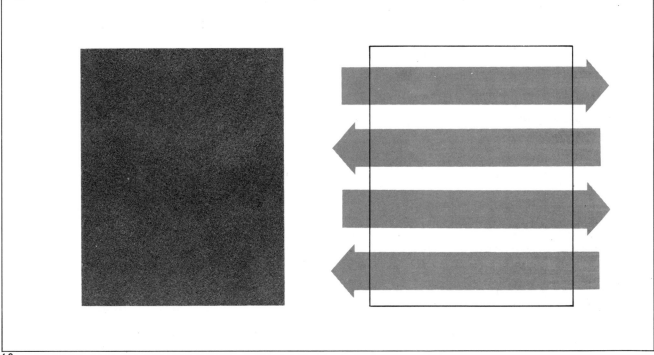

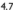
4.8

perpendicular to it: if your ground is vertical, spray slightly downwards. Remember as before to move your hand before operating the airbrush; you will also need to spray well over the edges of your ground, as the instrument is momentarily stationary at the end of a stroke just as it returns for the next. This stationary point must be off your ground, or else it will cause a smudge. The arrowed diagram shows the movement of the airbrush for an overall flat wash. Again, practise this until you are proficient (4.8).

Exercise 6: fading wash
Repeat exercise 5, but lessen the pressure on your finger lever as you progress down the page. This will result in a wash that gradually fades out to nothing (4.9); attractive, but not easy to do smoothly.

Exercise 7: restricted area wash
This exercise is a rather more difficult version of exercise 5; the object is to achieve a flat wash over the central portion of your paper (4.10). Hold the airbrush about 8in (20cm) away from your ground as before, but this time move the instrument back and forth employing *separate* strokes. Remember, with each spray, to start and stop your airflow while on the move, and aim to cover a definite area of the ground. One of the difficulties will be stopping the airflow accurately as you reach the edge of your central area, without slowing your hand movement.

Exercise 8: restricted fading wash
Once you are competent at exercise 7, you might amalgamate it with exercise 6 and effect a restricted area

4.9

wash that also fades as you go down (4.11). This will result in a hazy centre to your page which gradually fades to nothing, and is correspondingly more difficult than the preceding exercises.

Exercise 9: line at edge of masking

Place a piece of thick paper or card over part of your ground, ensuring that the top edge of this masking is horizontal. (Thin paper is not advised for masking here, as it is not rigid enough.)

[i] Draw a horizontal line just above the edge which the masking makes with the ground, about 1 in (2.5cm) into the ground. The spray will be such that a little spills over onto the masking (4.12).

[ii] Move the masking down the page, and this time draw a horizontal line on the masking itself, about 1 in (2.5cm) below its top edge. Some spatter will spread onto the ground above (4.13).

[iii] Move the masking down further, and draw a line precisely along the edge the masking makes with a ground, and then remove the masking (4.14).

Compare the kinds of line you achieve with these methods, and remember them well – they produce subtly different effects you will probably often need (4.15).

Exercise 10: small circles

[i] Starburst effect: this is effected freehand and requires an opaque ink of a lighter colour than the ground's background. Simply spray a spot with a tight circular motion, and spiral outwards slightly, so that the circle expands (4.16).

[ii] Freehand 'highlight' circle: you can also effect a light circle by spraying freehand a dark wash of colour over all your ground *except* a central circle. This is a complicated exercise which will take some effort to master (4.17). It is usually best to make up your flat wash with short, curved strokes. Start at the inner area and work outwards, remembering that your spray spreads, so that the innermost

4.10

4.11

4.12

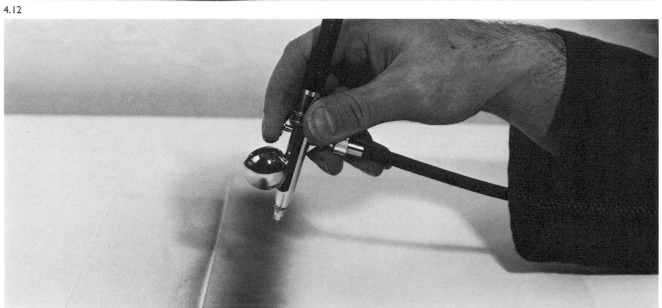

4.13

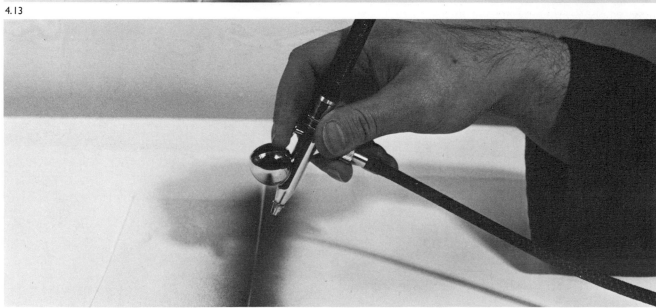

4.14

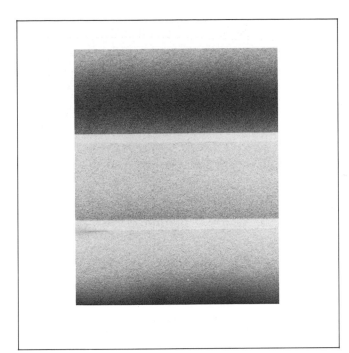

4.15

4.16

spray will spill-over from a spraying done about 1 in (2.5cm) further out. Avoid repeatedly going over your strokes to get them accurate – all you will succeed in doing is give the effect of an uneven wash. The arrowed overlay shows the direction of the strokes.

Exercise 11: simple coloured sphere

Start with a mask made of card with a circular hole cut out of the centre. Firstly, effect a flat wash upwards from the bottom, leaving a 'highlight' circle near the top (see exercise 10ii). Take a second colour and effect another flat wash, this time leaving a much larger 'highlight' circle near the top to encompass the other 'highlight' circle. If you now remove the masking, you will discover a rudimentary sphere (4.18). You will probably be surprised how different the ground looks once the masking is taken away; it is seldom as you would have envisaged.

This is a difficult exercise, and must be executed slowly. It is a gradual process, and requires time and patience; it is particularly easy to saturate the ground with ink, if you are not careful. Remember also to clean the airbrush between colours. This can best be done with a thorough rinsing of the paint-well and airbrush with water, as the ink is not waterproof. After use, clean thoroughly with methylated spirit or denatured alcohol.

Exercise 12: complex coloured sphere

There are many ways to render the sphere shape; those illustrated in this chapter are examples of possible ways to do it, and a little experimentation by the reader may well devise others. A more complex version of exercise 11 is as follows (4.19).

4.17

4.18

Firstly, take a pale coloured ink and effect an insubstantial flat wash over the whole area of the circular hole left by the masking (as in exercise 5). Then spray a line around the edge of the masking, preferably in a darker hue of the same colour, so that only a residual line is left inside the masking (as in exercise 9ii). Continue with a flat wash, leaving a 'highlight' circle near the top (as in exercise 11). Now, in a third colour, spray freehand a crescent that sits in the lower half of the circle, its outside curve following the line of the circle at the bottom. This is a difficult stage – the crescent should be effected freehand by the restricted area method of exercise 7. Finally, spray another circular line near the inner edge of the masking, but this time spray the top and bottom segments heavily, and the curves in between very lightly indeed. Remove the masking. It may not come out perfectly first time, but don't be discouraged.

Exercise 13: monochrome sphere

The method for producing a monochrome sphere is much the same as for a coloured one, though more difficult (4.20). Fill your airbrush with black ink, and follow the instructions as described in exercise 12. Do not, however, begin with the initial light flat wash – ignore that, and start with the line around the edge of the masking. Then follow the above instructions throughout, but bear in mind that this time you are building up layers of ink in such a way that each new layer makes the overall shade darker. Once you have rendered your sphere form, make adjustments by eye until it looks right. Remember that what you are seeing while the mask is on may not quite match up to the look when the masking is removed.

Masking Techniques

It is quite possible to use the airbrush freehand most of the time; but it is often more convenient and accurate to use masking. In fact, probably around 90 per cent of all airbrush work involves masking for optimum effect and efficient use of time. You will need a good stock of the usual drawing equipment, such as T-squares, French curves, etc., to make your mask cutting as easy and accurate as possible; we also recommend a surgical scalpel as the best mask cutter, although there are a range of proprietary tools on the market, including curve cutters. As for the masking itself, there are several types which are explained and illustrated below.

Liquid masking

Liquid masking is described in chapter 3 (page 76). It is mainly used as an aid to photo retouching and modelling, and it is therefore discussed in more detail in those sections. It is cumbersome and sometimes difficult to use, as it often does not easily come away from the surface onto which it has been painted.

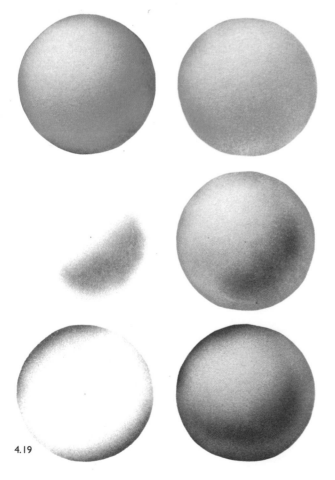

4.19

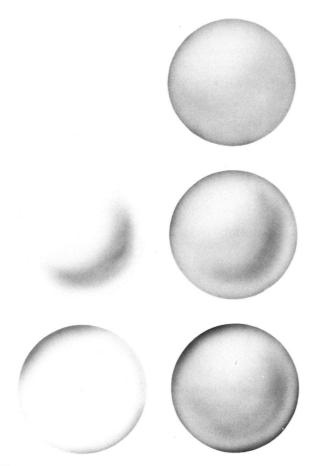

4.20
Film masking

Friskets
Modern proprietary masking film is effective enough to have made frisket masking redundant for most applications. However, there are those who stick by it, and just about all the in-print instruction manuals on the airbrush recommend it. Basically, frisket making involves painting a masking fluid – a liquid masking similar to the type mentioned above – onto a masking sheet, letting it dry, and then removing it as film. Apart from being a messy and inconvenient procedure, it has definite drawbacks: in particular, it tends to leave odd traces of film behind on the ground after it has been pulled off. It is therefore necessary to check over the surface before spraying.

Another method of masking is to use celluloid, weighted down with coins, rather than attached to the ground. While this obviates one problem, it engenders others. For instance, you are confined to a horizontal surface and have to avoid the obstacles made by the coins when airbrushing (4.21). This method, therefore, is not recommended for general usage.

Modern films are convenient and easy to use, as well as being quick – hence we will concentrate on these. They fall into two basic categories – for smooth surfaces, and for rough or textured surfaces.

4.21
Masking film for smooth surfaces
If you are working on a flat, smooth ground, then the best masking to buy is the proprietary airbrush masking film. This is low tack, and holds itself onto the ground largely by static electricity. If there is adhesive on it, it leaves no trace on even the most delicate surface. It is transparent and comes with a white backing sheet.

For rough surfaces
By 'rough' we mean those surfaces that are not smooth and completely flat, such as canvas, a curved or textured surface, or those with a gloss finish that sometimes resists and for this we recommend library book covering film. This can be obtained as a transparent film on a white backing – though there are alternatives, such as patterned film! This kind of masking is higher tack, and contains adhesive, although it does not leave the adhesive behind on the ground. Should you be worried about this, however, dip some cotton wool in white spirit and wipe it very lightly across your ground when dry and any remaining adhesive will come away. Be careful when you wipe – white spirit is also quite efficient at removing paint!

Care of masking film
It is worth treating all masking films with some respect, both in storage and usage. They should not be stuck down too forcefully onto the ground, certainly not burnished

down, because they may disturb the surface underneath, or remove previous coats of paint. Equally, if in the process of airbrushing you lean hard on the masking once it is in position, the same results may follow. Masking films should also be kept away from direct sunlight or direct heat, as they bubble or peel at the edges, and have then to be discarded (4.22).

4.22

4.23

Applying film masking

There are one or two points to remember about the application of masking to the ground. As an airbrush spray spreads beyond the main stream of its flow, it is important not to allow the spray to spatter past the outside edge of the masking, and so affect unwanted areas. This only happens when the masking is too small for the particular job. There are two main remedies: either cut your masking larger than the artwork – a wasteful and expensive tactic with large work; or cut a smaller piece of masking, and improvise as follows (4.23). Put the film's backing paper (or newspaper) round the outer edges of

the masking, so that its effective area is substantially increased. Stick it in place under the edges of the film masking. It is simple then to stick the outer edges of the 'extra masking' with adhesive tape, around the margin of the ground. It is imperative not to attach adhesive tape to the in-use ground, as it may have high enough tack to lift some of the painted surface away when it is removed.

Mask-Cutting Strategy

In many pieces of airbrush artwork, the cutting of the masks is the most skilful part of the whole procedure. It is not just the wielding of the scalpel; to airbrush with masking necessitates thinking in advance. You may incur great expense providing masks for each area to be masked off – complicated artwork can require a lot of masks!

There are several better options. Occasionally you can use one mask for two or more 'holes'; in this case you simply attach the sheet of film to the ground, and cut the required areas. When you are airbrushing one of the holes, the others must be covered up with something such as a loose sheet of paper. It is important to cut all the area you need before you spray over the masking for the first time. If you make any cuts after the first spray, you give yourself two problems: first, the medium already on the masking from the first spray may obscure, partially or wholly, the area you wish to cut next. If you cannot see through the mask, it is very difficult to cut the mask accurately! Secondly, most media dry very slowly on the smooth and impervious surface of a mask, so that if you subsequently try to cut the mask in another place, you will end up with the medium all over your hands, which will then probably spread to areas, such as the ground, where it can be disastrous. The scalpel may even push colour through to the ground, giving the new area a wet outline.

One possible tactic is to cut two adjacent areas. If you remove one and spray, and then remove the other and spray again, you get one area light and another dark, from the same mask. If you have used two colours, you get a colour mix.

Separate masks, straightforward though they sound, are time-consuming and occasionally pose problems of their own. If, for instance, you have sprayed one area in a particular colour, and are using a separate mask to spray a related tone near it, you may run into difficulties matching them up. The reason for this is that the spraying of the second area will inevitably spill over onto the mask, and most probably obscure the area you are trying to match it with. The overspill onto the mask spreads a surprising distance. Experience counts here – exact matches often have to be judged instinctively. You can, however, make things easier by spraying each colour on a separate card, so that you can find a match from the card, rather than on the ground under a mask. But do not be discouraged if at first you are not adept at working out how best to arrange

masking – it is a difficult art, acquired only through practice. Calculating the logic of it is often not easy, but will repay the effort both in time and expense.

Mask cutting

You cannot overestimate the value of a very sharp knife. We have recommended a surgeon's scalpel with disposable blades – easily sharp enough, so long as the blades are replaced regularly. You will know if you should have replaced one and have not when the masking you are delicately incising tears instead of coming away cleanly (4.24). Blades can be rehoned with a sharpening stone, but new ones are easily available. Surgeon's scalpels are flexible and versatile.

4.24

The knack of masking is to cut the mask cleanly once it is fixed to the ground, without cutting the ground itself. As many films are thicker than a paper surface, this can require a skilled hand. The cut must be definite and clean. It is not satisfactory to tear the last bits away; this can disturb the rest of the masking, it may damage the ground underneath, and it may still come away ragged. It is possible to overlap layers of masking on a ground. Therefore, you will need to increase the pressure when you cut.

The technique of mask cutting is closest to that of freehand line drawing done with a pencil. The strokes must be definite, confident and precise. If they are not firm enough, and you have to score over them again, you may get an unsatisfactory edge. If you are cutting a curve, remember the curve cutter, a tool with a versatile blade point. The point moves with the curve, and saves the user shifting the balance of the blade part way through. Do not worry if at first you cut past the edges of your lines, or end up with jagged curves. Eventually it will become second nature to draw a firm, light stroke across masking.

It is worth noting that you can produce good artwork if you are a good cutter of masks, though a mediocre airbrusher. It is, however, almost impossible to produce good masked work if you are a bad cutter and an excellent airbrusher.

Raised masking

We have dealt only with masking fixed to the surface of the ground. This will provide you with good, crisp edges to your artwork. But if you want a softer-edged effect, it is best to go for raised masking. Pre-cut card is quite adequate, and some people even use their hands; in fact, almost anything – card, paper, etc. will do as a raised mask – it must simply obstruct the spray (4.25). The technique is

4.25

4.26

4.25-6 The group of raised masking above was used to produce this simple mountainscape below.

simple: hold the mask at a convenient distance from the ground, and spray as usual. It is worth experimenting to see how versatile this method is, and to know how far away raised masking needs to be for certain effects.

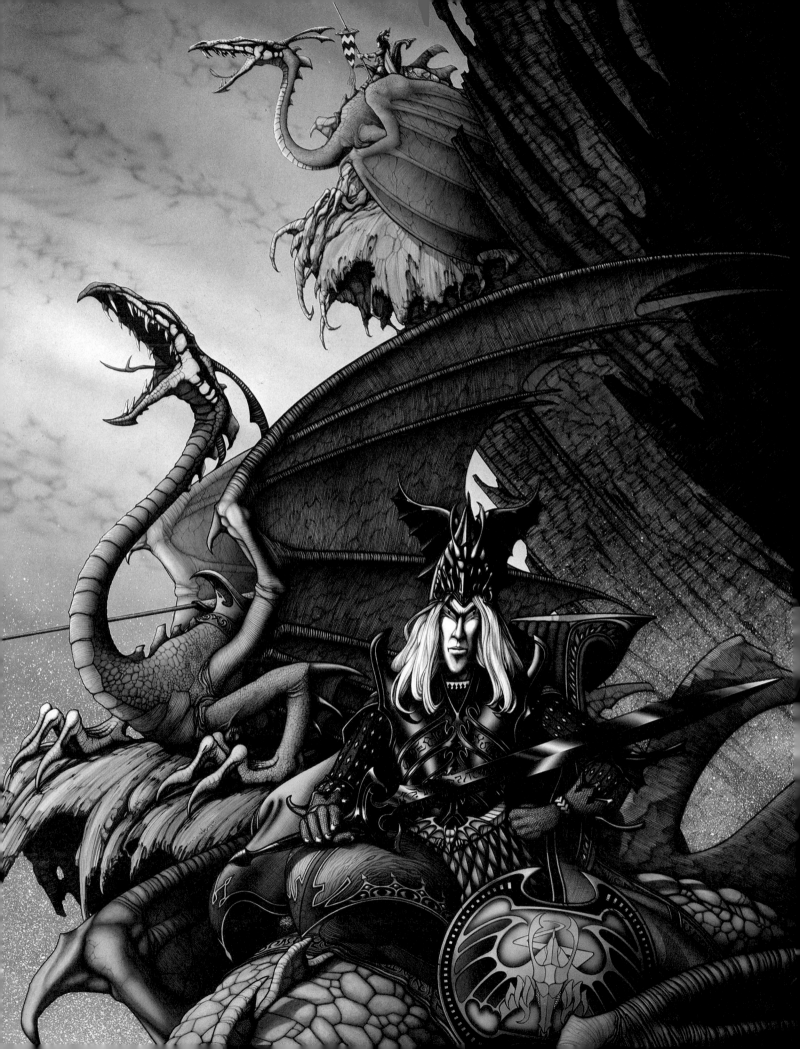

Chapter 5
Simple Techniques

This chapter contains simple exercises, which gradually increase in complexity, in airbrush use and masking. On each occasion, a piece of artwork is built up, using relatively straightforward methods, to achieve an impressive and apparently complicated whole. The devices demonstrated here form part of the accepted 'language' of airbrush work, and are usually the conventional means to tackle a project. However, at no stage do we suggest that the way proposed is the only, or necessarily the 'right' way to do it. Often, there is no such thing as the right way. It is up to the artist at all times to look hard at his subject – this is particularly true in figurative contexts – and deduce for himself the most suitable method. Our aim is primarily to supply the process for the artist to make that decision, not to teach him certain set ways.

5.1

Two-Dimensional Approaches

This refers to any work on a flat ground and is primarily used in illustration for textured or shaded backgrounds, which can be interesting but unobtrusive, and are often overlaid with cels (such as in animation), or painted over. They usually take the form of a faded wash, without the often undesirable effect of a brush texture, and are ideal for product advertising, for example, where the product must catch the eye and stand out from its background.

Simple background work

The illusion of setting something in a location is simple to create. Mask off the bottom half of the ground (with a raised piece of card – don't bother with masking film), and spray the remaining area blue, in a wash. Then mask off the top area, and spray the rest yellow, also in a wash (5.1). You now have a beach. If you were to spray in a little shadow, and place a drawing on a cel over the top – such as a pineapple – you would have the vivid image of a pineapple standing on a sandy beach (5.2). This is a

Left: Rodney Matthews, illustration entitled Dragon Lord.

5.2

delightfully simple technique, often used to achieve impressive results. And it takes very little skill and is singularly effective.

Overspray (and underspray) for specific effects
Various textures can be achieved by techniques of under- and over-painting. For the addition of shadow, or a reflective sheen on, for example, a rectangular package, mask out those areas for which the textural effect is undesirable, and spray freehand any additions you want.

For windows and glass, where the airbrush is often used to add or alter reflections, this method works well (5.3). Firstly, paint the scene visible through the window with a handbrush, then overspray with an opaque colour to provide the effect of glass. If you are working in colour, a pale pastel is usually best for overspraying highlights; if in black and white, then a white, or a fairly light grey. An analogous method produces the effect of other sorts of glass such as goldfish bowls. Brushpaint the reflected scene, and overspray with a pale colour. Reflections in water can also be effected successfully using the same procedure.

Simple trompe-l'oeil effect
The following device was here used to enliven the cover of a promotional booklet, which would otherwise have been drab and ineffective. Were you to turn to the centre page of the booklet you would see the entire photograph featured on the front. An airbrushed 'folded back page' is added on the cover to give the false impression that the page has already been turned (5.4).

The corner of a copy of the centrefold photograph is firstly stuck in position on the bottom right corner of the cover, and a sheet of masking laid over the whole image. The outline made by the photo and the pre-drawn turned-back page is cut out, but the only piece initially removed is the corner formed by the shadow of the turned page curling back on itself; this is sprayed. The rest of the masking is then removed, and a freehand line is sprayed at the line of fold, where the folded page meets the diagonal edge of the photograph. This spills over somewhat, creating an imprecise impression of shadow.

5.3 Buckminster Fuller. An example of the overspray technique applied to a photograph of New York.

5.3

Stone block

This is a more complicated kind of background, and useful for overpainting with figures to create a kind of hieroglyphic effect. The stone is initially drawn in outline, and completely masked. It is cut in two strips: the major area, comprising all but a thin strip up the left side and along the top of the stone, and the remaining strip. The major mask is removed, and the area sprayed in two colours, grey and brown. The other mask is then taken away, and the whole stone sprayed in two other colours, blue and yellow, until a satisfactory subtlety of colour and texture is built up. When the outside masking is removed, and the figures brushpainted in tempera on top, the effect is that of a textured and coloured stone, with foreground figures standing out (5.9).

Set of steps

The method for spraying these steps is simple and repetitive. Here the outline is drawn, and the whole area masked out. Each step is then cut individually, and the mask covering the bottom step removed. A line is sprayed along the bottom edge of the step (5.6), so that overspill falls on the rest of it (see Chapter 4, exercise 9i); the mask is then peeled away from the second step (5.7), a piece of card is held to prevent overspill onto the bottom step, and a line is drawn along the base of the higher step (5.8). This process – spraying the bottom of each step individually, and then covering it up against overspill from the next one being sprayed – is continued right to the top (5.5). Once there, it may be necessary to spray a wash over the whole area of the steps to obtain a uniform depth of colour.

5.4

5.5

5.6

5.7

5.8

5.9

Lettering effects

Stencil (5.10) This is a simple effect; the whole ground is masked out, and the shape of the letters cut out – in effect, a stencil is made. Broad strokes are then sprayed at a diagonal angle from several inches away; this creates a glossy effect popular in magazine advertisements.

Fade (5.11) The letters are cut out from a mask to make a stencil, as above in 5.10. A faded wash is sprayed over the whole area, fading from the left, and a new effect appears.

Fast (5.12) For ease, the letters are this time applied with a handbrush. The whole area is then masked, and a wide parallelogram cut and removed at the left of the first letter. A wash fading from right to left is then sprayed, to achieve an effect of speed. Devices such as these may be simple, but they are valuable for graphics applications such as advertising and display work.

Graffiti (5.13) Here is an occasion where airbrushing comes into its own as foreground against a drawn background – the reverse of earlier examples. Again, it is simple: the bricks are first drawn with a pen, and the word 'graffiti' written across it freehand.
A slightly more interesting variation is to mask the whole area. The shapes of the bricks are then cut and removed, leaving a very fragile mask. A faded wash is sprayed over the wall to define the bricks. Lastly the word is written freehand, as above (5.14).

5.10

5.11

5.12

5.13

5.14

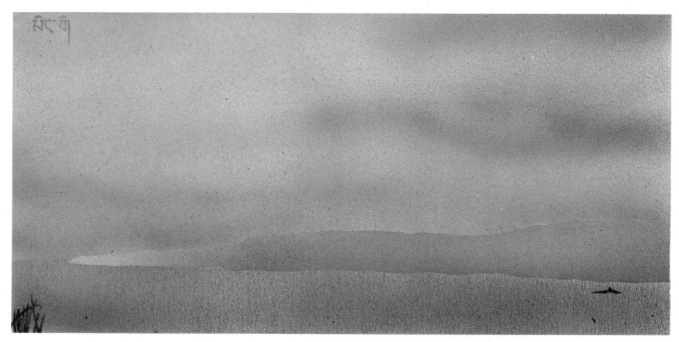

5.15

Integrated backgrounds and foregrounds

Landscape (5.15) This technique is an extension of the method used in the pineapple illustration (5.2). The estuary is drawn in first, and then the area above the horizon is washed in a sky colour, using card masking to prevent overspill into the lower half. The sky is then masked with the card, and the water sprayed in; each wash is applied a little more strongly than the finished effect, bearing in mind that they will all be sprayed over again. The landscape is then brushpainted, and the whole picture gently oversprayed white, to create a unified effect.

Townscape (5.16) The design is again drawn on first, but this time clouds are brushpainted in and airbrushed over until the brushstrokes are lost and a fluffy texture achieved. The most distant item is then brushpainted, and the whole picture gently oversprayed white, to create a unified effect. The next furthermost item is brushpainted, and the whole picture oversprayed white again; this process is repeated, gradually moving up to the foreground, until the whole picture is painted. One final overspray in white is added to preserve tonal unity, and the townscape is complete. When overspraying, some washes may fade as the artist thinks necessary, to vary or retain colour tones underneath.

Airbrushed foreground (5.27) this time the background – the table, ashtray, wall, floor and cigarette – is brushpainted first; the cigarette smoke is then added freehand with an airbrush. It is necessary to work up from the cigarette, gradually operating the instrument further away from the ground, to achieve the effect of the smoke wafting. This has to be done lightly and with care so as not

5.15 Seng-gye, Black Rock and Gold Cliff, Severn Estuary, May late evening *(1976) acrylic on board, 16 x 30in (35 x 76cm)*

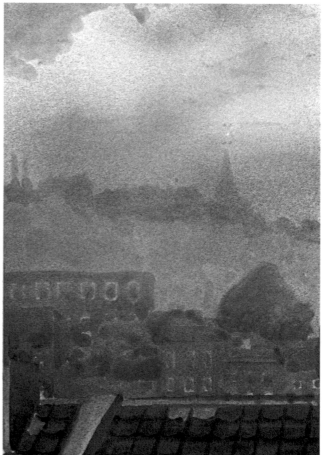

5.16

95

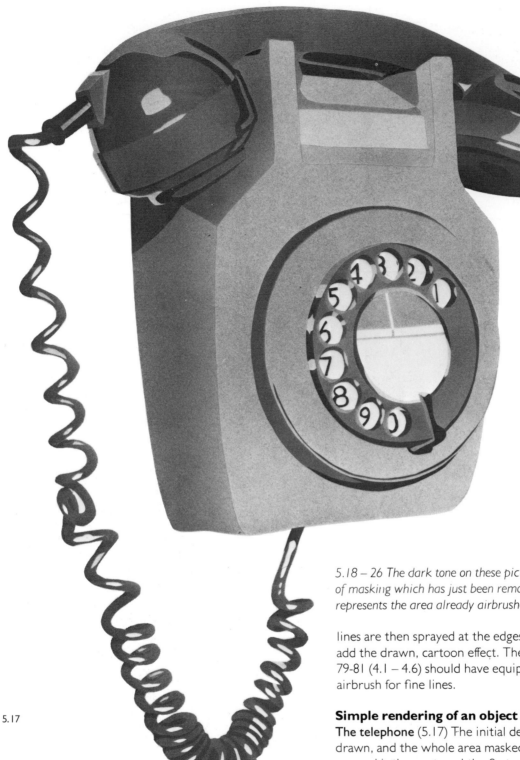

5.17

5.18 – 26 The dark tone on these pictures represents the area of masking which has just been removed. The paler tone represents the area already airbrushed.

lines are then sprayed at the edges of each colour space, to add the drawn, cartoon effect. The line exercises on pages 79-81 (4.1 – 4.6) should have equipped you to use an airbrush for fine lines.

Simple rendering of an object in two dimensions
The telephone (5.17) The initial design is carefully line-drawn, and the whole area masked out. Every area to be sprayed is then cut, and the first set removed for spraying (5.18). These sections will eventually come out darkest, as they are to be oversprayed most often. The second set is then unmasked and sprayed, with spillover landing on the first set as well (5.19); then the third, and so on until the whole area to be sprayed is exposed (5.26). The telephone pictured here took nine stages – so there are nine different graduations of tone in all; but it was done with only one mask.

to obscure the background unduly. The lettering is added last, spelling out the poster's message.

Line drawing – cartoon style effects (5.28) The pop-art style cartoon blow-up is impressive, and quite simple. The flat colours are initially painted in with a handbrush; fine

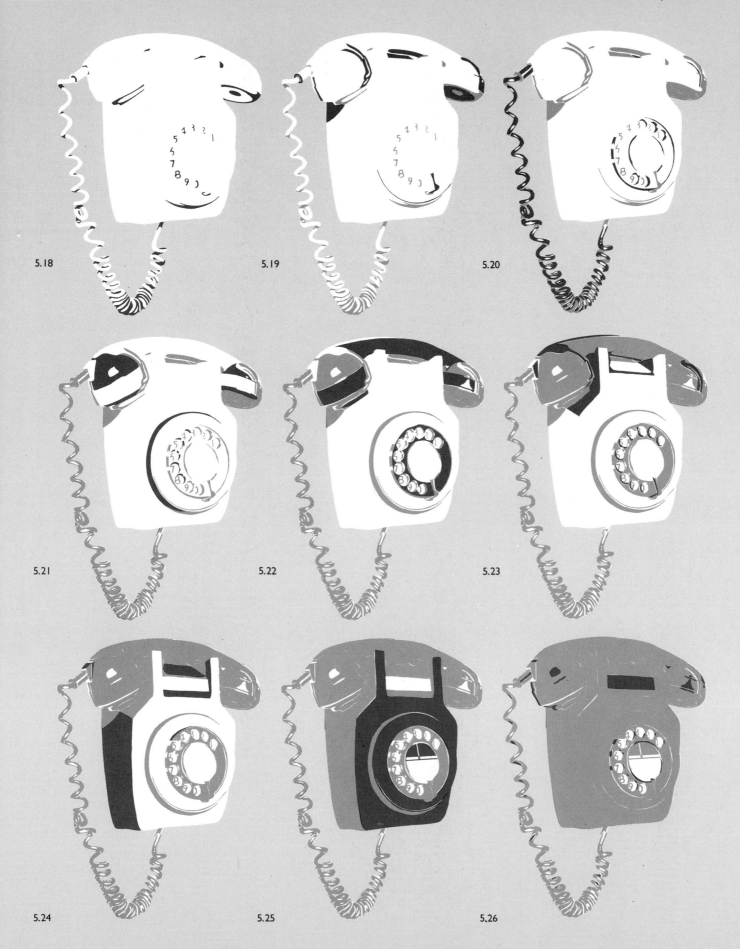

5.18

5.19

5.20

5.21

5.22

5.23

5.24

5.25

5.26

5.27

5.28

5.28 Seng-gye, OUF!' (1972)
acrylic and gold leaf on canvas, 20 x 30in (51 x 76cm)

A figure (5.33) This is effected in the same way as the telephone, except for one additional technique. A flap is cut and pulled back inside an area of masking about to be removed; the tip of the area thus exposed is lightly sprayed (5.29), and then the whole area of masking removed for spraying (5.30-31). The effect thus gained is of a darker fold, blending in softly with the area around it and leaving no unwanted hard edges (5.32). In places, such as the foot, there is some freehand spraying within the area defined by the mask, to improve the definition of the shaping.

5.29

5.30

5.31

5.32

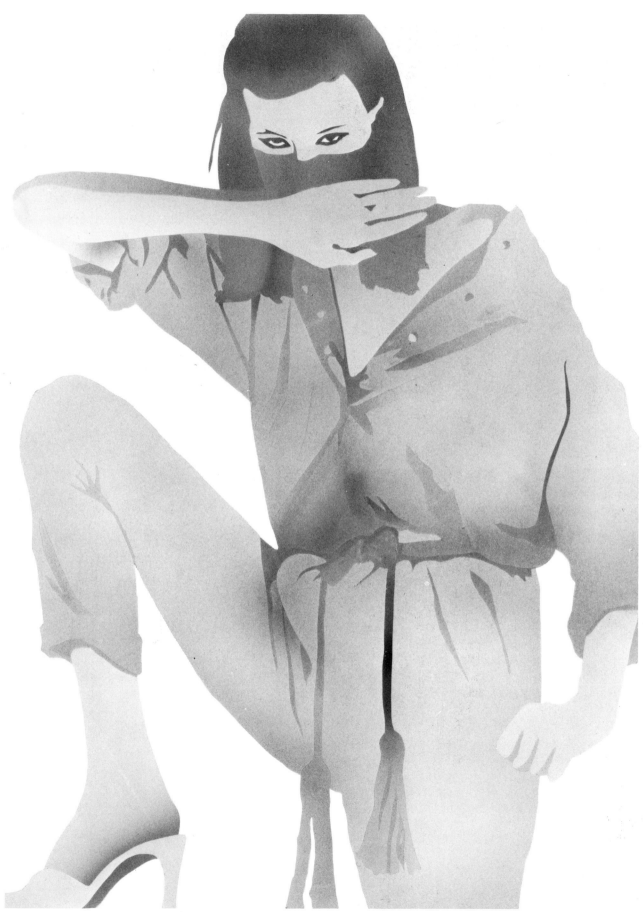

5.33

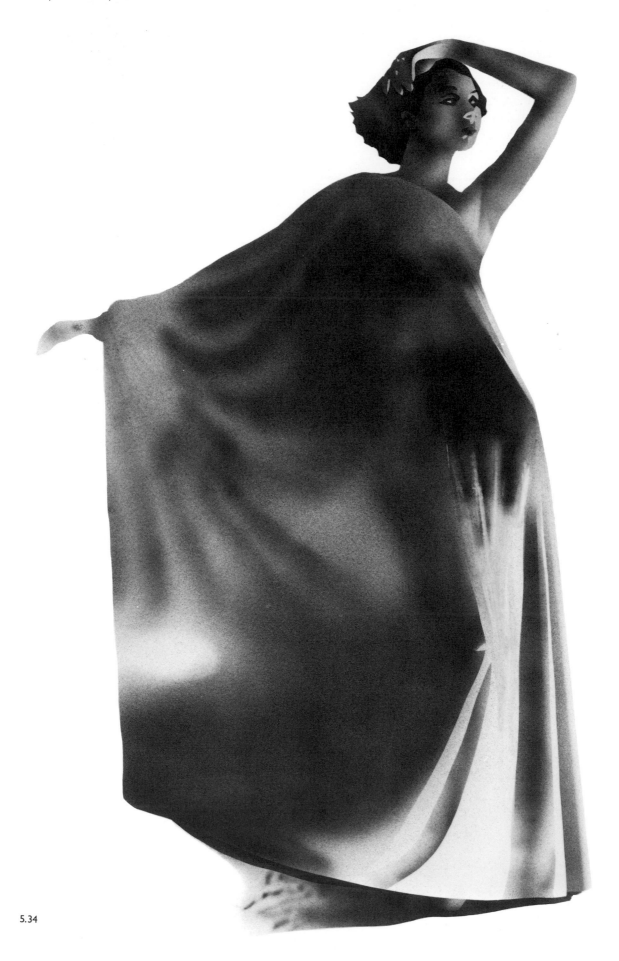

5.34

Second figure (5.34) This figure is effected in a similar way, except that the airbrush is used far more extensively freehand within the area of a mask. A new subtlety is therefore introduced: one area to be sprayed is given a split mask, one half of the mask is removed, and a short line is sprayed at the edge made with the second half of the mask (5.35). The half is then removed (5.36), and the whole area sprayed normally (5.37); the result is a hard line within one tonal area (5.38).

Other familiar masking techniques are also used. Card masking is introduced at the armpit and the outside fold of the dress; and soft masking (here a thumb) creates the highlight on the garment's side. A wet cotton swab can be used on the dress to remove ink, at the last adjustment stage.

If any of the above techniques are to be used for an artwork for reproduction, there are extra factors to be considered. If it is to be reproduced on a coarse screen, as for newsprint, then there is very little advantage in using the airbrush over a handbrush; if the screen is fine, then a difference will be noticed.

As has been mentioned above, crude methods of reproduction do not warrant subtlety of colour. Most of the subtlety will be lost in the process, and the end result will look dowdy. The airbrush is a very fine instrument, and can atomize paint to a fineness beyond the limits of many printing methods. So the general rule is to work simply and boldly with the airbrush for reproduction; more boldly than you want the end result to be – the printing will soften the effect.

Layouts

If you do not have much time, and want to produce a finished effect, then most of the above methods can be used; a little masking is required, but most of it should be simple. If you use the airbrush sparsely and cleanly good results can be quickly obtained.

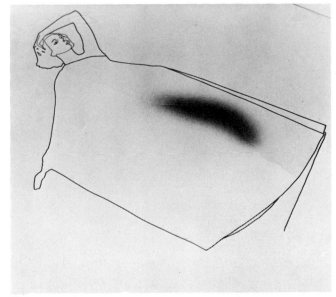

5.35

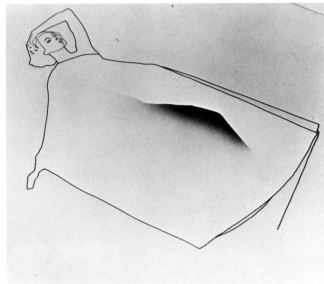

5.36

5.37

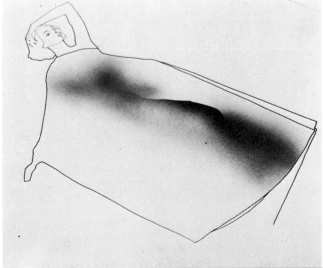

5.38

5.39

Three-Dimensional Approaches

In general, airbrushing in three dimensions is less complicated than working in two. There are bigger problems with masking but less masking to apply. In most cases you do not need the same degree of colour subtlety; usually no shadows are necessary, for instance. However, there are several points to take note of, the first is relevant when you come to set up the studio. The initial problem is that you will not necessarily be spraying towards such a flat, well-defined ground as before; usually your surface will be curved and irregular, so when you use the airbrush, a lot more spray will miss the object. Be careful to clear the working area of unwanted material. Secondly, the effect of hairs or fluff on, for example, the surface of a model plane or train will ruin the effect. A vertical ground such as canvas picks up less dust than a three-dimensional surface. It is therefore even more important that you spray in dust-free conditions, particularly for the plastic- and enamel-based paints which pick up dust more easily.

Airbrushing a three-dimensional object is often less complicated; unless you are intending to achieve an effect of heightened illusion, you do not need to worry about shadows. The shapes you paint are defined by the actual object; for clarity the rule is to keep it simple. If you want a highlight, don't paint it in as you would with a piece of flat artwork – light it that way, when it is in position. This is particularly relevant when the object is to be photographed and reproduced: lighting can be experimented with, and is much more versatile than a painted highlight.

When the three-dimensional object itself will be seen, rather than a photograph of it, then subtle shading can alter shape, or compensate for poor modelling. But if this is taken too far, the results will look absurd. Normally the task is relatively simple; the only technical point to remember is to mix enough paint, or to use a standard enough colour to enable you to spray all sides of the object without colour change.

With the exception of surfaces such as car panelling, which for these purposes can be regarded as a curved two-dimensional ground, it is often not possible to use contact masking. The best that can be done is to hold up an obstacle to the paint – a hand or a card – as near to the surface as possible; this will result in soft edges. Such items as a rose effected in icing cannot be masked at all.

Wherever possible when spraying curved surfaces, it is best to try to follow the curve with your hand, keeping the airbrush at an equal distance from the ground. Experimentation with the airbrush is always worthwhile, and can come up with some interesting effects. Highlights and shadows can be added, not only for realism, but to alter the shape of the object itself, such as giving it a sharper or rounder appearance. These gross effects can create good illusions, but tend only to be effective from one viewing angle – if viewed from more than one point, the trick becomes evident. When such objects are to be reproduced in two dimensions, there is no problem.

Extreme subtlety can, however, be applied on some objects – for instance to add shadings in such a way that they appear as natural indentations. The viewer does not suspect the device, and so reads the shading as a hollow.

Work for reproduction has already been mentioned; it must also be remembered that, as with two-dimensional techniques, colours must be exaggerated to counteract not only the loss in the printing processes, but also the observer's prior knowledge of the object and its textures. The latter is particularly true in the illustrated example of the box of fruit which is made up to like like candy (5.39). To prevent the viewer immediately recognizing them as fruit, they are sprayed more thoroughly than otherwise necessary. The method is quite simple: the apples are sprayed first, then the pears, then the grapes, etc., in bold pastel acrylic colours; next they are oversprayed with iridescent white, to give them their sugar candy appearance. They are then placed in a box, and photographed. The whole process is straightforward, but that does not mean it is quick; this box of fruit took eight hours to prepare.

Chapter 6
Advanced Techniques

This chapter discusses techniques for using masking beyond the simple stages described earlier and the logic of masking: which areas to mask off with each other, in what order, etc. Almost all that follows is concerned with film masking; there are just a few words first regarding liquid masking. There is also a section containing three sets of quite difficult exercises: mask cutting, painting using masking and freehand work.

Liquid masking

There are not many time-saving devices in this form of masking because liquid masking limits you to masking off one area at a time. The process is thus a gradual and straightforward building up of colour areas. Also, the single rule is to mask as little as possible over an area of finished paintwork.

Left: David Jackson, press advertisement.

Film masking

Edge blurring

To get a hard edge you normally direct your spray at an acute angle to the mask, and therefore an obtuse one to the ground. The pressure of air has an incidental extra function of helping push the masking more firmly down. If, however, you reverse the angle of spray so that it is obtuse to the mask, and acute to the ground to be painted, the air pressure tends to attack the hard edge of the masking by getting underneath it and fluttering it slightly. A blurred edge (6.1) can thus be achieved by combining increased air pressure with decreased paint flow, sprayed at the edge of the masking at an obtuse angle to it (6.2). A slight fade then results under the masking. If too much paint is applied, there is the danger of a blotch forming under the mask. It may be necessary to lift the mask edge gently with a thumbnail; test with air only, to ensure that flutter is occurring, before spraying with medium.

6.1

6.2

6.3

6.4

6.5

6.6

Variation in a line

It is possible to make a firm line soft in one place and then firm again. All you need do is introduce an air bubble at the edge of the masking – this can be done by crinkling the masking slightly as it is applied (6.3). Where the bubble is, the edge will be soft, since the masking is away from the ground, and hence loose at that point.

If you are faced with two almost adjacent colour areas, which you want to fade into each other and meet at one point, the same technique can be applied. Place a thin strip of masking at the borders of the two areas concerned and make your bubble again, but this time it should bubble right through the strip, from one edge to the other (6.4). The masking will then resemble a humpback bridge. When you come to spray each area the paint will fade under this 'bridge', so that the two areas can fade into each other there. Elsewhere, the hard masking will keep them apart in well-defined edges (6.5). For these effects, it is best to aim the spray at a slightly acute angle to the bubble; the spillover will cause the desired fade.

Simple masking economy

There is little point in prising off small pieces of masking from a ground to be used again, whether in the same shape or re-cut. Film masking stretches, distorts, and sticks to itself as it is removed. Nor is it usually worthwhile to use a piece of masking cut out and removed before spraying. If, for instance, a sheet of masking is fixed to a ground and a circle cut and removed (so that a circle can be sprayed), you should not subsequently use the circular piece of masking to colour all the rest of the ground. Often the second mask (in our case the circle) needs to be slightly smaller than that originally cut, to ensure that when the ground is sprayed, the edge made with the circle already painted on the ground is adequately covered, or a little overlapped. Otherwise, with bad luck, a tiny unpainted area can result. There are other dangers too: distortion can easily occur in the mask when it is being cut; the second (circular) mask will lose tack, as it has already been stuck to the ground once, before it was cut out, and while being positioned; if the second mask is at all complex or difficult, it will probably have been removed in sections, and thus be unusable. If in our example the artist wanted to cover all the ground except for the circle already painted, plus another small area, another sheet of masking would be necessary.

So the rule is do not re-use masking. The only exception is when a large unused section has been removed whole; a smaller mask can be cut from it if it is immediately put back onto its backing paper.

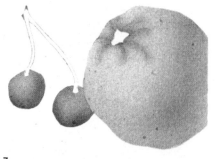

6.7 6.8 6.9

6.10

6.10 Overlays: transparent at top; opaque beneath.

You do not, of course, have to use all the unmasked ground a piece of masking offers. If a circle is left blank to be painted, you can paint in a semicircle, or a smaller design, freehand. Masking does not always fully define the area to be sprayed (6.6).

The logic of masking

Film is expensive, and using several sheets to cover large areas, exposing tiny details to the spray, can be a daunting and prohibitive practice. Also repeatedly masking and cutting is time-consuming; any savings that can be made are welcome. Remember also that by about the third cut on the same edge, the ground beneath has weakened considerably; another reason to keep cuts to a minimum. The turtle (below, 6.11) was wholly airbrushed and yet

required only eight masks altogether.

The first, vital distinction that must be understood – and it is the crux of the whole approach to masking which follows – is between what we may define as masking positively, and masking negatively. In the former case you mask out an area of the ground in order to spray the rest; a positive step in building up colour in your artwork. To mask negatively, however, you mask out an area in order to leave it unpainted; masking in order *not* to spray.

In practice, you will probably have done exactly the same thing: masked out one section, and sprayed the rest. But the difference between the two becomes extremely important at an early stage in the creation of the artwork, in deciding well in advance how many masks you need, and what areas to mask out with which other areas.

Leaving a section of a painting blank throughout the majority of stages in the building up of colour can be a valuable strategy. Often a design has been drawn straight onto the ground, and it can sometimes be useful to preserve it, particularly if it is intricate and precise. Airbrushing over it at a preliminary stage, before it has been properly developed, can be very frustrating. Also, with inks you cannot build up layers of colours with the abandon that you sometimes can with opaque colour. If you have a magenta area, and spray it turquoise over the top, they will mix, rather than one asserting itself (6.10).

6.11 Seng-gye, Untitled (1976)
oil on canvas, 24 x 66in (61 x 168cm)

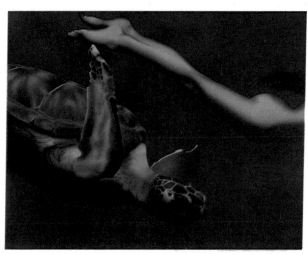

6.11

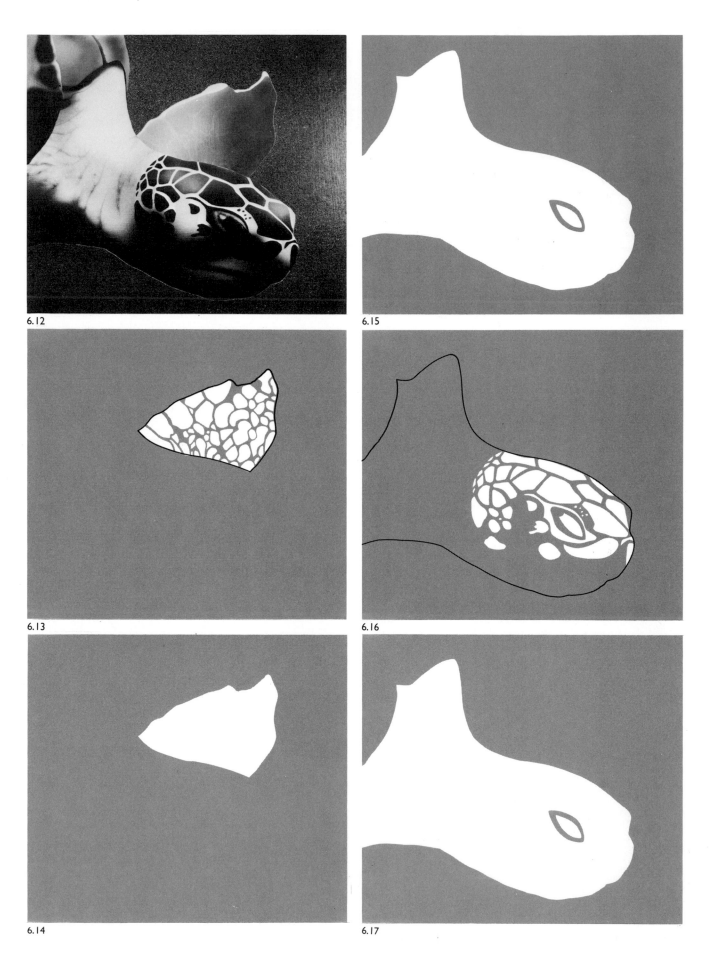

6.12

6.15

6.13

6.16

6.14

6.17

In addition to the one main distinction, there are three more practical factors to bear in mind.

Saving the mixing of paints

This can be achieved precisely because the colours will mix on the ground, as indicated above. So an area that comprises a red section adjacent to an orange section, which itself is adjacent to a yellow section, can be sprayed using two masks and two colours instead of three. Simply mask out the red section, and spray the other two areas yellow (6.7). Remove the masking, mask out the yellow section, and spray the other two areas red (6.8). The middle area will be orange (6.9).

Consideration of the foreground

If, for instance, you wish to paint a mountain with grasses in front of it, the mountain should be sprayed first. The background should normally be built up before the foreground, particularly when the object in the foreground is to be sprayed on top of the background. Otherwise, the grasses would be obscured a little by the mountain, and the definition of distance would be confused.

Of course, you might have a painting with the same mountain and grasses, but also a bird in the sky. In this case the sky would be sprayed first but both the mountain and the bird could, if desired, be sprayed together, as they are both in front of the sky. The same mask could be used for both, and the same colours used, or not, as desired.

The distance relationship

In the painting with the bird and mountain described above, the reason that the same mask can be used for both features is that they are some distance from each other on the actual ground – and therefore there is not the same risk of overspill that can occur on one area when you spray another. Had the bird and the mountain been close together, the only way to spray them both on the same mask would have been to cover one area while the other was sprayed, or else to spray them the same colour so that overspill would not show.

Applications

There are some simple applications of these points of logic. The partial obscuring of a detail can be effected as implied above. If we look at the turtle painting (6.11), we notice the spots on one of the turtle's flippers (6.12). These are textured as follows: the flipper is masked out,

6.12-17 demonstrates the logic of cutting mask shapes to achieve the effects on the turtle's flipper and head. The mask for the flipper was cut to shape (6.13) and when the contour lines were removed, the second stage (6.14) was sprayed to give shade and texture (6.12). After cutting the first mask for the head (6.15), the second mask for the head was treated in the same way (6.16-17).

with holes removed for the spots, and then sprayed boldly (6.13). The masking is removed and the whole flipper sprayed (6.14); the spots recede somewhat and are partially obscured. Overspraying the spots alters their colour, so this has to be planned for in advance. It has to be remembered that what is originally painted strongly will look weak when finally oversprayed.

This leads to a further technique, useful for work which is not for reproduction. If you are using a thick medium such as oil or acrylic, a 'creased' texture can be built up. The spots on the turtle's flipper, for instance, could easily be made to stand out in relief, though have no separate colour. In this instance the spots are sprayed heavily as before, allowing them to partly set, but the whole flipper is oversprayed so strongly that the colour of the spots is lost. The flipper is then of one colour, with the spots in relief.

The highlighting of a slightly more complex area demonstrates the logic of good masking. Consider the head of the turtle, its markings, and the surrounding sea. In order to spray the markings without fully obscuring them, as was done with the flipper, the following method is used. The sea is masked out, and the head sprayed its basic colour (6.15). The mask is then removed, and a new one placed over the whole area; this time the spots and the outline of the head are both cut out, but only the markings removed (6.16). They are then sprayed dark; the rest of the masking cut is removed, and the major shadow sprayed freehand (6.17); the remaining masking, now covering only the sea, is finally removed. This process does not occur in isolation, of course; the rest of the painting is also being built up at the same time.

You will perhaps notice that the masking covering the head can be removed directly after spraying the markings, while the paint is still wet. With oils especially, it is normally preferable to remove a piece of masking while the overspill on it is still wet. This may dirty the hands, but if the paint were allowed to dry, the mask might tug some of the dry paint off the ground itself, and the edges might flake. You should, of course, do all the cutting required on a mask before removing and spraying any area. Cutting a mask with overspill on it is a mucky, and, if the lines you want to cut are at all obscured, a hazardous procedure. When removing an irregular piece of masking, make sure that none of the edges of the mask falls back into wet paint on the ground.

One more point – when mixing paints, mix to waste. The logic of masking sometimes dictates that it is some days before you re-use a shade that has to match some other area; so mix enough first, and strain it all. Put what you do not use immediately into a container with a little thinner, and cover with cling film. Ideally the container should be almost full. Acrylics will keep for three to four days, oil paints considerably longer. When you come to re-use the paint, more thinner may have to be added, as some will have evaporated.

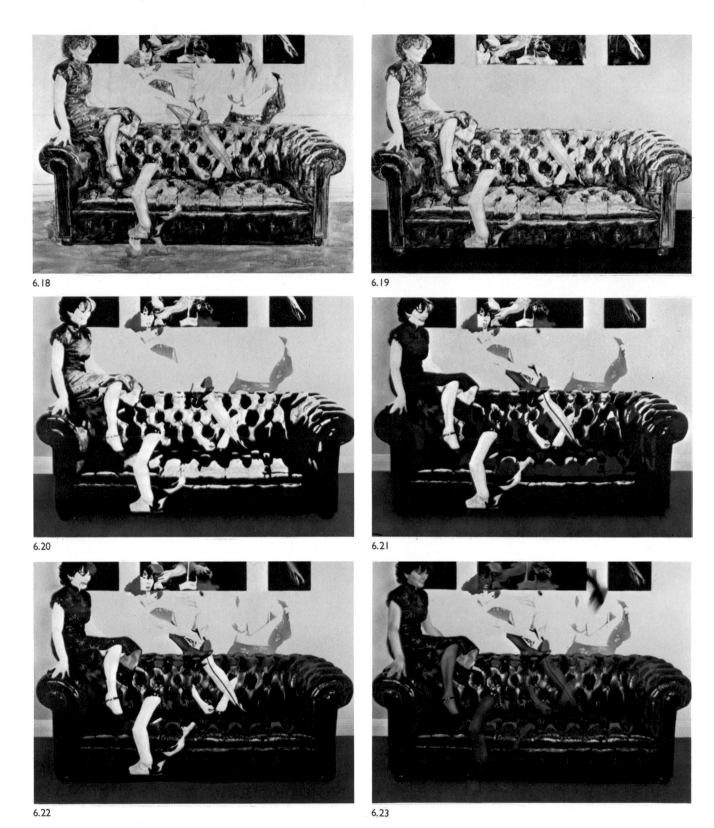

6.18
6.19
6.20
6.21
6.22
6.23

6.18-24 Illustrate the masking stages involved in the creation of a complex airbrushed painting. The underpainting (6.18) was broadly brushpainted. 6.19-24 Show the result through painting in each successive mask. In each stage some underpainting is replaced by more finished work to achieve the final result (6.24).

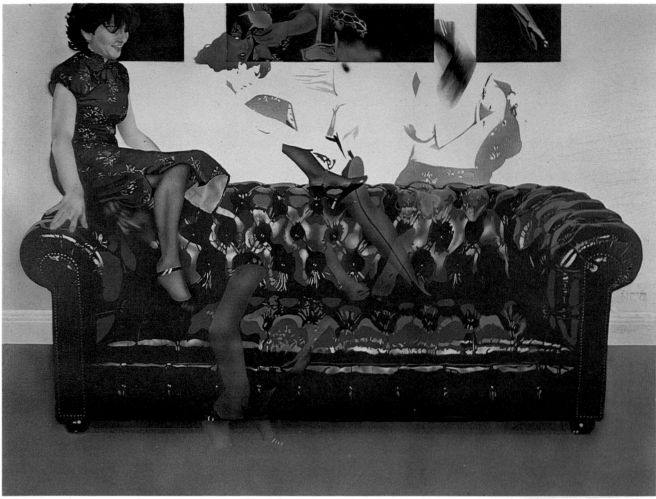

6.24

Washes

Some airbrush users go no further with the instrument than to lay on washes – either because they do not want to get involved at a more complex level, or because they don't like the effects an airbrush can achieve. In graphics and illustration, the airbrush is often used just for washes.

Washwork has a variety of functions: there is the wash and overglaze method, exemplified by the simple landscape on page 95 (5.15). The wash can replace brushpainted water-colour washes, where a saturated spray of a thin paint mixture is used. It can achieve a smooth layer of paint to work over in some thick medium such as oil – this sort of wash may eventually be totally obscured by the brush or airbrush overwork.

For bold airbrushed underwashes, where the overpainting contains the details of the artwork, it is advisable for both speed and convenience, to use cheaper sprays such as the powered mouth diffuser, rather than the fully fledged airbrush.

Large area washes, as described in exercise 5, page 81 (4.8), demand a surprising amount of control. They may be basic, but flat washes stand out by being patchy if not executed properly. Very little else shows up bad

6.24 Seng-gye, Untitled (1980)
acrylic on canvas, 36 x 48in (91 x 122cm)

technique so clearly. This is particularly unfortunate as background flat washes combined with brush foreground and detail result in some of the most comfortable combinations of the two instruments. The union is often so successful that it will not strike the casual observer that both have been used, the effect seems so natural.

Highlighting the line drawing (6.25) A simple wash, masking out the actual drawn forms, can be an effective way of highlighting the line drawing. A lightly airbrushed background, in a colour such as grey, can be used to throw the drawing into relief.

Abstract work

A faded airbrush wash will often create a smoother colour field than a brush, and can, in an abstract work, allow the observer to be more aware of colour itself. But in a hard-edged painting, using an opaque flat-colour paint, it is better to use the brush. The finished effect will be similar, but less work will be needed to achieve the same result than with the airbrush.

6.25

6.26

Unmixed colours

It is quite feasible to mix colours on the ground, laying them on unmixed, where they may or may not shift across the wash (6.27). The colours used should be laid on more faintly than desired for the finished effect, as the effect of overlays is cumulative. (This is not so with modular colours, where tonal values are fixed.) The mixing of colours on the ground achieves a delicate luminosity.

Step fading

If you need a wash that fades in definite stages, rather than gradually as with the normal faded wash, then masking is required (6.26). Apply a sheet of masking to the relevant area, and cut it so as to define the stages of the fade. Remove one 'strip' of masking, and spray. Now remove another and spray again. Continue until all the area is exposed. You now have a wash that fades in steps, with the area where the masking was first removed the strongest, and the area where the masking was last removed the lightest. If you don't want the stages to appear so crisply cut, simply use loose masking instead of film.

Tints, overlays and overglazing

These employ similar techniques and should be effected with the minimum possible masking. They are, after all,

additions after the event', extras rather than focal points in themselves. The use of masking gives them a far more definite presence than freehand work.

Tints The definition in this kind of artwork is achieved by the original line drawing. The colouring is simple, no shading is needed. The important part of the work is the drawing; the only help it can be given is the occasional light degree of fading which can suggest modelling, too delicate to be stated in the original drawing.

Overglazing The purpose of overglazing is not colouring, but the provision of a finish. Transparent paints should be used to create this unifying effect, but it is also possible to overglaze to lose certain aspects of the painted statement beneath.

Overlay (6.30) The airbrush can add an entirely new dimension to the possibilities of water-colour; this was, of course, Burdick's major goal in inventing the airbrush in the first place. Now you can add colour, and then paint over the top using an airbrush. One of the traditional limitations of water-colour has always been the impossibility of overpainting, as this might redissolve the paint underneath. The airbrush, in effect, opens up a whole new vista.

Freehand airbrushing
One immediate advantage freehand airbrushing has over masking is that the traditional methods of 'wet on wet' and 'wet on dry' can be applied at will, giving a full range of possibilities. Where you are hampered is in the creation of sharp lines: very fine details are feasible, but a handbrush or masking is required for lines. This can be unfortunate for fine art applications in particular, as such an alliance – where only tiny details have been handbrushed – tends to be an uneasy one.

Any large areas sprayed freehand are likely to have uncontrolled edges; so the traditional method of building up a painting layer by layer, refining it each time right up to the final details and glazes, is equally appropriate for the airbrush. For instance in laying out the formal areas, we suggest a rough block underpainting in acrylic effected by brush or spray-gun (6.31). As it will not be visible in the final painting, anything can be used, even a 4in (10cm) household brush! The work can then be sprayed stage by stage, each one involving the whole painted surface as you cannot complete a small area at a time (6.32). With each new layer the entire painting becomes more closely defined (6.33), a process which can lend spontaneity to the whole work (6.34).

Many car customizers, while aware of the necessity for a layer-by-layer approach, fail to carry the process through. A number of layers of spray are used to create a flat base coat, and the design is dusted in on top. Apparent depth is then provided by copious layers of lacquer, but that depth is phoney; the work looks ill-defined and inadequately developed. If mistakes have been made and then corrected, those areas are crisper than the rest of the work. The effect of depth should be created in the paint, with sufficient layers to build up the finished look that is required. Lacquer protects, and that is all it should be used for.

We have referred already to the 'delicate luminosity' of some airbrushwork. This tends to be created when working in colour, particularly freehand. The atomization of the paint achieves a more refined and adaptable result than the effects attempted, for example, by Seurat and the Pointillistes: they were inevitably restricted to a fairly stiff composition when they split light by applying dots with a brush. If you airbrush with colour, and allow it to mix on the canvas as you build it up in layers, you can work 'straight from the tube' (only thinning first) and therefore have the freedom to create smooth and relaxed gestures, with all the paint split into dots by the very nature of the technique. Effects can be created by laying very fine particles of colour across each other, dividing light in a manner undetectable to the eye.

This technique has unlooked-for side effects: one is the tendency to obscure form. By persistently reworking a painting, you inevitably run the risk of creating – on very close examination – an indeterminate surface where any strict, formal approach by the artist becomes obscured. This introduces a critical principle in fine art airbrushing: a new language of airbrushstrokes is required. It may sound obvious, but there is a different language of brushstrokes to be learned. In working with the handbrush, you tend to seek the details from which the whole is constructed in any particular aspect of the work. There are many more handbrushstrokes to a given area than there are airbrushstrokes. With airbrushwork, the overall impression is foremost; the process of construction through eloquent gestures, rather than the minute comments of the handbrush. This involves the artist in working in a more general manner and, paradoxically, in a more specific and precise way too. The artist can work more freely and spontaneously, but he must also be more controlled and disciplined. The painter has to establish a new repertoire of strokes appropriate to the airbrush – direct strokes, individual as handbrushstrokes are, but different in nature (6.35).

These new considerations vary from those applicable to the handbrush and they defy generalization. But the artist must be as conscious of light as of colour and the different effects caused by laying light over shadow and shadow over light. There is also the question of the viewer's distance from the painting: the effect of a clean distinction of light against dark from a distance of about 3ft (96cm), and a concomitant chiaroscuro effect of light blending into darkness that is inevitable on close examination. The feel and appearance of the work will alter depending on whether light is sprayed before shadow, or vice versa.

6.27

6.28

6.29

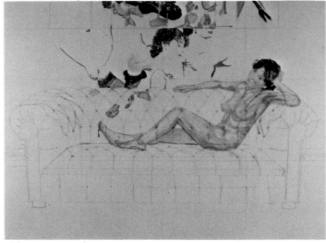

6.31

And, once this is decided, it is possible to minimize the chiaroscuro by defining a line as sharply as possible along the border of an area, and gradually working away from that line into broader strokes.

Apart from awareness of the differing demands of light and dark, the artist needs a knowledge of the possible uses of opaque or transparent paints, in media such as oil, alkyds or acrylic. The airbrush offers more scope here; opaque paints used very thinly in the airbrush can go almost semi-transparent.

As a rule you will probably find that the more layers you apply with the airbrush, the thinner they become. Underpainting can normally be effected with a spray-gun, using heavy layers of paint and laying down broad gestures; the heavier the coat of paint, the stronger the gesture in terms of the design on the ground. The airbrush requires a greater thinner-to-paint ratio than a powered mouth diffuser for example; hence as you work up to greater detail, replacing one instrument with the other, you come to be using thinner paint.

6.30 Airbrush water-colour overlays do not disturb previous layers of paint, as with a handbrush.

6.30

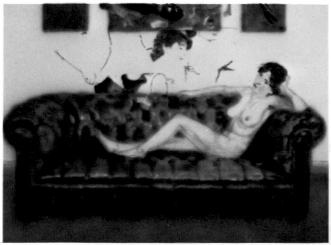

6.32

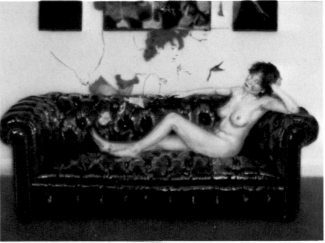

6.33

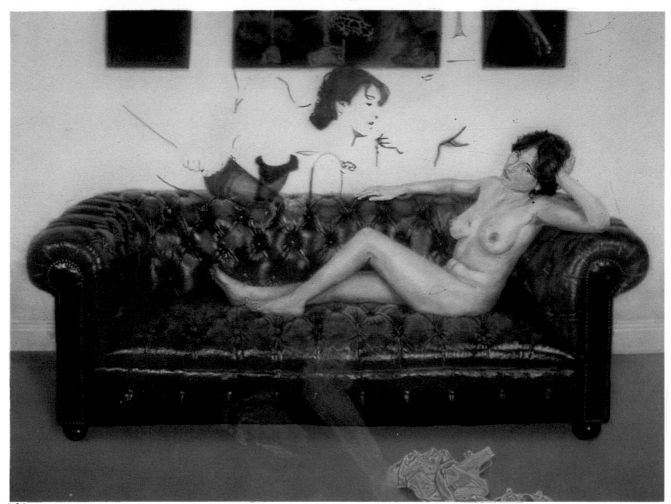

6.34

6.34 Seng-gye, Untitled (1980)
acrylic on canvas, 36 x 48in (91 x 122cm)
6.31–34 show stages in the creation of a freehand
airbrushed painting. Distinctive details were brushpainted onto
the original drawing (6.31) for clarity and the picture was then
progressively and extensively modified as with conventional
brushpainting technique.

Advanced Exercises

Mask cutting
Exercise 1

Draw a complex shape in outline and photocopy it twice.
Lay a sheet of film masking over both copies and cut the
shape out of the masking; then remove your cut-out
masks. Lay the cut-out mask from each copy onto the

6.35

6.35 This detail from 6.34 is here reproduced to the actual size of the painting.

other ground and see how perfectly – or imperfectly – they fit. Airbrush over both while the masks are in position, and then remove the masks. Any colour that remains on either ground represents the extent of your error in cutting or laying the masks.

Exercise 2
Lay film masking over a ground, and cut a shape; it can be as simple or as complex as you like. Remove the masking so that only the shape itself is still covered and spray a light colour across the whole ground, being sure to go right up to the mask edges, so they are crisp and well defined. Once the ink is dry, lay a new sheet of masking over the whole ground; there will be a ridge where it covers the masking already in place. Try to remove the identical shape, cutting exactly at the ridge. Remove all except the masking that covers the shape, and spray the whole ground again, in a different colour. If your cutting has been perfect, each spray will have covered precisely the same area. Remove all the masking, and see whether there is any area inked in only one colour; this is the extent of your inaccuracy in cutting.

Exercise 3
Take a sheet of very thin paper and draw a design. Lay a sheet of masking over the entire page. Then lay a smaller sheet of masking on top, which partially covers the shape. Lay a third sheet of masking over the second, so that it partially covers the area of the design that the second sheet covered. Now lay a fourth sheet, partially covering the area of the design covered by the third. The thickness of masking goes up in steps across the design. Cut that shape out, and remove the negative masking from all but the shape. It will tear if you have not cut deep enough. Remove the rest of the masking and hold the paper up to the light to see if there are any places where you cut too deep and went through the paper.

Exercise 4
This exercise is for the artist in three dimensions. Gum a matchbox to a piece of paper and lay a sheet of masking over both (6.36). Now cut the masking so that it falls precisely at the base of the matchbox, reaching it, but not overlapping its sides. This will involve cutting part of the masking which is in the air, rising between the paper and the top of the matchbox – and will need excellent judgement. Do not expect immediate accuracy; all these exercises are difficult, but this one especially so.

6.36

Painting with masking
Exercise 5
Draw a rectangle, and divide it into a series of adjacent squares. Cover the whole ground, and cut the masking so that every square can be removed. Then, on a sheet of masking still on its backing paper, cut an exact copy. Lift the first square of masking from the ground, and spray with black ink to an even grey tone. When this is dry, remove a square from the masking on its backing and cover the sprayed area. Lift the second mask from the ground and attempt to spray it the same even grey. When dry, cover with a mask from the sheet still on its backing and spray the third square – and so on until the end of the rectangle. Remove all the masking from the ground and see how constant your grey turns out to be. Even experienced airbrushers, who are used to matching tones through masking, will probably be surprised at the degree of error.

Exercise 6
Repeat exercise 5, but instead of aiming for an even tone right across the rectangle, try to achieve an evenly stepped grey scale. Firstly, start dark, and let each square become lighter, in equal steps. Then start light, and darken each time.

Exercise 7
Draw a circle, and divide it into several segments emanating from the centre. Cover it with film masking and cut out the segments, but do not remove any. Cut an identical circle plus identical segments on another sheet of masking still on its backing. Now remove one segment and spray it so that it is dark at the point nearest the centre of the circle, fading to light in the middle of the segment and darkening to a mid-tone at the circumference. When dry, cover this with a mask from your cut duplicate, and remove the next segment's mask. Spray this a different colour but, again, make it dark at the centre of the circle, fading to pale, darkening to mid-tone. Cover when dry and repeat this process with every segment, each in a different colour. Then remove all the masking and you should have a circle of many colours, dark at the centre, fading to light, fading to mid-tone – each segment having an equal intensity at every point (6.28). Matching the intensity of a colour that is under masking is probably the trickiest spray-matching of all.

Freehand
Exercise 8
Draw a simple grid and aim a small dot of ink at each of its intersections; vary the size of the dot by varying the distance you hold the airbrush from the ground. Next, take a plain piece of paper, and without the help of the grid, spray dots of ink in the grid pattern just outlined. Once you can do this well, reconstruct the grid by drawing straight, thin, even lines across the rows.

Exercise 9
Buy a 'join-the-dots' book, of the sort normally intended for children – and do the exercises by spraying the lines with an airbrush.

Exercise 10
Draw a series of concentric semicircles using a pencil and compasses. Now spray each line freehand with different colours as accurately as possible. For example, it might be interesting to create a rainbow pattern. Alternatively, spray the areas between the lines, filling each area in a single stroke with a minimum of overlap. Again, you might like to create a rainbow by this method (6.29).

Exercise 11
Draw a thin line in ink on a plain sheet of paper. Now achieve an even mid-tone one side of that line, keeping the other side of the line as ink-free as possible. This is difficult freehand. The best technique is to spray with the airbrush very close to the paper, when near the line, and gradually develop into broader strokes the further away from the line you get. This minimizes overspill onto the other side of the line, although it necessitates care in getting the tone even.

Exercise 12
Take a simple stencil, such as an ellipse. Lay it on a sheet of paper and draw its outline in pencil. Now fill the ellipse in freehand, overspilling as little as possible. Spray the whole ground except for the ellipse, allowing as little overspill into it as possible. This last step can be done in another colour after the ink has dried, or on a separate ground. The pencil line remains as a check to your accuracy.

Exercise 13
Spray a simple square outline freehand, about 4in (10cm) across. Then spray another slightly smaller square outline inside the first. Spray another inside that, and another, until eventually the outlines you have to draw are so small that you cannot continue; you will find you fill the last square in, instead of outlining it. Repeat the exercise, this time outlining smaller and smaller concentric circles.

Exercise 14
Take a large sheet of paper and spray a large, simple, circle. Do not mark it out first; just make a confident airbrush gesture, and spray it quickly and evenly.

None of these exercises is easy, so don't be discouraged when you find perfection hard to achieve. Just measure your performance over several attempts, and see your proficiency improve.

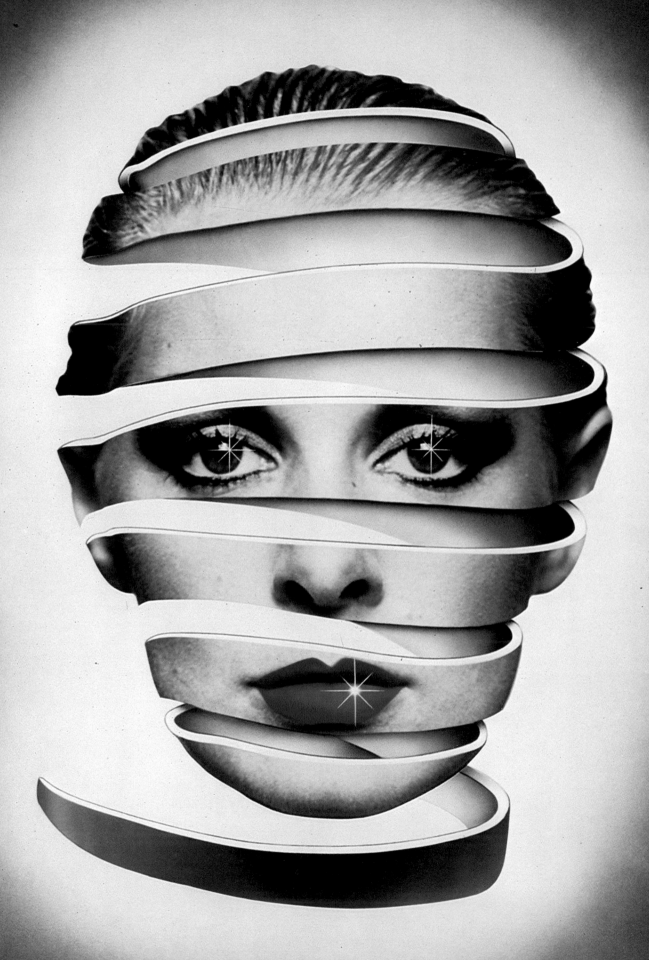

Chapter 7
Specialized Applications

Retouching

Photo retouching implies a different approach from most airbrushwork: with most airbrushing you start out with a blank ground and build up a picture; with retouching you already have a picture and you then modify it. This chapter therefore deals with modifications, and the methods discussed are not necessarily exclusive to work with photographs, although by far the major uses are photographic. Photo retouching is probably the biggest single function of the airbrush; important among its earliest uses were photomontage, tinting, and portraiture. The airbrush has an imaginative set of possibilities when combined with photography, and it is well worth the time to obtain a few old prints to experiment with, just to see what can be done.

A warning should be given here: the airbrush will not improve a good photograph, merely alter it. Gratuitous airbrushing can only ruin the work of the original photographer if the photograph is already acceptable. Practice is necessary because if the retouching is too crude it shows up badly. To see for yourself, simply skim through a newspaper which has advertisements that also appear in glossy magazines. Often the same photograph has been used, the original reproduced in colour, and a retouched version in black and white in the newspaper. Very often the airbrushwork that has gone into the retouching shows up as overdone by comparison with the original. The object of retouching a general-interest news photo, for example, is to show the details of the scene with maximum clarity, not to demonstrate retouching to the detriment of the photograph itself.

The point of these warnings is partly to plead for circumspection in use and partly to demonstrate that conversance with the standard airbrushing techniques is at least as necessary in retouching as in any other application

— and more so than some, for a much lighter touch is needed to airbrush a photograph than a piece of graphics. To modify is usually to alter in minor and subtle ways, requiring precision and care, in contrast to the big gestures and strokes used in other fields. In fact, using a retouched photograph in a graphics context is not necessarily easier than originating the whole image by airbrush. To remodel a shape or face on a photograph needs as great a knowledge of shadows and composition as is required in the origination of the whole work. Why, then, is photo retouching such a widespread practice? What are its specific commercial applications?

News

We have seen that the object of retouching a news photo is to clarify the important details; this usually entails fading the irrelevant aspects into the background to make the central details stand forward. It can also dramatize certain features, either for clarity, or to give the photograph maximum impact. So the camera never lies? Retouching can be used — and has been — to totally alter the import of a news photograph.

Modelling

The removal of blemishes in portrait photography is one of the original, and still one of the major uses for retouching. In Edwardian photography the applications were subtle, aimed at improving the complexion of the subject, removing spots and imperfections; but today the producers of cheesecake and fashion magazines, not to mention advertisers, will go as far as remodelling the entire shape of a figure — rounding up breasts or removing fat from thighs, for instance. It is easier to give a more alluring impression of eye make-up in a magazine advertisement if the girl is photographed first and the eye make-up tinted in. The reasons are not necessarily ignoble; when reproduced in the magazine an airbrushed make-up will possibly render a more accurate approximation to the actual colour of the cosmetic; or perhaps the same photograph is required for re-use demonstrating other

Left: Peter Barry, creative photo retouching.

colour make-ups. Often, of course, this treatment serves to make the final advertisement that bit more eye-catching. The same method is used in other areas of advertising, as for sunglasses. The model is photographed wearing a pair of empty frames and the tint of the shades is added later.

Product presentation

Similar principles underlie the cleaning up of 'product' photographs (7.1-2). Industrial items are photographed for brochures or for manuals and then retouched; usually this involves fading out the background (particularly if the object was photographed *in situ* in the factory, with other machinery around it), and it can also entail bringing out certain key details to illustrate important components. Rust and paint are cleaned up and all metalwork given an extra shine by retouching. For magazine or poster advertisements the product must of course look flawless. Glass bottles, for instance, or even cigarette packets, are very difficult to photograph without either reflections or uneven textures. When reproduced to poster size, it is imperative that the displayed cigarette packet be perfect; and retouching is often the only way to achieve this.

Fashion

One of the airbrush's most common photographic applications is the removal of unwanted colour reflections in fashion advertising. If a model is wearing, say, a white top and a red skirt, the skirt will reflect red in the top when photographed; so the reflection is airbrushed out.

Architecture

Retouching is used to add – or take away – a piece of architecture in proposed plans for sites (page 92; 5.3). This can be done either on the original photograph itself, or on a cel overlay.

General uses for reproduction

Apart from these specific applications, there are some methods of retouching which are useful for most forms of reproduction: the outright removal of extraneous or distracting elements; the extension of a photograph to fit a predetermined format; the restoration of old or torn photographs, either to re-photograph or to reproduce; the retouching of photographs that are to be reproduced from screened prints, to prevent 'moiré' marking; or the reversing of lettering, on a photograph that is going to be reversed out, so that the letters read correctly. With the aid of an airbrush, a photograph can say almost anything you want it to say.

Creative applications

All the above techniques can be used, and, with a little experimentation, countless others will emerge. Photomontage is a common application (the same principle applies for any kind of collage): gather the

elements together, and spray the edges of each as you paste it up. This will have the effect of blurring the edges, making it difficult to see where one element begins and another ends, thus unifying the disparate elements.

Retouching techniques

Bear in mind one or two points before setting out to retouch: wherever possible, it is advisable to have a spare print of the photograph you are retouching for reference. Halfway through touching up a piece of machinery in a photograph, with masking and with-paint obscuring part of that photograph, is no time to realize you do not know which piece of steel tubing is important and which piece is not. Secondly, cleanliness is especially important for retouching. The eye may discount fluff and dust in an originated artwork, but in a photograph the onlooker expects total flatness, and therefore notices any unintended dirt. Dust therefore must be kept away from the process whites and cels must be clean and unmarked (they do mark easily). If you are not meticulous about this, there is no point in carrying out the retouching.

Blocking out

This process is simple: treat the photograph as a half-finished artwork, mask out the area that is important, and spray the rest – a standard exercise in masking negatively. Opaque colours should be used, or else process white and lampblack. Most professionals will tell you that you do not really need all those gradations of grey that are produced for black-and-white retouching. Temperas or acrylics are as good as anything for work in colour.

Some blocking out is possible on photographic negatives as well as on prints; though negative retouching is usually only attempted on large format negatives, and blocking out tends to be the only form of such retouching done. It does not matter whether you use opaque white or black for this – it will still block out all the light. But there are difficulties, both with masking and with working small areas. It is really only worth retouching the negative if it has to produce several high-quality prints. Otherwise it is better to use an enlarged print, retouch it and re-photograph.

There is an alternative for the creative experimenter: if you retouch a negative with an air eraser, it is possible to let some light through. This field is almost unexplored, but some interesting results can be produced.

When working on the negative, the positive or a cel overlay, whether for reproduction or not, always avoid cutting deeper than the masking; that is, into the working surface. Photographs show the incision and form a sharp white edge there, which is out of keeping with the work itself. Film masking results in a crisp edge anyway, though it happens less with liquid masking, which is therefore often preferred.

7.1 Before

7.2 After

Fading and blocking with a cotton swab

There is an alternative to masking for blocking out and this can also be used for fading an area back. Make a cotton bud to suit your purpose and dip it in water or a suitable thinner, as applicable. Then freehand airbrush the area to be faded out and wipe back the excess paint with the cotton bud; this will be adequate for most areas. For fine detail work it is often advisable to use a handbrush dipped in the appropriate thinner to wipe away excess from difficult borders. After clearing the edges, use a cotton bud for the rest of the excess. To block out completely using this process, repeatedly spray freehand and wipe away the excess after each spray to prevent too much excess building up, until the desired area is totally obscured. A single application of this method will fade an area back without completely blocking it out (7.3).

Combining a photo with original artwork

It is simple enough to block out the background of a photograph and substitute it with a new airbrushed one (7.4): block out as described above and then use that area as new ground for your artwork. Clearly this type of combination is not restricted to backgrounds.

Restoring old photographs

Here is one occasion where freehand work – preferable anyway to masking, where possible – is very important. You cannot spray over faults or tears in the original, which in an old print would anyway be ethically undesirable, as

7.3

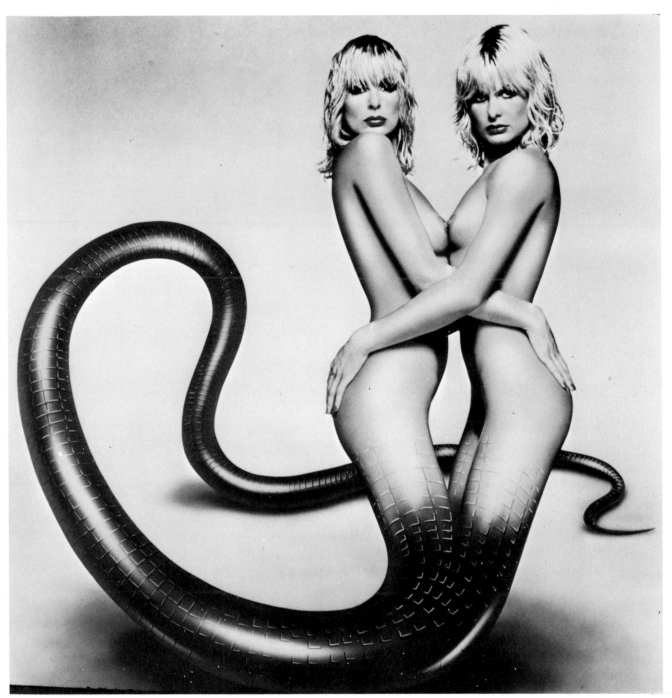

7.4

7.4 Peter Barry, album cover.

well as detracting from its value; so photograph it again and then airbrush over the unsatisfactory areas. At each stage spray as if this were the freehand origination of the work; but the only way to blend your airbrushwork with the specific quality – grain or texture – of the photograph, is experience. This is not a task for the amateur; however, as you are not working on to the original photograph, if disaster strikes you can at least reprint it and start again.

Work for coarse screen reproduction
For such applications as newspapers, where a coarse-screen reproduction process is used, subtlety is wasted.

The nuances of the original photograph can even be lost, as the tones tend to merge a little. So work boldly: if, say, there is in the photograph a jacket of similar tone to the background, which will fade into it when reproduced, then add contrast, quite crudely, with the airbrush.

Additional tips
Masking To avoid cutting out film, with risks to the surface, you can use liquid masking, or else other

7.5

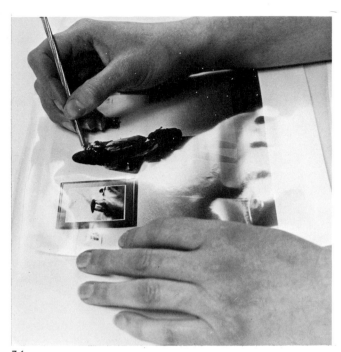

7.6

photographic prints. Make several copies of the print you are working on and cut out the mask from another print. Place this over the print in use, weight it down with coins (or something similar) and spray (7.5). The edge will be very slightly soft, as are the edges in the photograph itself.

One alternative, if you are nervous of cutting film masking too deeply, is thin celluloid or thick cellophane. Apply it to the surface and score out your masking area with a delicate engraver's tool (7.6). Remove it from the surface and cut out along the scored line; you can then stick it to the photograph with rubber cement, or weight it down, and work.

O. R. Croy, in his excellent book *Retouching*, suggests one further possibility, which can be used in conjunction with the airbrush: namely, a masking varnish. His recipe involves boiling together two parts linseed oil with two parts petrol and one part chalk. This is used as liquid masking – paint it on, and then spray. The varnish, which incidentally is waterproof, can be removed without trace with a wad of cotton wool soaked in petrol (gasoline).

Soft edges Very soft edges, for clouds, for example, can be effected with a piece of well pulled-out cotton wool, or coarse blotting-paper, as masking (page 89; 4.25).

Paints It is better to use too little paint than too much (you can add more); and it is inadvisable to mix black and white actually on the ground to achieve the shade of grey you are using to block or fade. Any colour mixing should be done before spraying.

Retouching has many variations, but all depend on a basic familiarity with standard airbrush techniques. There is no substitute for this.

Printing

Although for most of its history the airbrush has been widely employed in the preparation of work for photographic reproduction, it is only within the last few years that its uses in the sphere of artists' prints have been developed. Artists' prints are a specialized and prestigious genre where an artist has a hand in the method of their production; he will make the engraving, or apply ink to his own lithograph, or carry out his own colour separations. In general, he will be responsible for originating the design so that it is ready to be produced, and he will possibly even print the design himself. However, the presentation of a piece of artwork to a printer for photographic separation and reproduction does not result in artists' prints, just in reproduced artworks.

This area of airbrush applications is young and new possibilities are being developed all the time. Several of the innovations noted below have come about during the time this book was in preparation. The list presents an up-to-the-minute review of the methods currently in use or in development; inevitably, it will soon be outdated.

Stencils

The simplest and most direct manner of printing, which was suggested in some of the very early manufacturers' catalogues, was the use of stencils for such purposes as display cards or invitations, using thick card as a mask. The advent of film masking has given rise to the possibility of very complex masking; when used for printing, this means that the print run is limited by the life of the weakest film stencil used, often resulting in editions of under thirty. After a time, a piece of film masking will curl at the edges

and lose tack until it becomes unusable. A more durable alternative to film is an etched thin metal.

A cheap press for stencil printing can be made from a baseboard with a hinged flap within which is a hole the size of the desired picture. This hole is then covered with a piece of film masking and cut to shape. Normally at least one stencil per colour will be needed. The ground is then inserted between the base and the flap and registered, so that it is in exactly the right position; the relevant area is then sprayed. The ground is removed, a new one inserted, and the process is repeated. When you have finished the run, remove the stencil, replace with the next one, and spray the whole run again with the new colour. This method is a controllable, simple and effective way to produce your own artists' prints. Each print will differ slightly from the next, as it is virtually impossible to spray each time with exactly the same emphasis and coverage. Consequently, identical prints cannot be made; but the 'one-off' print, where each is individual and distinct from the rest (each, for example, using a different colour), can easily be produced by this method. As was noted on page 107 (6.6), masking economy, the stencil need not dictate the limits of your spraying – there is room for fades and blank areas within the area masked to be sprayed – so each print can be varied by the different amount and extent of spraying within the same masks (7.10). Hand tinting lithos and etchings are other uses for this technique.

Lino-cuts

The air eraser is a versatile instrument for this and other types of printing. Although you cannot successfully use it to define the cuts, which must be effected by the proprietary tool, the air eraser can improve the texture of relief sections, producing, for example, a mottled rather than a plain area on the final print.

Wood-block printing

The cuts made into the wood in this process are sheer and deep. The method of using the air eraser to texture relief areas also works here, but there is extra potential as well for using the airbrush. At the inking stage, after the cutting, the airbrush can be used to ink the relief areas, allowing the possibility of fades. As the ink that overspills onto the deeper, cut sections will not be printed, being too far away from the ground at that stage, you can spray freehand without fear of problems caused by excess spray. (This technique cannot readily be used with lino-cuts, as the cuts in the lino are not deep enough to ensure that overspill onto the cut sections does not get printed.)

Silkscreens

This method involves photographic stencils which are processed directly onto a screen. The airbrush can, however, be used in the preparation of a colour separation, or for making adjustments to the negatives that are used to prepare the screens (7.7), after the proofs. The latter application is photo retouching (pages 119-123); the former can involve airbrushing onto glass.

Each colour is defined by a photographic filter, and then passed through a random spatter half-tone screen created by airbrushing dots of opaque ink at very low pressure onto glass. The resultant positives are then erased or sprayed further, as required. Andrew Holmes is an artist who uses this method to achieve highly complex and individual works; *Sugar Shack* (7.8) is a 12-colour print effected this way.

If you are airbrushing through a silkscreen, after one or two efforts the ink will soak and block the fine mesh, wiping out any subtlety the printer may have hoped for. This method therefore requires regular blotting of the screen. The disadvantages probably outweigh any possible gains.

Litho printing

This, one of the youngest forms of printing, originally involved a stone being waxed in a particular pattern, and then wetted. When inked the wax accepted the grease-based colour, but the wet stone resisted it; so that if a paper were pressed against the inked stone, the waxed pattern would be printed through. Stone has now generally been replaced by a zinc plate.

The wax, therefore, positively defines the design. A current alternative to wax is a greasy ink, which can be sprayed through an airbrush when thinned. This can be applied direct to the plate for printing, either freehand or with masking; again, one plate is used per colour. When printing ink is added and pressed off, remarkably accurate and subtle prints can be made (7.9).

The air eraser can also be used for cleaning lithographic plates, so an airbrush can both put on and take off a design.

Engraving

With engraving, a design is cut into a plate with a sharp tool, and ink is applied and then wiped so that it remains only in the hollows. When printed, the design engraved is positive, as each cut defines an inked line or area in the finished print. The air eraser is itself primarily an engraving tool and can readily be used to engrave a design for printing, using hard abrasives.

Etching

With this method, wax is applied to a plate which is then dropped in acid, so the areas that are not waxed are eaten away. The plate is retrieved, and the wax cleaned off, leaving the areas that were waxed standing up in relief. The whole plate is inked but then cleaned so that only the hollow areas, originally unwaxed, are inked. When printed onto damp paper, these unwaxed areas compose the design.

The airbrush can be used to spray thinned wax onto the plate; but this has the disadvantage that each stroke of the

7.7

airbrush defines an area that is not finally to be printed. In other words, the airbrush is used negatively.

The air eraser can also be used to print by etching; wax can be applied to the whole plate and cut away using soft abrasives, so that the air eraser this time positively defines the design. The air eraser and ink-spraying techniques mentioned here can also be used easily to create a wide range of textures for mezzotinting.

Specialized Areas

Fine art materials

Much of this book has been devoted to techniques that can be applied to fine art, but a further word should be added about media and grounds. The airbrush can be used for fine art with any of the standard grounds – canvas, paper, plastic etc. using traditional media. The authors have airbrushed with egg tempera, ink, water-colour, acrylic, oil, alkyds, even traditional Chinese inks and Japanese colours and enamels, with complete success. Different media can be combined with or without masking, in combination with any of the standard techniques.

The heavier paints have to be efficiently thinned, with the correct thinners, or the instrument may become clogged. Oils and alkyds, when sprayed, are noxious and often toxic, so a well-ventilated room is essential. A face

mask is also absolutely necessary, though a respirator would be better still. For heavy paints the pressure needs to be increased and this results in blowback.

The techniques shown in previous chapters all apply; if you look at the gallery pages 30–63, however, you will see that it is the task of the real airbrush artist to push and extend the borders of what has been done before and to experiment as much as he can, rather than simply work to set formulae. The airbrush has only been available for nine decades, so there is much still to be discovered.

Illustration

The graphics techniques and applications for illustration are much as laid out in the techniques chapters; any medium from ink through gouache (7.11) to oils is suitable. The only difference in approach is that commercial artists may opt for the 'quick and easy effect', such as a starburst or a glamorous sheen, for a particular purpose.

The reason for the difference in approach of fine and illustrative artists is self-evident. An artist with unlimited time at his disposal may approach the airbrush and the job at hand somewhat differently from the illustrator who has tight deadlines.

One-off layouts for demonstration

This is basically an extension of graphics technique. In competition for some project, the airbrush can give a

7.8

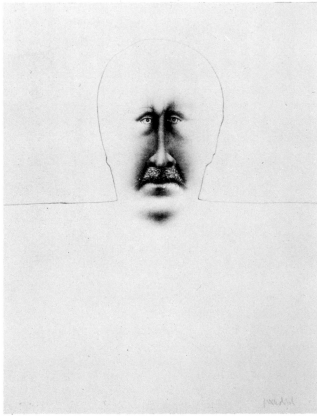

7.9

more effective and realistic look to a product than can be achieved with a simple line drawing, as it translates more easily to the desired effect in the client's mind. It adds polish and a look of professionalism, all-important in today's highly competitive environment.

This applies equally to one-off demonstrations for display at trade fairs, exhibitions and lectures. All that is required is a knowledge of the basic techniques for two- or three-dimensional artwork.

Signwriting can also be carried out effectively with the airbrush. If you mask out the areas surrounding the letters, leaving a kind of stencil masking, you can then employ as many colours as you like in the spraying. Any standard paints that can be adequately thinned may be used, and the result will be many times more impressive than simply brushpainting one colour.

7.8 Andrew Holmes, Sugar Shack *silkscreen.*
7.9 Paul Wunderlich, Self-Portrait *(1977)*
colour Lithograph, 25 x 20in (65 x 50cm)
7.10 Seng-gye, stencil print.
7.11 Sue Saunders, Greenpeace greetings card
gouache on card.

7.10

7.11

Sculpture

This section refers to all three-dimensional decoration, and you should refer for general techniques earlier in the book (page 103). However, a few tips and a little information can be added.

The airbrush is used in a variety of ways – whether treating the sculpture as a curved ground to paint, simply embellishing it, or exaggerating or emphasizing certain features of the solid object. The shape of the work can even be subtly contradicted by the use of soft shading which does not show up brushstrokes; the paint delineates one shape, which counterpoints the physical shape of the object, giving rise to a series of possible effects and deceptions. It is more generally useful to be without the distraction of brushstrokes, for the values of the surfaces and shapes can then be retained. This is particularly so in figurative work, where if a piece is to be coloured at all it is important to capture the tone and colour available in the model.

An object has its own highlights and shadows, but shading can be used to heighten some effects. On a sculpted face, for example, the depth of the cheeks could be delicately increased by the well-judged addition of shading. It is, however, easy to overdo the effect. Furthermore, it is inadvisable to attempt it on corners and rounded edges, unless the piece is to be viewed from one angle only. Flat or concave surfaces are normally more suitable.

The airbrush can be used as widely and confidently as the handbrush; a full range of liquid colours can be used, provided they suit the surface. When dealing with impervious surfaces, it is best to roughen them enough to provide a tooth for the paint to cling to; other, more absorbent materials, may require sealing and priming before spraying.

Ceramics

Almost any kind of airbrush can be used for ceramic decoration, but the broader tipped double-action, or the single-action models are usually favoured because of the difficulty of spraying some paints through a fine nozzle to the necessary thickness. It is probably useful to have a large tipped single-action airbrush to use as a glaze gun; it is more controllable than the smaller industrial spray-guns which are often suggested for this purpose, but will afford quite an adequate spread of spray.

With practice, it should be possible to achieve the right consistency for spraying not only proprietary ceramic colours, but also slip colours and enamels. This leaves the airbrusher a considerable choice of possible media. The consistency is often an important factor; if you spray some finishes too thinly, the ground is soaked with water. This may result in the pores of the clay closing, which in turn can prevent further coats of paint from adhering properly in the firing so that they flake off.

It is vital to avoid fingermarks on the surface of pottery

7.12

which is to be painted; the best safeguard is to use a turntable of some kind – the potter's wheel would do – so that you can spray from all sides without handling. With certain proprietary pottery colours you can get interesting effects by erasing some areas of paint with slightly damp stiff brushes, or a fibre eraser, whichever is appropriate. Highlights of the orginal clay colour can also be achieved by scratching back the medium with a metal tool.

Dry masking can be used – card is often the easiest – but avoid any that need adhesive or tape. It is possible to create a mask which has arms extending beyond the edges of the objects; if it is resting on a surface, the arms can then be stuck on to that, sandwiching the item between mask and surface (7.12). Otherwise the masking must be held or supported in place.

When restoring pottery, provided the piece does not need to be re-fired, thinned oil paints can be used for decoration. Otherwise seal the cracks as necessary and apply any of the media mentioned above, filling across the exposed areas freehand or with masking.

If you experiment with both media and masking, you should be able to apply all the basic techniques noted earlier in this book, treating ceramics as three-dimensional areas or curved two-dimensional surfaces. The airbrush can be used to create a wide range of decorative effects: although many manufacturers do not like it known, 'hand finished' often means 'airbrushed'.

Automotive Customizing

Not all customizing paint jobs require the airbrush; you would not use one, for instance, to finish a car in metal flake. Much has been written about spray-painting cars; for the full picture, you should refer to a specialist manual.

Here we will deal only with airbrush technique.

There are three general occasions for using an airbrush: muralling (7.13-7.14), special effects (7.15-18), and certain sorts of finishing work. The last usually amounts to such exercises as producing a soft line, or blended edge, around a panel, where more fineness and control is required than a spraygun can manage. For special effects, see the suggestions below; if you are enterprising and want something a little more challenging, you might try applying some of the unusual effects noted in the sculpture section.

In general, car painting should be regarded as two-dimensional rendering, on a curved surface. There are certain points to remember; the most important is that an artwork on a car requires at least as much care and respect as if it were on board or canvas. A well-prepared ground is vital; you do not want rust bubbles appearing underneath your masterpiece. Ideally, strip the painted surface right back to the metal, and cut out any areas of rust, rebuild, then respray. Only use the airbrush once a thick surface of several paint layers has been built up; it will be better looking in the end, as well as safer, to have a good number of coats underneath. If the car is new, strip back any wax there might be, as it resists paint; then (and do this also if you have resprayed the car), gently rub a very fine abrasive paste over the paintwork to create a 'tooth' so your airbrush work will grip.

Whether you work freehand or with masking, it is advisable to build up the picture as thoroughly as if it were on canvas. Some customizers simply dust the design on in one, but this gives a thin effect which looks sub-standard

and is easily damaged. Once you have completed the mural or effect, you will need a large number of coats of lacquer to protect it and to increase the feeling of depth. It is not uncommon for 30-40 coats to be applied to a mural.

Car enamels, acrylic lacquers, and coach paints are suitable for the airbrush in this area. Most professionals use the last two as they are more lightfast than conventional enamels; if you have spent two months muralling a car, you do not want it to fade before the year is out. It may be worth checking the compatibility of the paints you use, just to make sure that one can be safely applied on top of another.

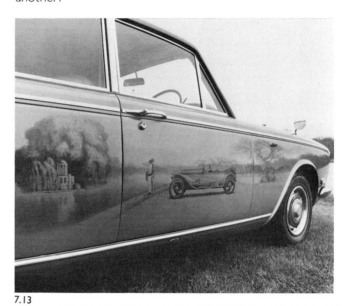
7.13

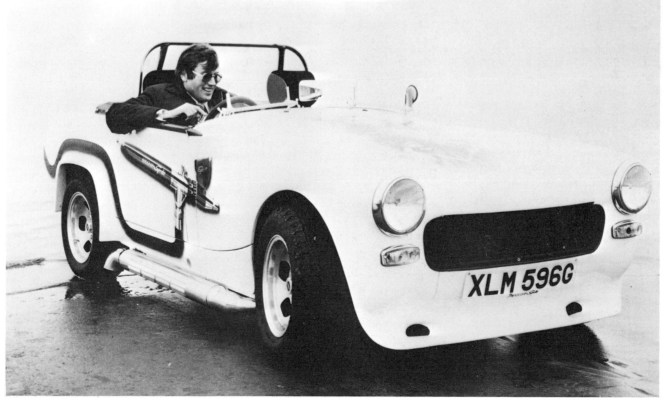
7.14

129

Examples of special effects

Repeated card stencilling
A relatively simple card stencil can produce an impressive repeated design. A straightforward ellipse, or a scroll, or a wave, if overlapped, can be transformed into a fascinating pattern, particularly if more than one colour is used. Repeated semicircles, for instance, can turn into fish scaling (7.15). Or one simple pattern, a series of waves perhaps in one colour, can be cross-hatched with another, such as V shapes, acting against it in a different colour.

Textured stencil effects
Stencils such as fishnet stockings, lace, a wire network stretched over a frame (7.16), or even a string vest, will produce textured designs ideal for covering large areas. The stencil should be placed taut over the ground, stuck with masking tape, sprayed, and removed when the paint is dry. Either follow the pattern or spray the whole area. Patterned lace in particular can give the end result a sharp and professional appearance; though the technique is exceptionally simple.

A pattern can be stuck to the ground with tape so that it makes an endless line, and then followed with the airbrush. The spray overspills slightly either side of the pattern (it is normally best to operate at very close range, to give the overspray a narrow, sharp appearance); when the tape is removed, the effect is of a negative pattern defined by thin areas of spray either side. The process can be repeated several times, using different colours.

Cobwebbing
This is probably the easiest effect of all. You will need an air system capable of high pressures – up to 60 or 70psi (4 or 4.8bar) – and an airbrush or spray-gun with a wide nozzle. Use unthinned heavy liquid paint such as enamel paint, and force it through a wide nozzle at a high pressure. The paint will stick to the ground in veined, string-like patterns. The degree and complexity of webbing can be varied by altering the operating distance from the ground, or the nozzle setting. If your paint is not thick enough to form an effective web, let it stand for a while to allow the thinners in it to evaporate. The pattern will be textured in relief; you may wish to seal it with clear lacquer, and sand down the surface.

Circles and spider blobs
A filled-in circle can be obtained simply by holding the airbrush close to the ground and spraying a short, concentrated burst of paint. It will form itself roughly into a circle; too short a spray will not allow the circle to form properly, but too long a burst lets the circumference break down. A little practice is all that is required to produce perfect circles.

The spider blob is basically an air-blasted circle. Spray a circle as above and then turn off the paint supply, so that you are concentrating a blast of air into the centre. This will explode the edges of the wet circle into an array of spidery lines rather like a mophead. Using paints thinned to greater or lesser extents, and varying the bursts of air, you can get different degrees of spidering.

Modelling
There are several reasons for the popularity of the airbrush in this field. A model can be anything down to $1/72$ the size of the original, so strokes made with a handbrush and the wrong texture of paint will show up. Most originals were themselves spray finished – cars, tanks and planes for example – so not only are airbrushstrokes unobtrusive, but they copy the techniques used on the original (7.21). More than that, when thinned adequately, it is possible to spray a layer of paint on the model, whose thickness is in scale with the paint on the original.

There are a few points which apply generally to all airbrushwork, but which are of extra importance here. Firstly, ensure that the paint is adequately dirt free. Because you are working in fine detail, dust must be avoided at all costs. Clean efficiently between colours and make absolutely sure the environment you are working in is as dust-free as possible. Dirt on the model can be equivalent to a stone on the original!

Some dedicated modellers grind their own pigments to be sure of achieving the smoothest possible coat of paint. Considering that for a $1/72$ model, the paint should be 0.0019in (0.05mm) thick to preserve scale, it is hardly surprising that a little extra effort is made. If you do not grind your own, use specialist scale model paints; normally those with enamel bases are flatter and easier to work with. Paint thinners evaporate, even when stored, so paints should be checked periodically.

The airbrush provides a smooth-surfaced finish which does not obliterate fine detail; neither does it cover up bad modelling. Before spraying, ensure all joints are adequately filled and/or sanded. Remove any ink, grease, or finger-prints with a weak detergent solution. Do not spray until the surface underneath is clean and smooth.

Masking techniques are necessarily primitive, as they are with most three-dimensional applications; some components, such as wheels, are better sprayed off the model (7.19). If you are spraying very small items before assembly, the actual pressure of air going through can be enough to move them about. If this happens, lightly tack down the component with adhesive tape, or a plasticine-based product. As for what kind of masking to use, that is up to you. Card, film, and liquid masking are all equally easy; the modeller might otherwise choose graphics tapes, which come in a variety of widths from $1/32$ in (0.79mm) upwards. Masking tape often comes with slightly rough edges and it is worthwhile smoothing them out, so that the roughness does not get in the way of the work. For very small details, use several thicknesses of liquid masking. Remove the masking gently with a cocktail stick when the

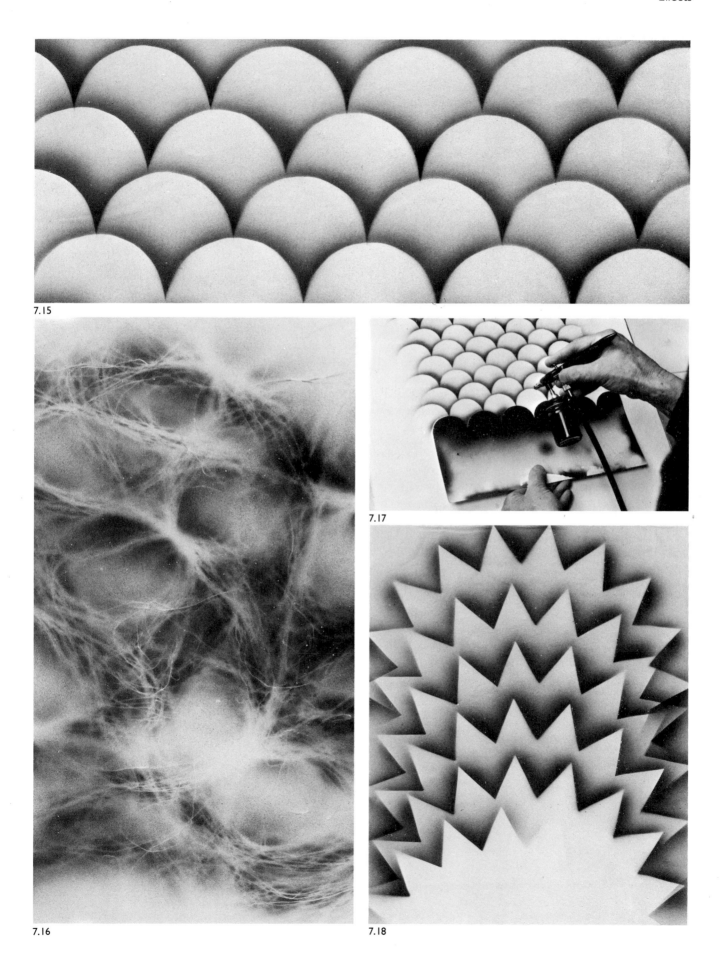

7.15

7.16

7.17

7.18

paint is dry. Make sure the paint is thoroughly dry before being masked over, otherwise, when the masking is removed, it will pick up some of the very thin paint.

One or two special effects are possible, such as weathering. Paint the whole model the same base colour as the material of the original; then add the ordinary paint layers and wear down or chip the desired sections, adding rust colouring to give a rusty, weathered effect.

Texture can be added by puffing fine dust for dirt to base layers of paint while they are wet, and then spraying over them. A handbrush could obliterate the effect, but the touch of the airbrush is light enough to preserve it. You can use the airbrush on models for anything from very fine lines to spraying from so far away that all you deposit is a fine layer of dust all over. When a heavy coat is required, it is better to dust very light coats repeatedly, letting them dry before dusting others, than simply to use one heavy coat.

In general experiment as much as possible. The object in airbrush modelling is to achieve a precise and accurate effect, as close as possible to the original, and for this experimentation is useful, while skill in rendering detail is of vital importance. The degree of complexity of some models, coupled with the size of areas to be painted, may lead the modeller to consider using one of the higher grades of airbrush rather than the cheaper versions, which do not have quite the same fineness of touch. The airbrush is as useful in painting scale dioramas and settings as it is in spraying the models themselves.

Tinting photographs
The Victorians liked bright colours in their photographs, and hand tinting by brush was carried out in a brash but fairly simple way. By the early 1900s colour photography had arrived but the actual colours were barely discernible, resembling more an enigmatic sepia than what we think of now as a colour print. By 1910 the individual colours were clear, but muted. It was the airbrush, with its subtlety and even texture that immensely improved colour tinting.

There were other reasons too for tinting. Early colour photography was complicated and time-consuming, and it was often easier to tint a black-and-white photograph than to take a colour one. Tinting was always useful for reproduction (page 15); it saved taking a new photograph, and would be suitably bright. But tinting did not stop there. The wonderfully coloured seaside photographs of the 1940s and 1950s were also tinted. Modern photographs are occasionally tinted from black and white (7.20).

To achieve an Edwardian look to a new photograph, first bleach out the black and white into sepia, and then colour as required. Avoid hard masking, which will give unnaturally crisp edges. Tinting a photograph is no different in technique to tinting any other artwork, but masking is normally necessary. Spraying and then wiping off the excess with a cotton bud is a process that does not work well here, as previously applied colours can be removed by the swab. For an old-type appearance, use cardboard, paper or cellophane masking; these are not absolutely sharp. Hard masking, such as film, is suitable for a modern look.

Animation
The airbrush is occasionally used in motion picture animation, but its employment tends to be confined to backgrounds and titling. What the airbrush excels at, subtle and fine tonal variations, are anathema to animators who need to reproduce the same tone time after time. It is almost impossible for the airbrush to repeat designs and tones. Having said that, one or two innovators have made animated films with the airbrush; one such won the 1975 Annecy Film Festival.

There was one other field in which an airbrush was occasionally used in motion pictures, but that is now obsolete. An outdoor scene in an epic would have been shot with the camera directed at the actors and action through a painted sheet of glass which acted as border. Cliffs or hills, for instance, may have been painted on with an airbrush, and the scene acted out on a plain; the viewer

7.19

of the film saw the scene set in hilly country. Today travelling mattes and highly professional special effects have taken over.

Backgrounds

This normally requires airbrushwork on paper, canvas or cels. Cels are fragile and easy to mark, so care must be taken; it is best to wear thin cotton gloves. Each cel is punched with holes so that when placed on a pegboard, it sits exactly in position. As a picture may be composed of up to five cels (after that, colour depth increases too much), it is vital that all the cels be lined up precisely. Variations in tone matter less with backgrounds because, in general, they will be used for several frames, whilst animated figures may move every frame; in such a case, the same background cel is re-used, but a new cel with more action is placed on top. The kinds of background vary enormously according to the film; they may be anything from a simple drawing to an in-depth rendering.

Titling

Film titling is often accomplished with hot press metal type, impressed with the desired colour, pressed on to a cel. Sometimes titling is done by hand. The airbrush can be employed for the characters themselves, though this is rare; however, it is used for drop shadow or other embellishment to the letters.

Textiles

Liquid dyes, fabric paints, bleaches and any paste dyes that can be thinned can be sprayed in an airbrush, and in many ways, from decorating a material still in the weaving process, to painting bed linen (7.24). Most textiles can be sprayed, provided they can readily be dyed and fixed before washing or dry-cleaning. Dyes cannot be airbrushed onto textiles which have finishes in them, unless the finishes can be removed first, or which need wash dyeing. Do not airbrush with a water-soluble dye if it cannot be fixed before washing, nor with a dye soluble in carbon tetrachloride, without fixing before dry cleaning. The dye must be appropriate; it is no good spraying a cotton dye onto nylon. It is always advisable to test the dye on a scrap before commencing; check the absorbency of the material to control the spreading of the dye.

If you airbrush during the weaving process, spray the warp whilst it is on the loom. It is not worth adding too much detail, as most of it will be lost when the weft is woven in. Finished material can be airbrushed with a suitable dye as it stands, whether crumpled up for textural effect, or stretched for a specific design, whether achieved freehand or with stencils. For a design on a finished garment which is not bound by seams, you will need to work with a dummy figure. Proceed as for spraying a two-dimensional pattern on to three dimensions, and mask with whatever is suitable — stencils or cardboard for soft masking, film or wax for crisp edges.

For batik, prepare the material with wax as a masking (as you would for standard batik work); but do not simply dip it into your dye, spray the dye on. The wax masking will give a hard edge to the design but you can work freehand within those limits if you wish, for fades and softer edges. You can also spray as many colours as you wish, within the bounds of the one design; to achieve this with standard batik methods entails several wax masks. In fact, as far as airbrushing is concerned, batik merely signals the use of a mask made of wax.

These methods can be extended to any design on hand-painted cloth; but if you are using a repeated pattern there will be minor differences in the individual sections as the free play of the airbrush is not identical every time.

Scenic painting

Many airbrush manuals mention scenic painting; in practice, for general stage or television work, however, the subtlety the airbrush can create is more than the audience or camera can see. For most purposes, use the two-and three-dimensional techniques as described earlier (Chapter 5), with a spray-gun.

One exception worth noting is the effects of the American rock band The Tubes. They are renowned for the effort they put into all aspects of their visual presentation; they use the airbrush for costumes (7.27) and for backdrops.

Murals

The airbrush is admirably suited to interior or exterior mural painting (7.28); if you are working on a large scale, it is advisable to spray freehand, as very sharp edges will look out of place. The techniques are as for all two-dimensional work.

Frescos

The traditional technique for fresco was to paint into wet plaster; this resulted in a mural composed of very small sections, the size of each area being dictated by how much the artist could cover while the plaster was still wet. There seems to be a good case for carrying out modern frescos with an airbrush on the wet plaster. It can cover large areas relatively quickly, so such a mural would be comprised of fewer sections.

Stencilling

Any stencilling of doors or furniture can be effected with an airbrush, on top of the usual stippling. Standard stippling results in a flat-area effect; by contrast, the airbrush produces gradations of tone. If you are working on a dark surface, it may be worthwhile applying a light or white underpaint, so that the delicate shadings produced by the airbrush are not lost against the background colour. Stippling, which uses thick paint and is done evenly, does not present this problem.

7.20 Bob Carlos Clarke, creative photo tinting.
7.21 Ray Hasgood, airbrushed model car.
7.22 Illustrated shop window, Tigre.

7.23 Cross-section of the human heart, an airbrushed medical illustration by Ri Kaiser.
7.24 Selection of airbrushed fabrics and artifacts from Miracles design shop.

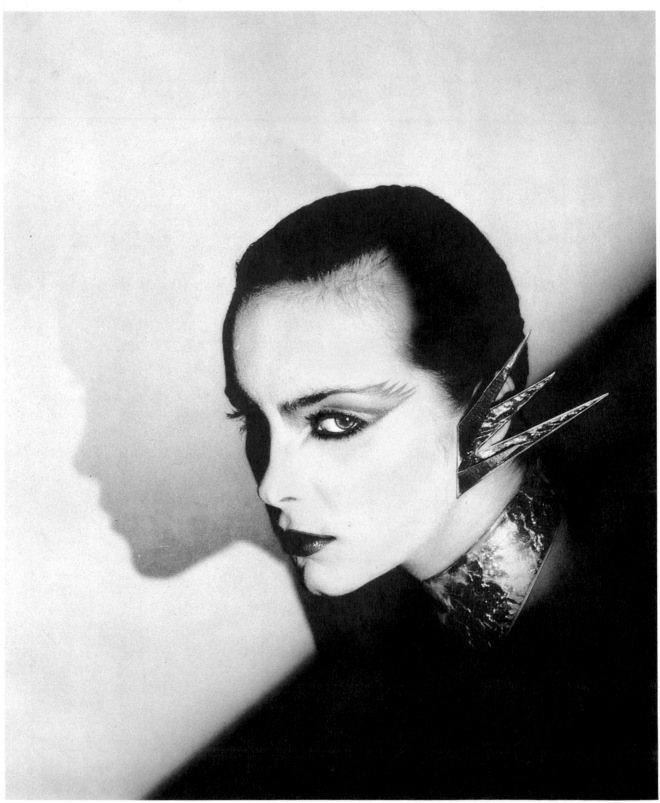

7.20

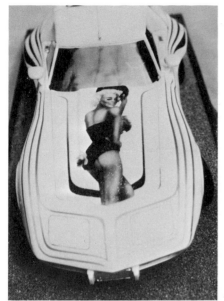

7.21

7.22

7.23

7.24

Glass painting

Windows

Designs can be successfully airbrushed onto glass. Where a lot of condensation is likely, such as the shop window of a sauna, or a hairdressers, the design will resist the later condensation on the window and be unaffected. Tiny atomized droplets of paint adhere to glass much better than paint applied with the brush in strokes.

To spray on glass, where you work on the inside for the design to be seen from the outside, you will need to exercise care. The first coat you apply becomes, when viewed from the other side of the glass, the topcoat. So you must remember that you are working from topcoat to background. It is not a difficult way to work, once you get used to it, though there can be difficulties in seeing what you are painting. If spraying a shop window, it is quite possible to draw the design on the outside of the window, then go inside and mask the whole of the window, cutting out along all the desired lines. You then can peel off successive layers, so that each time you are spraying the new area just uncovered, plus the whole area previously unmasked.

If the design is ultimately to be seen from the inside of the window, work in general from dark to pale, getting gradually paler. The light coming in from outside will still be blocked by the dark paint, even if it is painted over partly or wholly inside. Use this method even if the light is equal from front and back.

When working on large areas it is not worth using the airbrush for all the stages. The illustrated window, 'Tigre' (7.22) was effected with aerosol and airbrush; and it is sometimes useful to have a powered mouth diffuser as well as, or instead of, the aerosol. As for paints, enamels work exceptionally well, and are occasionally preferable even to glass paints, depending on the circumstances.

Glass for framing

When spraying the back of a glass for framing, it does not matter whether you follow this order, though it is probably best to work from foreground to background.

7.25 Denny Johnson, customized vehicle window.

7.25

Glass engraving

The air eraser can be used with hard abrasives to engrave glass. The American airbrusher Denny Johnson has originated many excellent designs in this way (7.25).

Stained glass

For any traditional stained-glass applications and techniques where liquid colour can be applied, the airbrush opens a new range of possible effects.

Architectural projections

The airbrush is very useful in combination with photographic or other artwork to achieve a 'realistic' impression of how a piece of architecture will look on site, for showing to clients, planning officers, and other interested parties. These vivid displays are particularly useful to those unfamiliar with reading plans (5.3).

With photographs, new buildings can be added, taken away, or moved to a new photographic background. Perhaps two prints can be provided, one 'before', showing a site as it looks originally, the other 'after', with the new building. The airbrush can also be used to retouch a photograph, showing a building to its best advantage. The use of three-dimensional techniques (page 103) can also add a more naturalistic effect to architectural models.

Production line work

The airbrush has been used in production-line work from its earliest days, in areas such as the enamelling of toy cars. Each worker has a set series of strokes and colours to use, and a group of reasonably dextrous people can add a hand-finished touch to almost any commercial item that has to be painted. It is a good way to give an individual appeal to mass-produced items (powder compact, page 17).

Cake decoration

The airbrush can be used successfully to spray colours on food decoration, particularly cake icing. There are one or two things to remember: firstly, the airbrush must be totally clean. People will eventually eat the product, and however appealing the idea of edible airbrush art may be, it is no use if you poison your guests by leaving traces of a toxic medium in the instrument.

Masking is impossible in nearly all cases, or else more trouble than it is worth. The areas to be covered are small, delicate and normally three-dimensional. If you are decorating icing figures to go on the cake, airbrush them first, and then put them in place; that way you avoid overspill. In general, follow the basic principles described earlier in the section on three-dimensional artwork.

Pre-photographic colouring

Another application connected to photography is the colouring of items prior to their being photographed (5.39). It is a technique that has been used extensively since the 1960s, in advertising, graphics photography and

also 'art' applications, mainly to produce Dada effects where the object concerned appears in the photograph in a light or colour that is impossible in nature. Its main uses are therefore connected with three-dimensional techniques.

Photographic colours are not necessarily true and for subtle effects you need to exaggerate the colour. But there are certain points to remember: it is worth checking that the paints you use will not be affected by your lighting, and also that the colours, which may look perfect in natural light, are also appropriate under photographic lights. Test first; a minute or two spent in advance can save hours later.

This kind of colouring cannot significantly alter the texture of an object. Something such as clay should be used for that, before spraying. Paint does of course have its own texture, which has some effect on that of the object; acrylic, for instance, gives a plastic finish when sprayed on a peach. A critical lens will state these sheens, so it is as well to be aware of the texture of the paint. Airbrushes, at least, atomize the medium more finely than aerosols or spray-guns; if you use either of the latter, you risk an 'orange-peel' effect – a lumpy texture through bad atomization of the paint.

Body painting

This often appears as a technique of pre-photographic airbrushing, but it is used also on other occasions such as for parties, showgirl effects, or for unusual make-up. In general, paint as for standard two-dimensional rendering , but note these points: check if you need a foundation before applying any paint; operate at low pressure – no more than 30psi (2bar); use non-toxic paints; do not create detailed effects on the skin which will be destroyed when the model moves; and take extreme care when spraying anywhere near the eyes – airbrush spray can overspill widely. Apart from the unpleasantness of paint in the eyes, even a low pressure blast of air can be alarmingly powerful.

Masking is normally relatively easy, so long as you have help when applying it. A piece of material draped over the body and pulled taut can provide a straight edge and card masking is often suitable for specific patterns and areas. Body painting can be great fun; so heed the warnings above, then let your imagination fly.

Surgery

One of the most surprising, and most beneficial uses of the airbrush is in surgery. In difficult brain operations, latex is sprayed on delicate brain tissue as a protective covering. This not only says a great deal about the ingenuity of the medical profession but is a tribute to the airbrush itself, demonstrating its versatility and its high-engineering qualities, its ability to remain sterile, and to layer a surface extremely finely without touching it. As it is aimed and used in very precise conditions it has also, of course, to be capable of a highly accurate spray.

Medical illustration

The purpose of medical illustration is to clarify and identify areas of the body which are confusing when seen photographically or in real life (7.23). The airbrush can therefore be used, in conjunction with standard graphics techniques, either for originating artwork or retouching photography.

Miscellaneous

There is a host of other applications for which the airbrush can be used, but for which it is appropriate to provide little extra information beyond the basic general techniques. Here are a few of the more popular ones.

Technical illustration (pages 62-3) This is the one field of airbrushing for which a specific language has evolved. Generally, the airbrush is used in conjunction with line work, to depict a product yet to be made or to clarify the structure or principles of the machinery by the cutaway method.

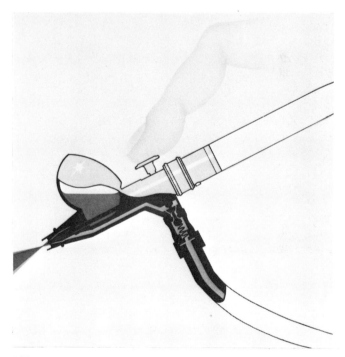

7.26

Audio-visual presentation The airbrush is particularly suitable for work to be projected or enlarged (7.26), as smooth gradations are held even at extreme enlargements.

Hair styling Take common-sense precautions (see section on body painting, above). Complex effects can be added after styling; colours which are normally applied as paste must have a strong dye when liquid.

Wood painting A full range of wood stains and dyes can be used; big-nozzle airbrushes can also handle varnish. A smooth airbrushed finish does not, of course, remove the need for adequate sanding down.

7.27

7.27 Mike Cotten and Prairie Prince of the Tubes wearing airbrushed T-shirts.
7.28 Airbrushed mural decoration in an apartment belonging to the Tubes pop group.

Furniture Furniture can be decorated or 'antiqued'; cane can be sprayed, and chipped areas renovated. Refer to the sections on stencilling (page 133) and three-dimensional decoration (page 103).

Screen painting Silk or paper screens can be painted; so can carved or relief screens.

Relief frieze decorating The airbrush has the advantage of being able to reach corners inaccessible to a handbrush.

Fish taxidermy, and fish lures See sections on modelling and sculpture (pages 130 and 128).

Boat customizing Refer to section on car customizing (page 128).

Jewellery enamels Use a finely controllable airbrush.

Air cleaner For blowing air to clean intricate electronics and so forth, the advent of micro-processors has led to a considerable growth in the usage of the airbrush, which is ideal for this purpose.

Muting gold castings (dental) Use air eraser.

Dried-flower arranging, and paper-and silk-flower making See section on cake decoration (page 136).

7.28

Appendix I
Care and Maintenance of Airbrushes

The remarks in this section will not be relevant to all airbrushes, but an airbrush owner will easily be able to identify which points relate to his instrument, particularly after reference to page 142, where airbrushes are keyed by type and model. In Appendix 2, the major types of airbrush are illustrated; their parts vary according to name and shape but they retain essentially the same functions; here we will employ a standard nomenclature.

Day-to-day maintenance

1 In order to change colours, run the appropriate thinner through the airbrush, spraying out onto scrap until the previous colour is completely cleared. It is best to rinse the bowl (of a fixed colour-cup airbrush) several times before doing this. With some gravity-feed models, the nozzle cap can be loosened and air blown through it; this causes a blowback into the cup, and helps to clear medium from the nozzle area and paint-feed. Remember to tighten the cap afterwards. (A, B, C, D, E, F1).
2 Clean the airbrush thoroughly after every session of work. If you intend to break for a while, empty the airbrush and clean it through; otherwise the medium has time to dry in the nozzle, where it may accumulate and cause a blockage. (A, B, C, D, E, F1).
3 The more sophisticated airbrushes should be returned to the dealer approximately every 18 months for a routine service. This is a wiser practice than allowing faults to develop and cause more serious damage. A damaged cork washer, for instance, can easily be replaced at a service, before it sets off other problems. (D, E, F1).
4 When replacing the needle, loosen or remove the needle-locking nut. Firmly but gently push in the new needle until it sits in place, and then tighten the needle-locking nut. (C, D, E).
5 Make sure the needle is pulled back, if replacing a nozzle with the needle *in situ*. Once the new nozzle is tight, gently ease the needle forward; then loosen the needle-locking nut, check that the needle is sitting in place, and tighten the nut. (C, D, E).

6 If you wish to repair sophisticated airbrushes yourself, you may need a set of specialized tools. People with no mechanical knowledge or experience are advised not to

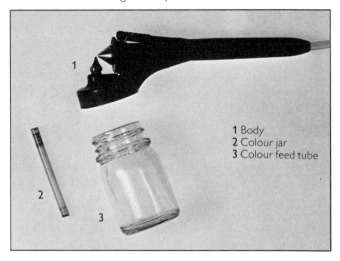

1 Body
2 Colour jar
3 Colour feed tube

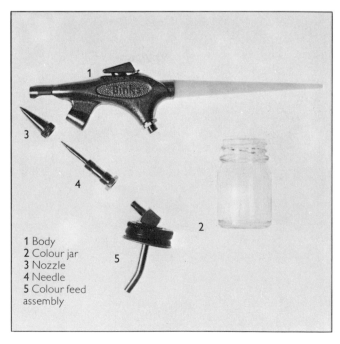

1 Body
2 Colour jar
3 Nozzle
4 Needle
5 Colour feed assembly

try this. Some manufacturers supply a set of tools to accompany their product, others do not.

7 Only use oil, vaseline or grease, as specified in the manufacturer's instructions. If you find, during a repair, that an area looks to have been greased or oiled, but can find no mention of it in the instructions, check with your dealer or manufacturer. (All models).

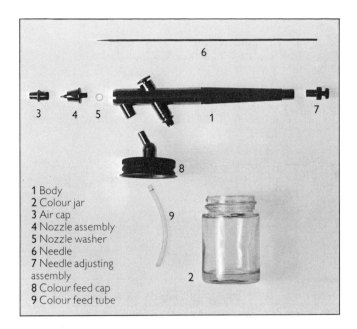

1 Body
2 Colour jar
3 Air cap
4 Nozzle assembly
5 Nozzle washer
6 Needle
7 Needle adjusting assembly
8 Colour feed cap
9 Colour feed tube

Photographs of parts for reference in day-to-day maintenance. Left: adjustable spray-gun. Below left: diffuser-type, needle-in-nozzle airbrush. Right: single-action, needle-in-body airbrush. Below: double-action airbrush. Bottom: full parts diagram for diffuser-type, needle-in-nozzle airbrush.

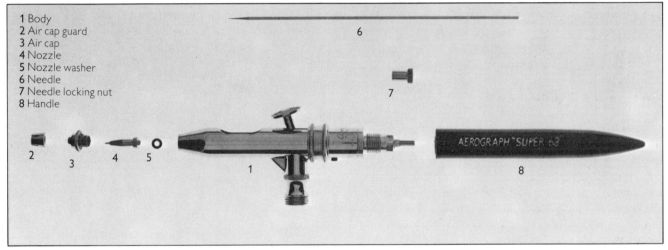

1 Body
2 Air cap guard
3 Air cap
4 Nozzle
5 Nozzle washer
6 Needle
7 Needle locking nut
8 Handle

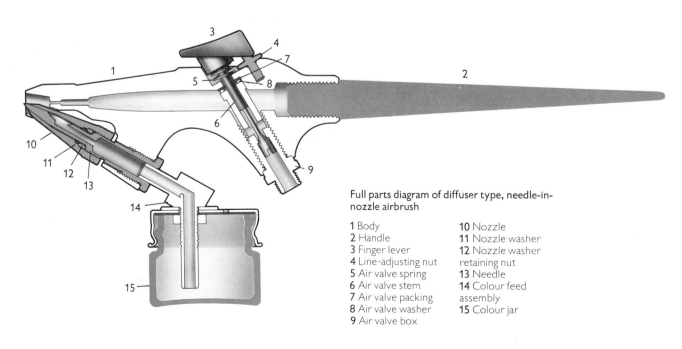

Full parts diagram of diffuser type, needle-in-nozzle airbrush

1 Body	10 Nozzle
2 Handle	11 Nozzle washer
3 Finger lever	12 Nozzle washer retaining nut
4 Line-adjusting nut	13 Needle
5 Air valve spring	14 Colour feed assembly
6 Air valve stem	15 Colour jar
7 Air valve packing	
8 Air valve washer	
9 Air valve box	

Fault chart

This fault chart, which we believe to be the most comprehensive listing ever published, deals with faults caused both by incorrect handling and mechanical trouble. If your airbrush develops a problem not listed here, return it to your dealer for inspection and repair.

Key to relevant models

Simple spray guns A
Single-action diffuser-type airbrushes B
When used with jar B1
When used with colour cup B2
Single-action needle-in-body airbrushes C
When used with suction-feed jar C1
When used with suction-feed colour cup C2
Gravity feed cup C3
Fixed double-action airbrushes D
When used with suction-feed jar D1
When used with suction-feed colour cup D2
Gravity feed cup D3
Gravity feed bowl or paint well D4
Independent double-action airbrushes E
When used with suction-feed jar E1
When used with suction-feed colour cup E2
Gravity feed colour cup E3
Gravity feed bowl or paint well E4
Special category airbrushes F
Turbo airbrush F1
Air eraser F2
Air-supply systems X
Gas canisters X1
Gas cylinders X2
Compressors without reservoirs X3
Systems with reservoirs X4

Symptom	Diagnosis	Cure	Relevant model
1 No medium being sprayed	(a) No medium in colour cup.	Fill cup.	A, B, C, D, E, F
	(b) Nozzle too far from air supply.	Adjust nozzle.	A, B
	(c) Paint inadequately mixed or thinned.	Empty, clean, mix thoroughly and strain paint.	A, B, C, D, E, F1
	(d) Feed tube has come out of medium.	Put more medium in jar.	A, B1, C1, D1, E1
	(e) Hole in top of colour jar closed.	Clean top of jar.	A, B1, C1, D1, E1
	(f) Medium has dried into nozzle.	Clean, or remove and clean, nozzle and needle; check that needle-locking nut attaching control lever to needle is tight.	A, B, C, D, E
	(g) Needle wedged in nozzle.	Carefully reset, checking nozzle and needle-locking nut.	C, D, E
	(h) With such as metallic flake paints; pigment settled in medium.	Run thinner through, and agitate the needle or paint jar.	A, B, C, D, E
	(i) Pigment settled in hole at bottom of cup feeding to brush.	Clean cup.	B2, C2, D2, E2
	(j) Needle-locking nut attaching control lever to needle loose.	Tighten.	C, D, E
	(k) Lever assembly broken.	Remove and clean nozzle, and replace lever assembly (dealer repair).	D, E
2 No medium being sprayed and/or bubbles in colour cup and/or spatter	(a) Nozzle cap loose.	Tighten.	C, D, E
	(b) Badly seated nozzle.	Remove, and re-seat.	C, D, E
	(c) Nozzle washer missing.	Replace washer.	C, D, E
	(d) Mis-match of nozzle and nozzle cap.	Replace one or both.	C, D, E

3 Spatter, or spitting	(a) Inadequate air pressure relative to paint supply.	Adjust.	A, B, C, D, E, F
	(b) Hair or dust in nozzle.	Remove and clean.	A, B, C, D, E, FI
	(c) Inadequately mixed or thinned medium.	Empty, clean, mix thoroughly and strain.	A, B, C, D, E, FI
	(d) Build-up of medium in nozzle cap.	Ensure needle firmly in nozzle, and clean carefully with brush and thinners.	C, D, E
	(e) Worn, cracked or split nozzle.	Replace as manufacturer's instructions.	B, C, D, E
	(f) Badly matched nozzle and needle.	Return to dealer and switch nozzle and/or needle until satisfactory.	C, D, E
	(g) Air-feed clogged by removal of nozzle when medium is in airbrush.	Remove nozzle and blast air through at high pressure.	C, D, E
	(h) Dirt or excess moisture from air supply.	Remove nozzle and blast air through. Check filtering at air source.	X3, X4 with all airbrushes
	(i) Medium clogging air-feed.	Washers preventing medium feeding into back of body worn, and diaphragm assembly broken. Repair speedily; beware of over-tightening needle-packing gland when replacing washers.	C, D, E
	(j) Owner has let medium into handle aperture, and diaphragm assembly broken.	Replace diaphragm assembly (dealer repair).	C, D, E, FI
4 Spatter, with the spray emitted at an angle	(a) Bent needle or split nozzle.	Replace.	C, D, E, FI
5 Spatter at start of strokes	(a) Build-up of medium due to letting lever return too quickly at end of previous stroke.	Release lever gently next time.	D, E
	(b) Medium build-up in nozzle cap.	Ensure needle firmly in nozzle, and clean carefully with brush and thinners.	C, D, E
	(c) Hair or dust in nozzle.	Remove and clean.	A, B, C, D, E, FI
	(d) Slight impurities or excess moisture in air line.	Remove nozzle and blast air through. Check filtering of air supply.	A, B, C, D, E, FI when used with X3, X4
6 Spatter at end of strokes	(a) Slight impurities or excess moisture in air line.	Remove nozzle and blast air through. Check filtering of air supply.	A, B, C, D, E, FI when used with X3, X4
7 No air coming through	(a) Something turned off at compressor.	Check compressor.	X2, X4
	(b) Canister empty.	Fit new canister.	XI, X2
	(c) Pressure drop in canister, making it cold.	Stand it in lukewarm water, or change it with another. (It is best to change canisters frequently. Do not exceed temperature marked as maximum on canister, if standing it in water.)	XI

	(d) Safety valve in adaptor blown due to excess pressure in canister.	Turn off, unscrew hose, turn on, and repeatedly push the valve to release air.	X1
	(e) Air-feed in airbrush blocked.	Empty, remove nozzle and blast air through airbrush. (Check diaphragm assembly on air valve.)	A, B, C, D, E, F
	(f) Lever assembly broken.	Replace (dealer repair).	D, E
	(g) Air valve stem broken.	Replace (dealer repair	A, B, C, D, E, F
	(h) Adaptor at canister sticking.	Free if possible, or replace.	X1
	(i) Blockage in air-supply tube from compressor.	Remove airbrush from lead, and carefully blow at very high pressure.	X
8 Air leaks through nozzle when airbrush off	(a) Air-valve spring incorrectly tensioned.	Retension, or replace, as necessary.	A, B, C, D, E, F
	(b) Diaphragm assembly and air-valve stem or ball incorrectly adjusted.	Dealer repair.	B, C, D, E, F
9 Air leaks through control lever	(a) Diaphragm assembly broken.	Replace (dealer repair).	B, C, D, E, F
10 Air leaks at source	(a) Connections loose.	Tighten connections.	X
	(b) Adaptor screwed insufficiently tight.	Screw down. NB for beginners: some makes of adaptor leak as you screw down; just keep going.	X1
	(c) Washer gone in hose or connections.	Replace washer(s).	X
11 Air blasts out at very high pressure	(a) Pressure of compressor set too high.	Turn down pressure control.	X2, X4
	(b) Canister overblowing.	Blow off air until pressure satisfactory (if heating it in water, remove).	X1
12 Medium leaks	(a) Airbrush held at angle letting medium out of colour cup.	Hold airbrush level; do not overfill bowl.	B2, C2, C3, D2, D3, D4, E2, E3, E4, F1
	(b) Washers and joints inadequately seated or tightened.	Check and re-set.	C3, D3, E3
	(c) Nozzle washer(s) missing or damaged.	Replace.	C3, D3, D4, E3, E4
	(d) Friction grip of jar in airbrush too loose.	Re-bed jar in body of brush more tightly.	B, C1, C2, D1, D2, E1, E2
	(e) Needle set too far back when not in use.	Turn forward after use.	C3
13 Medium drips from nozzle during operation	(a) Air supply inadequate relative to medium.	Increase air or decrease medium, or check air supply.	C3, D3, D4, E3, E4
	(b) Loose nozzle cap.	Tighten.	C, D, E
	(c) Medium spill from colour bowl running to nozzle and dripping.	Hold airbrush level; do not overfill bowl.	C3, D3, D4, E3, E4, F1
14 Flooding of medium onto ground	(a) Colour over-diluted.	Re-mix colour more thickly. (Do not simply add pigment.)	A, B, C, D, E
	(b) Needle too far back.	Reset needle further forward. Use needle more gently.	C E

		(c) Paint tube or nozzle set too high.	Reset lever action. Adjust setting.	D A, B
15	Blobs at either end of stroke 	(a) Hand stationary at start or end of stroke. (b) Lever not eased correctly at start or end of stroke. (c) Ink is released before air.	Move hand before operating, and after releasing lever. Ease lever on and off. Reset lever action.	A, B, C, D, E, F A, B, C, E, F2 D
16	Uneven strokes or flaring 	(a) Airbrush operated from wrist, not whole arm. (b) Dust or hair in nozzle.	Use whole arm for strokes. Remove nozzle and clean.	A, B, C, D, E, F A, B, C, D, E, F2
17	Colour muddy or tinged with other colours	(a) Paint-well, feed, nozzle or nozzle cap dirty.	Clean.	A, B, C, D, E, F
18	Spidering effect 	(a) Airbrush too close to ground for nozzle or needle setting. (b) Too much medium relative to air. (c) Ink is released before air.	Move away from ground, or adjust setting. Adjust control lever to correct ratio. Re-set lever action.	A, B, C E, F1 D
19	Pulsating spray pattern 	(a) Pulsating air supply due to small compressor without reservoir. (b) Dirt in nozzle. (c) Nozzle cap or nozzle inadequately seated. (d) Worn nozzle washer.	Make reservoir as pattern given in chapter 3, page 74. Clean. Check and adjust. Replace.	X3 A, B, C, D, E, F2 C, D, E C, D, E
20	Lever fails to return after pressing down	(a) Air-valve spring has lost tension.	Stretch spring or tighten air-valve spring retainer. Replace spring as soon as possible.	A, B, C, D, E, F
21	Lever fails to return after pulling back or lever flops	(a) Needle spring is stuck or has lost tension. (b) Lever assembly broken.	If you can reach the spring, retension it, and grease lightly, cleaning off old grease. Replace (dealer repair).	D, E D, E
22	Knocking at back of airbrush when moving forward	(a) Balance weight at end of airbrush loose, thereby knocking needle.	Remove handle and ram a rod down it to push weight into place.	C, D, E

Tuning

The list above names the general faults of nearly all airbrushes. There are, however, some tips to be given regarding tuning which should be noted.

1 When replacing the needle gland washers, screw in the needle-packing gland until the washers just act on the needle without gripping hard or restricting its movement significantly; this has to be done by feel.

2 Lever tuning: the needle spring should be tensioned so that the finger lever springs gently but firmly forward into place when pulled back. It should not snap forward; this should be checked several times after re-tensioning.

3 Lever tuning: the air-valve spring should be tensioned so that when depressed the finger lever returns to place gently but firmly again, cutting off the air at the nozzle. If the lever does not return correctly, either the air-valve spring is badly tensioned, or the diaphragm nut is set too low and is permanently depressing the spring.

4 Ensure that when the lever moves, the air supply comes on before the needle moves. If necessary, adjust the needle setting and the needle-locking nut. It is possible that this will involve slight adjustment of the needle-spring box, and perhaps the distance sleeve of the needle-spring box as well.

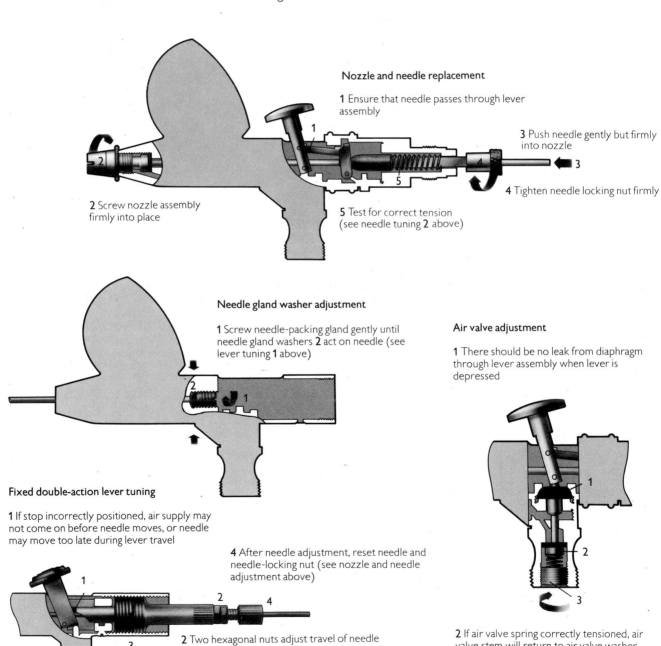

Nozzle and needle replacement

1 Ensure that needle passes through lever assembly

3 Push needle gently but firmly into nozzle

4 Tighten needle locking nut firmly

2 Screw nozzle assembly firmly into place

5 Test for correct tension (see needle tuning 2 above)

Needle gland washer adjustment

1 Screw needle-packing gland gently until needle gland washers 2 act on needle (see lever tuning 1 above)

Air valve adjustment

1 There should be no leak from diaphragm through lever assembly when lever is depressed

Fixed double-action lever tuning

1 If stop incorrectly positioned, air supply may not come on before needle moves, or needle may move too late during lever travel

4 After needle adjustment, reset needle and needle-locking nut (see nozzle and needle adjustment above)

2 Two hexagonal nuts adjust travel of needle assembly, hence adjusting stop 1

3 If nuts 2 give insufficient adjustment, needle spring box and its distance sleeve may need to be adjusted

2 If air valve spring correctly tensioned, air valve stem will return to air valve washer when finger lever is released, thus closing air supply to nozzle

3 Height of air valve spring retainer controls tension of air valve spring

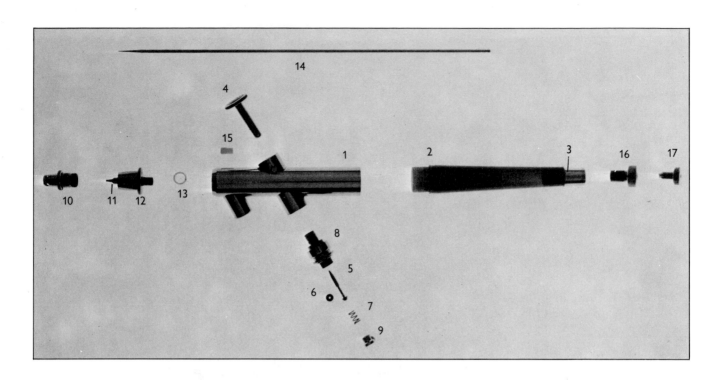

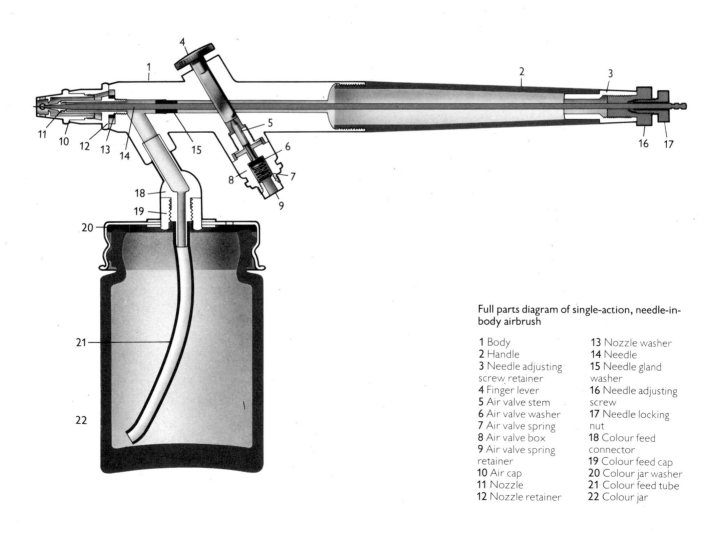

Full parts diagram of single-action, needle-in-body airbrush

1 Body	13 Nozzle washer
2 Handle	14 Needle
3 Needle adjusting screw retainer	15 Needle gland washer
4 Finger lever	16 Needle adjusting screw
5 Air valve stem	17 Needle locking nut
6 Air valve washer	18 Colour feed connector
7 Air valve spring	19 Colour feed cap
8 Air valve box	20 Colour jar washer
9 Air valve spring retainer	21 Colour feed tube
10 Air cap	22 Colour jar
11 Nozzle	
12 Nozzle retainer	

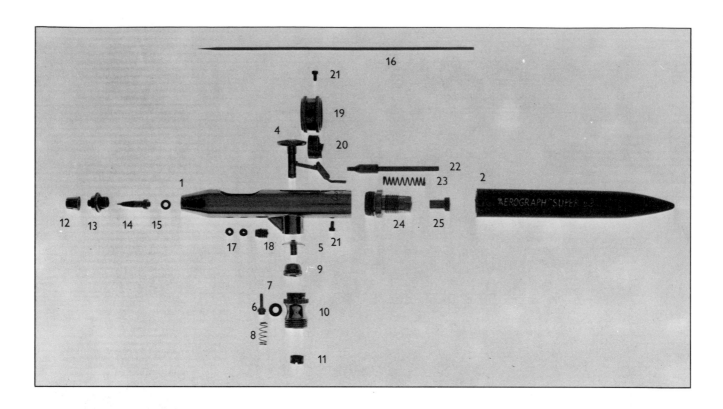

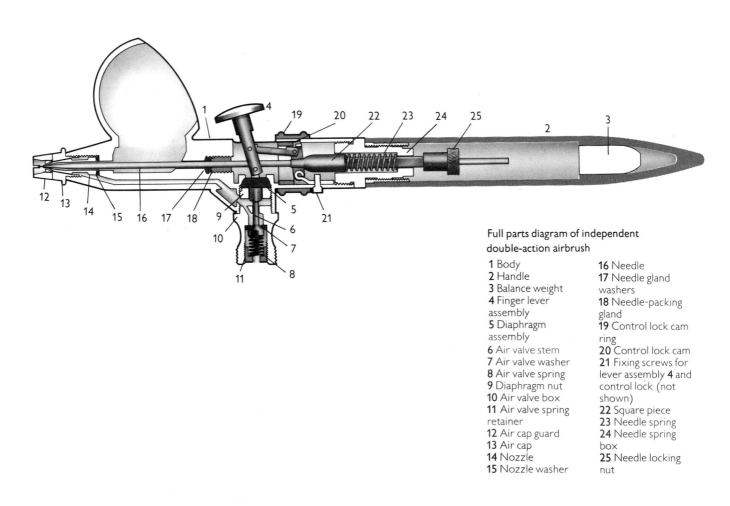

Full parts diagram of independent double-action airbrush

1 Body
2 Handle
3 Balance weight
4 Finger lever assembly
5 Diaphragm assembly
6 Air valve stem
7 Air valve washer
8 Air valve spring
9 Diaphragm nut
10 Air valve box
11 Air valve spring retainer
12 Air cap guard
13 Air cap
14 Nozzle
15 Nozzle washer

16 Needle
17 Needle gland washers
18 Needle-packing gland
19 Control lock cam ring
20 Control lock cam
21 Fixing screws for lever assembly 4 and control lock (not shown)
22 Square piece
23 Needle spring
24 Needle spring box
25 Needle locking nut

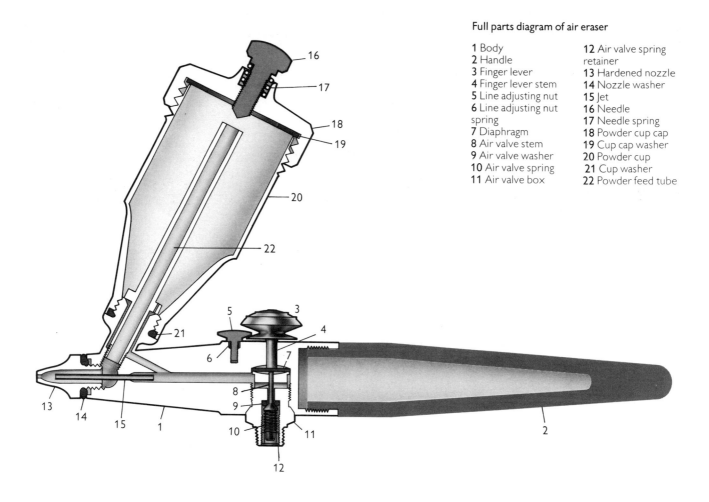

Full parts diagram of air eraser

1 Body
2 Handle
3 Finger lever
4 Finger lever stem
5 Line adjusting nut
6 Line adjusting nut spring
7 Diaphragm
8 Air valve stem
9 Air valve washer
10 Air valve spring
11 Air valve box

12 Air valve spring retainer
13 Hardened nozzle
14 Nozzle washer
15 Jet
16 Needle
17 Needle spring
18 Powder cup cap
19 Cup cap washer
20 Powder cup
21 Cup washer
22 Powder feed tube

The Turbo

The Paasche AB is a unique airbrush and develops faults which need to be dealt with separately.

Day-to-day maintenance

1 To clean the airbrush, cradle a tissue or rag under the needle bearing and tip the airbrush forward, making sure that the needle is not being obstructed. Operate the airbrush until the colour cup and needle bearing are both fully drained of paint.

2 The grease points should be lubricated with a light chassis grease.

3 When putting the airbrush away after a period of use with water-based media, clean the needle gently and very carefully with a soft cloth and proprietary metal cleaner to prevent corrosion.

Faults

1 Spatter, or the inability to produce fine lines, can be caused by the build-up of dried paint on the needle, or around the needle bearing. To cure, simply stop work and clean.

2 If the needle runs slow, or does not work immediately, if at all, it may be that the needle groove below the walking arm is blocked with paint. Or paint may have dried around the needle guide. The cure is to clean; the needle guide will also need to be greased.

3 The needle bearing can be eroded through friction caused by the needle. The bearing should be removed and replaced.

Tuning

Aside from fault finding, there are certain tuning adjustments that can be made to the AB, some of which may apply to a new model.

1 *New needle* To remove an old needle, firstly loosen the needle guide, making sure that the needle-guide spring does not fly out. A new needle should if necessary be bent so that it describes a 30° arc (one twelfth the circumference of a circle) before insertion. To replace, pull the finger lever back to push forward the walking arm. Lift the needle out from the needle bearing, and then from the walking arm. Insert the new needle firstly in the walking arm, under the needle guide, and into place.

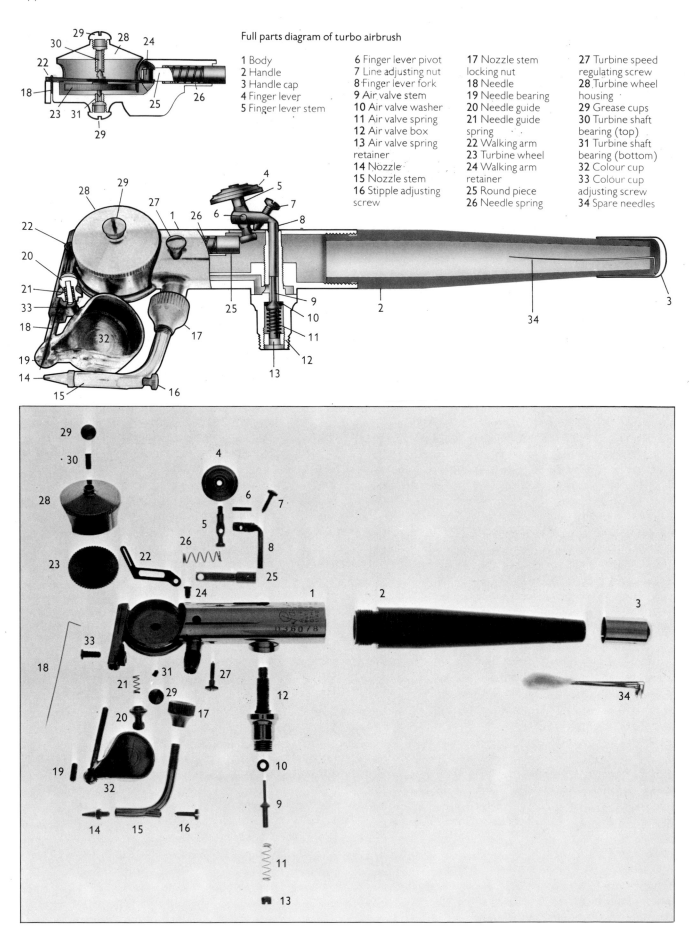

Full parts diagram of turbo airbrush

1 Body
2 Handle
3 Handle cap
4 Finger lever
5 Finger lever stem
6 Finger lever pivot
7 Line adjusting nut
8 Finger lever fork
9 Air valve stem
10 Air valve washer
11 Air valve spring
12 Air valve box
13 Air valve spring retainer
14 Nozzle
15 Nozzle stem
16 Stipple adjusting screw
17 Nozzle stem locking nut
18 Needle
19 Needle bearing
20 Needle guide
21 Needle guide spring
22 Walking arm
23 Turbine wheel
24 Walking arm retainer
25 Round piece
26 Needle spring
27 Turbine speed regulating screw
28 Turbine wheel housing
29 Grease cups
30 Turbine shaft bearing (top)
31 Turbine shaft bearing (bottom)
32 Colour cup
33 Colour cup adjusting screw
34 Spare needles

When viewed end on, the needle should pass straight across the centre of the nozzle; otherwise, spatter or a pulsating pattern can result.

2 *Needle bearing* The needle bearing fits into the ball socket of the colour cup assembly, and the small hole should be lined up with the fluid-flow groove from the colour cup. The manufacturers recommend that this should be checked with a toothpick.

3 *Nozzle* The nozzle can move up and down, and lock in position. If it is out of position it will pulse and/or spider. To correct, line up by eye, without operating air or paint; and if this fails operate the airbrush, easing the nozzle very gently up or down until it is in the correct position.

4 *Turbine pitch* To check the sound, remove the needle and apply 30 psi (2bar) through the airbrush. The power wheel and shaft assembly should sound like a dentist's drill. If the pitch varies for no apparent reason during normal operation, paint may have built up in the needle groove below the walking arm, or the needle guide or needle bearing. If it still happens when the needle is removed, it may have built up on the walking arm. Clean the relevant areas, and make sure that during operation the airbrush is held so that the finger lever is vertical, and the colour cup therefore tips down to the side. The cup itself should be angled down so that only the very surface of the paint in the cup touches the needle bearing – otherwise there is a risk of paint dripping. If the cup is too high, the needle may ride out of the bottom of the needle bearing; when the cup is correctly angled, it leaves the needle firmly seated. After altering the angle of the colour cup, the colour cup screw should be tightened.

5 *Turbine rattle* If there is turbine rattle as it winds down, then the grease cups need greasing.

6 *Distance from needle to nozzle* The manufacturers recommend a 3/64in (1.2mm) gap between needle and nozzle for general use, but it is perhaps better to arrive at the right gap by experimentation. Release the locking nut, and wind the air-blast tube round and round until the nozzle is very near to the needle, and paint is emitted as soon as the finger lever is depressed but not pulled back. Then wind the air-blast tube back, one revolution at a time, until air only is emitted when the finger lever is depressed, and paint emitted immediately the lever is pulled back. This is the correct position.

7 *Shaft bearings* If these are incorrectly aligned, the turbine might not turn, or else will drop in tone. In this case, gently screw down the top shaft bearing until the turbine stops. Then unscrew until it moves freely at full pitch. Do not unscrew further, as this may cause turbine rattle.

8 *Speed-regulator screw* When screwed fully down, this shuts off the air. Screw down until the pitch drops, then slowly screw back up. The pitch will rise, and then reach a point where it rises no more; this is the top turbine speed. The speed can now be adjusted as required.

9 *Stipple adjuster* Screw this in until it causes the nozzle to stipple, and then screw out again until the stipple disappears and you are spraying freely. This is the position for general use; it can be screwed in as required for stippling.

10 *Lever-adjusting screw* This is the equivalent of a line-adjusting nut and is sited behind the lever. Adjust it so that the lever can move freely for normal use; screwing in sets the lever further back.

11 *Paint build-up tip* If the airbrush is correctly tuned, and a build-up of paint on the needle is preventing you from drawing very fine lines, there is a temporary remedy, only to be used if you have no time to stop spraying and clean. Revolve the air-blast tube one turn at a time away from the needle until the fault is corrected. Remember to re-adjust the air-blast tube afterwards, and clean the needle as soon as possible.

Full-scale home owner service The turbo is an especially complicated airbrush, so it is useful to have a guide to dismantling for full cleaning, etc. Firstly, disconnect from the air supply, and empty the colour cup. Then push the air-blast tube upwards out of the way, and remove the needle as directed above. Next, unscrew the needle guide and remove it, and the needle-guide spring. Unscrew the colour-cup screw and remove the colour-cup assembly. Firmly but gently push out the needle bearing. Carefully prise off the wheel housing, making sure not to knock anything else; both grease cups should also be unscrewed. Push the finger lever back, exposing the walking-arm screw; loosen until the walking arm is free, and then remove the walking arm, being careful to leave the screw in place. Finally, remove the turbine wheel.

Now take a soft nylon or sable paintbrush, and clean all these items with the appropriate thinners. Clean all the front section of the airbrush, remembering also to clean underneath, and in the needle grooves and air-blast tube. Connect up to the air supply, and check that air comes out of both the air-blast tube and the turbine feed. If the latter is blocked, gently insert an old needle into the feed until it is clear. Reassemble the airbrush in the reverse order to the order of dismantling, remembering to grease the grease cups, and the base of the needle guide.

The Paasche AB is a complex piece of precision engineering; other airbrushes are less complicated, though equally well engineered. If treated properly they will last a lifetime and prove excellent value for money (very competitive with paintbrushes, considering their short life). It is vitally important to keep your instrument clean; and if a fault develops which you are not confident of being able to cure yourself, return the airbrush to your dealer for repair.

Appendix 2
Product Guide

Many models of the airbrush can be bought with accessories which are not mentioned below; as these accessories can vary depending on the distributor, they cannot be effectively catalogued.

Simple spray-guns, mixing air and paint externally, with adjustable paint control

Badger 250 Fitted with ¾fl oz (22cc) paint jar.

Badger 250-4 (not illustrated) Similar to the Badger 250, but fitted with a 4fl oz (120cc) paint jar.

Humbrol Modellers Airbrush Has simple control of air volume as well as of paint.

Single-action, diffuser-type airbrushes

Badger 350 Available with a fine, medium or heavy nozzle, and can be fitted with a 2fl oz (60cc) or ¾fl oz (22cc) paint jar, or a ¼oz (7cc) colour cup. (*Artistic SH* series is identical. SH-1 has a fine nozzle; SH-2 a medium one; SH-3 a heavy one.)

Binks Wren Available with fine nozzle (model 'A'), medium (model 'B') or heavy (model 'C'), though the nozzles are interchangeable so that any nozzle can fit any model. Each can take a 2½fl oz (75cc), ½fl oz (15cc) or ¼fl oz (7cc) colour jar.

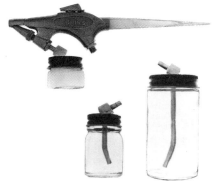

Paasche H Series Available with fine nozzle (model H-1), medium (model H-3) or large (model H-5), though the nozzles are interchangeable. Each can take a ¼fl oz (7cc) colour cup or a 3fl oz (90cc) jar. This series also features a control lock.

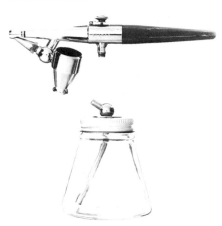

Paasche HS Series (not illustrated) Comprises three models which correspond to the H series – models HS-1, HS-3 and HS-5. The only difference is that this series features a threaded nut which secures the bottle assembly to a swivel connector, to allow a greater variety of spraying position (as on Paasche VL-S, illustrated below).

Paasche F-1 A smaller and more delicate version of the Paasche H, with a fitting for a $\frac{1}{4}$fl oz (7cc) side colour cup or a $\frac{1}{2}$fl oz (15cc) jar. There is no control lock.

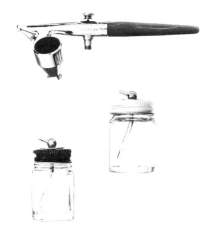

Single-action, needle-in-body airbrushes

Badger 200 Available with a medium nozzle (model IL), or large (model HD), though the nozzles are interchangeable. The air flow is controlled at the lever; the paint flow by a knurled wheel at the rear of the body. Suction-feed, this airbrush can take a $\frac{3}{4}$fl oz (22cc) or 2fl oz (60cc) colour jar, or a $\frac{1}{4}$fl oz (7cc) colour cup. Holes in the air cap reduce the risk of colour spread when working close to ground. (*Artistic* models SE-2 and SE-3 are identical to the Badger 200 IL and HD respectively.)

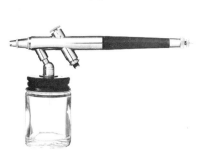

Olympos Young 88 This model takes an adjustable gravity-feed colour cup, and has a calibrated needle adjustment and an external needle-packing gland adjustment. It screws directly onto a gas canister without a lead, but can use no other form of propellant.

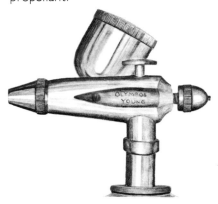

Wold K Available in left- and right-handed models; the paint flow is adjusted at a knurled wheel beneath the finger lever. Uses a 1fl oz (30cc), gravity-feed side colour cup; model KM (not illustrated) uses a 1fl oz (30cc) suction-feed jar; model R (not illustrated) can take either a 1fl oz (30cc) colour cup or jar, but here the paint flow is adjusted by a knurled screw at the rear of the body.

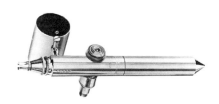

Wold J A more delicate version of the Wold K, and also available in left- and right-handed models. The paint flow is adjusted by a knurled wheel beneath the finger lever; uses a 1/16fl oz (2cc) colour cup. Model JN takes only a $\frac{1}{2}$fl oz (15cc) colour jar.

Fixed double-action airbrushes

Efbe Industrial C2 (C2 hinged) Available with a choice of 0.4, 0.6, and 0.8mm nozzles; suction-feed with a 2/3fl oz (20cc) colour jar.

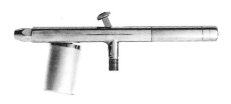

Efbe Industrial B2 (B2 hinged) As the C2 above, but with a gravity-feed side cup.

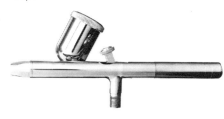

Efbe Designer (C1 hinged) A suction-feed airbrush with a 1/5fl oz (6cc) colour jar.

Efbe Hobbyist (B1 hinged) As the Designer above, but with a gravity-feed side cup.

Efbe Illustrator (B1 fixed) Has a gravity-feed colour bowl.

Efbe Retoucher (model A) As the Illustrator above, but with a finer nozzle and a gravity-feed paint well.

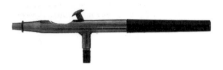

Grafo Type IIC Available with a choice of 0.3 or 0.5mm nozzle, and with a suction-feed colour jar.

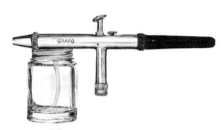

Grafo Type III As Type IIC above, but with a gravity-feed side cup.

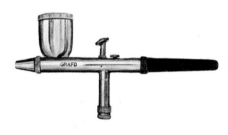

Grafo Type IIB Has a suction-feed colour jar.

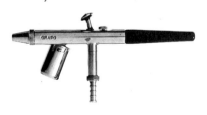

Grafo Type II As Type IIB above, but with a gravity-feed colour bowl.

Grafo Type I (not illustrated) As Type II above, but with a finer nozzle.

Humbrol Studio 1 Has a gravity-feed, centrally mounted colour cup, and an original sliding cam action. The nozzle can be replaced as an integral unit – however, you are not advised to attempt dismantling it yourself.

Wold 'U' (not illustrated) Available in left- and right-handed models, and has an unusual vertical finger control. Otherwise it resembles the Wold A-2, illustrated below.

Independent double-action airbrushes

Badger 150 Available with a fine nozzle (model XF), medium (model IL), or large (model HD), though the nozzles are interchangeable. Each is suction-feed, taking a $\frac{3}{4}$fl oz (22cc) or a 2fl oz (60cc) colour jar, or a $\frac{1}{4}$fl oz (7cc) colour cup. Other features include a line-adjusting nut, and holes in the air cap to reduce the risk of colour spreading when working close to the ground. (*Artistic* models SSV-2 and SSV-3 are identical to the Badger 150 IL and HD respectively.)

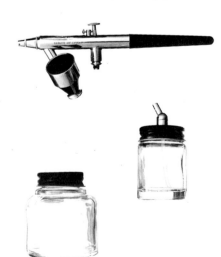

Badger 100 Available with a fine nozzle (model XF) or medium (model IL); the nozzles being interchangeable. Either a 1/16fl oz (2cc) or a 1/8fl oz (3.5cc) suction-feed side colour cup is supplied. This airbrush also features a line-adjusting nut, and screw-off bases on the colour cups for easy cleaning. Left- and right-handed models are available; the air cap also has holes to reduce colour spread when working close to the ground. (*Artistic* models S-1 and S-2 are identical to the Badger 100 XF and IL.)

Badger 100GXF Has a fine nozzle, and a gravity-feed colour bowl of 1/16fl oz (2cc); the air cap has holes to reduce the risk of colour spread when working close to the ground. (*Artistic* SG-1 is identical.)

DeVilbiss Aerograph Sprite Major Fitted with a broad nozzle, though this nozzle set can be changed for a fine one; the suction-feed colour jar holds 1fl oz (30cc). There is a control lock.

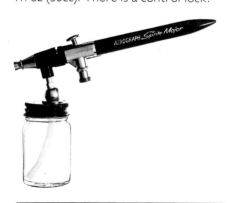

DeVilbiss Aerograph Sprite Fitted with a fine nozzle, though the nozzle set can be changed for a broad one; the gravity-feed paint bowl holds 1/6fl oz (5cc). The air cap has slots which reduce the risk of colour spread when working close to the ground; otherwise this model is as the Sprite Major.

DeVilbiss Aerograph Super 63E Fitted with a fine nozzle, and a gravity-feed paint bowl of 1/6fl oz (5cc). The matched nozzle and air cap can be replaced as a set. There is a control lock, and slots in the air cap which reduce the risk of colour spread when working close to the ground. A self-adjusting valve mechanism ensures long life.

DeVilbiss Aerograph Super 63A This model has a finer nozzle, and gravity-feed paint well. Needle-and-nozzle sets for the 'A' and 'E' are interchangeable; in other respects this airbrush is identical to the 'E'.

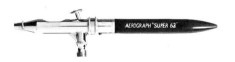

Holbein Neo-Hohmi Has a fine nozzle, a suction-feed side colour cup, and a line-adjusting nut. There is also an external needle-packing gland attachment.

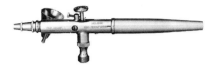

Holbein Y-4 Has a large nozzle, and a gravity-feed top-mounted colour cup; there is also an external needle-packing gland adjustment.

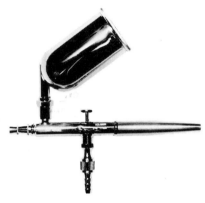

Holbein Y-3 Has a medium nozzle, and a colour bowl with a lid; otherwise this is as the Y-4.

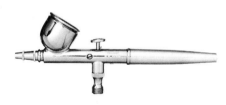

Holbein Y-2 Has a fine nozzle, and a smaller colour bowl than the Y-3; otherwise it is similar.

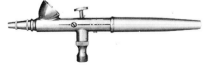

Holbein Y-1 Has a paint well; otherwise identical to the Y-2.

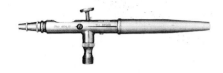

Iwata HP-D-S Has a broad nozzle, and a gravity-feed top-mounted colour cup holding 4fl oz (120cc).

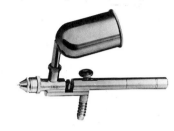

Iwata HP-D-L Has a larger nozzle than the HP-D-S; otherwise it is identical. This model is designed specifically for lacquers.

Iwata HP-C Has a medium nozzle, and a 1fl oz (30cc) gravity-feed colour bowl.

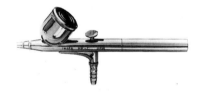

Iwata HP-B Has a fine nozzle, and a $\frac{1}{4}$fl oz (7cc) gravity-feed bowl.

Iwata HP-A As the HP-B, except that it has a colour well.

Paasche VLS Available with a fine nozzle (model VLS-1), medium (model VLS-3) or large (model VLS-5); needle-and-nozzle sets are interchangeable. These models are suction-feed, taking a ¼fl oz (7cc) side colour cup, or a 3fl oz (90cc) colour jar; they also feature a control lock, and a swivel connector to allow a greater variety of spraying positions.

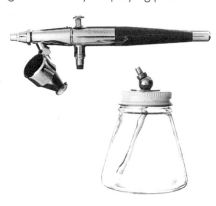

Paasche VL (not illustrated) Available in models VL-1, VL-3 and VL-5, which are identical to the VLS series except that they have no swivel connectors.

Paasche V Available with a fine nozzle (model V-1), or medium (model V-2); the needle-and-nozzle sets are interchangeable. There are left- and right-handed models; also a choice of 1/8fl oz (3.5cc) suction-feed side colour cup or 1oz (30cc) colour jar. This airbrush also features a control lock.

Paasche V-jr Similar to the Paasche V series, except that they have gravity-feed colour bowls; model V-jr-1 corresponds to the V-1; model V-jr-2 to the V-2.

Sata Decorating Gun Available in interchangeable nozzles of 0.2, 0.3, 0.4, 0.5, 0.6, 0.8 or 1mm. A 4in (10cm) extension piece can be obtained for the nozzle. The gravity-feed colour cup comes in 2fl oz (60cc) or 3.5fl oz (105cc) volume; there is also an externally adjustable needle-packing gland.

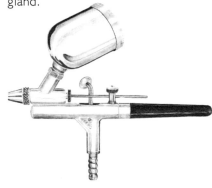

Thayer and Chandler Comes with fine nozzle (model A), or medium (model AA); left- and right-handed models are available. Suction-feed side colour cups come in 1/16fl oz (2cc) or 1/8fl oz (3.5cc) sizes. There is also an externally adjustable needle-packing gland, and a line-adjusting nut.

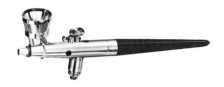

Wold W-9 Has a very large nozzle, and a suction-feed colour jar of 4fl oz (120cc), 6fl oz (180cc) or 8fl oz (240cc). This model also features a line-adjusting nut.

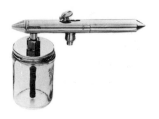

Wold Master Has a large nozzle, and a suction-feed side colour cup of ½fl oz (15cc); it also features a line-adjusting nut. Left-and right-handed models are available.
Wold Master M (not illustrated) As the Master, but can also take a 1fl oz (30cc) colour jar.

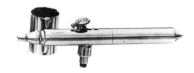

Wold A-2N A medium nozzle, suction-feed airbrush taking either a side colour cup of 7/32fl oz (6cc) or a colour jar of 1fl oz (30cc). There is a line-adjusting nut, and left-and right-handed models are available.

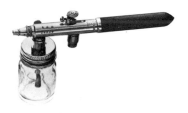

Wold A-1 Identical to the A-2N, except that it cannot be fitted with a colour jar; the nozzle and needle assembly is interchangeable with that of the A-2N.

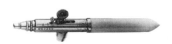

Wold A-2 Has a fine nozzle, and a suction-feed side colour cup of 1/16fl oz (2cc). This model features a silver-plated nozzle; there is also a line-adjusting nut, and a choice of left-and right-handed versions.

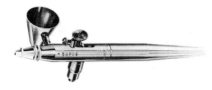

Wold A-137 (not illustrated) Similar to the A-2, but has a removable protective nozzle cap and no line-adjusting nut. Left-and right-handed models are available.

Wold A-196 A fine nozzle airbrush, with a gravity-feed paint well, and a line-adjusting nut.

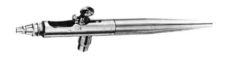

Special category airbrushes

Paasche AB This unique independent double-action gravity-feed airbrush is powered by a turbine at up to 20,000 rpm. The specially designed paint tip is for slow, detailed work. There is a colour cup, a colour cup adjusting screw, a stipple adjusting screw, a line adjusting nut, a turbine speed control, self-feeding grease cups to lubricate the turbine, and even spare needles provided with the airbrush body. Left-and right-handed models are available.

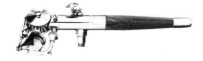

Glossary

Acrylic A water-thinned paint, based on acrylic resin.
Acrylic Enamel Type of acrylic paint often used for car-body painting.
Aerograph Name of first airbrush (of a type still in production). Has been known as generic term for airbrushing, and for airbrush work (e.g. Man Ray).
Airbrush The handpiece of a sophisticated paint-spraying system.
Air Eraser Sophisticated abrasive gun.
Air Valve Controllable valve permitting air to airbrush nozzle.
Alkyd A spirit-thinned paint based on alcohol and acid resin.
Artist's Print see PRINT (1).
Automatic Return Valve Valve on compressor regulating pressure in reservoir.
Bar Unit of atmospheric pressure equal to 10^6 dynes/cm² (approximately 14.5 psi).
Bernoulli's Principle Daniel Bernoulli's law of fluids, which states that the pressure in a fluid decreases as its velocity increases.
Blocking Out Painting out undesirable sections of a photograph or other artwork during retouching.
Bowl Paint receptacle forming integral part of airbrush body.
Canister Disposable can of propellant.
Card Masking see MASKING.
Cel Transparent acetate sheet used for overlay.
Chinese Ink Traditional block ink which requires grinding in water.
Colour Cup Removable paint container with integral feed tube.
Colour Separation The breaking up of an image into suitable base colours for reproduction.
Control Lock Device for locking airbrush control lever in position.
Cylinder Large refillable container of propellant.
Diaphragm Assembly Valve and lever system found in some independent double-action airbrushes.
Diffuser Simple airbrush nozzle system.
Diorama Three-dimensional type of scaled scenery background.
Double-action Airbrush control which dictates both the amount of air and the amount of paint released.
Dye Any medium coloured by a totally soluble agent.
Egg Tempera Water-thinned paint based on egg or egg-yolk, sometimes with oil.
Enamel Spirit-thinned paint based on cellulose or equivalent.
Film Masking see MASKING
Fixed Double-action Airbrush control which dictates the amount of paint and the amount of air released, in a fixed ratio.

Fluid Tip see NOZZLE.
Freehand Detailed airbrush work independent of masking.
Frisket see MASKING.
Gouache Water-thinned paint with tempera or acrylic base.
Gravity-feed Method of introducing medium to airbrush by gravity.
Grey Scale Scale of grey values between black and white.
Ground Surface on which painting or design is made.
Handbrush Conventional paintbrush.
Independent Double-action Airbrush control which dictates both the amount of paint and the amount of air released as independent actions on the same lever.
Jar Removable paint container with feed tube in lid.
Line-adjusting Nut see CONTROL LOCK.
Masking Obstruction preventing ground being sprayed in a particular area. There are two main categories: *loose masking* – where the mask is not attached to the ground, e.g. card masking; and *contact masking*, where the mask is attached to the ground, e.g. film masking, masking tape, frisket, and liquid masking including varnish masks.
Medium Liquid vehicle with which pigments or dyes are mixed for use.
Mezzotint Method of obtaining broad areas of texture, tone or colour in incised printing.
Modular Colour Proprietary paint system whereby colour intensity is graded against a grey scale.
Moiré Clouded appearance obtained by crossing any two imperfectly aligned screens.
Mouth Diffuser Traditional spray tool powered by blowing.
Mural (1) A painting executed directly on a wall. (2) Two-dimensional scene painted on a vehicular surface (car customizing).
Needle Airbrush component controlling the amount of paint allowed through the nozzle.
Nozzle Airbrush aperture releasing paint into the airstream.
Oil Paint Spirit-thinned paint based on a mixture of linseed or comparable oil with varnish.
Overblow Escape of excess pressure from propellant.
Overlay Transparent sheet laid over artwork for adding further colour or detail.
Overspray The laying of spray over artwork in order to modify or advance the effect.
Paint Any medium coloured by suspended particles.
Photo Retouching see RETOUCHING.
Pigment Particles of a specific colour suspended in a medium to create paint.
Pressure Regulating Tank Small tank used to prevent fluctuations from compressor reservoir.
Pressure Return Valve see AUTOMATIC RETURN VALVE.
Print (1) Specialized genre where the artist has a hand in the method of paint production (Artist's Print).

(2) Artwork reproduced by mechanical means.

(3) Photographic positive.

Propellant Airbrush power source.

p.s.i. Imperial unit of atmospheric pressure: pounds per sq. in. (approximately 0.07bars).

Render To originate (artwork).

Reservoir Air storage tank at compressor.

Retouching Modifying or advancing an existing artwork or photograph.

Safety Valve Valve on canister or compressor to release excess pressure.

Screen (Photographic) transparent sheet marked to allow light through in a specific or random pattern to create a half-tone plate for printing.

Single-action Airbrush lever which controls only the amount of air released, when paint is controlled elsewhere.

Spidering Effect caused by excess of medium or air, especially when airbrush is close to ground, creating tendrils of medium instead of a finely diffused spray.

Starburst Form of highlight caused by spraying light medium onto a small area of a dark ground.

Stipple Coarse spray of paint used for producing grainy effects.

Suction-feed Method of introducing medium to airbrush by suction (see **Bernoulli's Principle**).

Tack Degree of adhesion, especially of masking to ground.

Tank see RESERVOIR.

Tooth A rough or roughened texture on impervious ground enabling medium to adhere.

Turbo Turbine-driven airbrush.

Water-colour Water-thinned paint based on gum arabic or equivalent.

Notes to Chapter 2

1 David Hardy and Bob Shaw *Thomas Cook's Galactic Tours*, Sackett and Marshall, London.

2 Man Ray *Self Portrait*, Andre Deutsch 1963 p. 73

3 Penrose, Sir Roland *Man Ray*, Thames and Hudson 1975 pp 48–50

4 de Kooning, Willem, quoted in *Pop as Art* by Mario Amaya, Studio Vista 1965 p. 45

5 Dine, Jim *ibid* p. 45

6 Lichtenstein, Roy, in an interview with G.R. Swenson 'What is Pop Art' in *Art News* 62, no. 7, 1963

7 Salt, John, in an interview in *Art in America* Nov/Dec 1972

8 Eddy, Don *ibid*

9 Goings, Ralph *ibid*

10 Estes, Richard *ibid*

11 Close, Chuck *Artforum* January 1970

12 Glaser, Bruce, Professor of Art History at University of Bridgeport, Connecticut, in the catalogue notes to Audrey Flack exhibition, New York, April 1976

13 Gombrich, E.H. *Art and Illusion*, Phaidon 1960 pp. 271–275

Bibliography

Technical

Caiati, Carl *Airbrush Techniques for Custom Painting* (Badger, Chicago 1978)

Dalley, Terence (Ed.) *The Complete Guide to Illustration and Design Techniques and Materials* (Mayflower, New York 1979)

Croy, O.R. *Retouching* (Focal Press, London 1964)

Hayes, Colin (Ed.) *The Complete Guide to Painting and Drawing Techniques and Materials* (Phaidon, Oxford 1979)

Gill, Robert W. *Manual of Rendering with Pen and Ink* (Thames and Hudson, London 1973: Van Nostrand Reinhold, New York 1973)

Goldman, Richard M. and Rubenstein, Murray *Airbrushing for Modellers* (Almark Publishing Co. New York 1974)

Kodak Booklet E70 *Retouching Ektacolour Prints* 1977

Critical

Gabor, Mark *The Pin-Up, A Modest History* (Universe Books, New York, 1972: Pan Books, London 1976)

Gombrich, E.H. *Art and Illusion* (Phaidon, Oxford 1977: Princeton University Press 1961)

Gregory, R.L. *Intelligent Eye* (Weidenfeld and Nicolson, London 1971: McGraw-Hill, New York 1970)

Lucie-Smith, Edward *Late Modern* (Thames and Hudson, London 1969: Praeger Pubs, New York 1976)

Mai-Mai Sze *The Tao of Painting* (Princeton University Press, 1963)

van Briessen, Fritz (tr) *Way of the Brush* (Tuttle, New York 1962)

Walker, John A. *Art Since Pop* (Thames and Hudson, London 1975: Dolphin Art Books, New York)

Wang Chi-Yuan and Martin, Ruth *Oriental Brushwork* (Grosset and Dunlap, New York 1964: Pitman, London 1964)

Wolfe, Tom *The Painted Word* (Farrar, Strauss and Giroux, New York, 1975: Bantam Books, 1977)

Index

Figures in italics refer to
illustrations